Magic Lantern Guides

Nikon
D70s/D70

Simon Stafford

LARK BOOKS

A Division of Sterling Publishing,Co., Inc.
New York

Book Design and Layout: Michael Robertson
Cover Design: Barbara Zaretsky
Editorial Assistance: Delores Gosnell

Library of Congress Cataloging-in-Publication Data

Stafford, Simon.
 Nikon D70s/D70 / Simon Stafford.-- 1st ed.
 p. cm. -- (Magic lantern guides)
 Includes index.
 ISBN 1-57990-618-4 (pbk.)
 1. Nikon camera--Handbooks, manuals, etc. 2. Digital cameras--Handbooks,
manuals, etc. I. Title. II. Series.
TR263.N5S7323 2004
771.3'3--dc22

 2004004517

10 9 8 7 6 5 4 3 2 1
First Edition

Published by Lark Books, A Division of
Sterling Publishing Co., Inc.
387 Park Avenue South, New York, N.Y. 10016

Distributed in Canada by Sterling Publishing,
c/o Canadian Manda Group, 165 Dufferin Street
Toronto, Ontario, Canada M6K 3H6

Distributed in the U.K. by Guild of Master Craftsman Publications Ltd.,
Castle Place, 166 High Street, Lewes, East Sussex, England BN7 1XU
Tel: (+ 44) 1273 477374, Fax: (+ 44) 1273 478606,
Email: pubs@thegmcgroup.com; Web: www.gmcpublications.com

Distributed in Australia by Capricorn Link (Australia) Pty Ltd.,
P.O. Box 704, Windsor, NSW 2756 Australia

If you have questions or comments about this book, please contact:
Lark Books
67 Broadway
Asheville, NC 28801
(828) 253-0467
www.larkbooks.com
Printed in the United States

ISBN 1-57990-618-4

Contents

5

Introduction

The Nikon Corporation has many years of experience building digital cameras. Their first and second generation of digital SLR cameras, the D1, followed by the D1X and D1H, broke new ground technically and made high-quality digital photography financially viable for many professional photographers. Subsequently, with advances in sensor technology their third generation camera, the D100, pushed resolution beyond that of the earlier models. Its improved technical specifications coupled with the fact it cost about half the price of a D1X tempted many avid enthusiasts to take the digital plunge!

It was from this heritage that Nikon introduced the D70— a camera for the enthusiast photographer with the flexibility to be used in a simple, fully automatic, point-and-shoot style, or with total user control of all its functions. In this regard, the D70 has proved to be an immensely popular camera for the novice photographer seeking to gain a basic knowledge of photography as well as for the more advanced enthusiast wishing to hone their skills. During April 2005, a little over a year after the D70 was first launched, Nikon announced a new model: the D70s.

New D70s Features:
- A 3'3" (1 m) long MC-DC1 Remote Release cord with a lockable shutter button that connects to a terminal located on the left side of the D70s camera body.
- An EN-EL3a (1500mAh) higher capacity battery and new compact MH-18a AC charger. The new battery offers an increased shooting capacity of approximately 25%. (The original EN-EL3 and MH-18 are both interchangeable with the new battery and charger.)
- A larger 2-inch LCD Monitor with a new BM-5 LCD Monitor cover. (The D70 LCD Monitor is 1.8 inches, but the resolution of both screens is the same: 130,000 pixels.)
- Improved AF speed and accuracy in low light/low contrast conditions. For Dynamic Area AF and Closest Subject Priority AF Modes.

- Increased angle of illumination from the built-in Speed-light for a lens focal length of 18mm. (The D70 Speedlight covers a focal length of 20mm.)
- Full compliance with EXIF 2.21 and DCF 2.0 standards for JPEG files shot in Mode II (Adobe RGB).
- Extended PictBridge direct printing support with print sizes selectable from within the camera menu.

At the same time that Nikon announced the D70s, they also declared their support for existing owners of the D70 by stating their intention to introduce a firmware update to include the following features:

- Improved performance for the AF system to equal that of the D70s.
- Updated menus similar to those of the D70s.
- Extended support for PictBridge direct printing, as available on the D70s.

This firmware updates the previous version (A 1.01 / B 1.03), and is available for download by the user from Nikon's technical support websites (see page 221).

Conventions Used In This Book

As a matter of convenience, where information or descriptions of a feature apply to both the D70s and the D70, I have usually referred to them in the singular, as simply the D70. Where information pertains to a specific model of the camera, I have commented accordingly to distinguish the difference. Additionally, all photos and illustrations apply to both models except where noted in the text. Unless otherwise stated, when the terms "left" and "right" are used to describe the location of a camera control, it is assumed the camera is being held in shooting position.

When referring to a specific Custom Setting, it will sometimes be mentioned in the abbreviated form: CS-X; where X is the identifying number of the function. In describing the

functionality of lenses and external flash units, it is assumed that the appropriate Nikkor lenses and Speedlight units are being used. Note that lenses and flash units made by independent manufacturers may have different functionality. If you use such products, refer to the manufacturer's instruction manual to check compatibility and operation.

When referring to Nikon software, it is assumed that Nikon View (version 6.2.0 or higher) supplied with many D70 cameras, Nikon Picture Project (version 1.0 or higher) supplied with some later D70 models and all D70s models, or the optional Nikon Capture (version 4.1.0, or higher), is used.

About This Book

To get the most from your D70 it is important that you understand its features so you can make informed choices about how to use them in conjunction with your style of photography. This book is designed to help you achieve this and should be seen as an adjunct to the camera's own instruction manual. Besides explaining how all the basic functions work, this book also provides you with useful tips on operating the D70 and maximizing its performance. The book does not have to be read from cover to cover. You can move from section to section as required, study a complete chapter, or just absorb the principle features or functions you want to use.

The key to success, regardless of your level of experience, is to practice with your camera. You do not waste money on film and processing costs with a digital camera; once you have invested in a memory card it can be used over and over again. Therefore, you can shoot as many pictures as you like, review your results almost immediately, and then delete your near misses but save your successes – this trial and error method is a very effective way to learn!

Simon Stafford
Wiltshire, England.

Overview of the Nikon D70s/D70

Design

The philosophy Nikon adopted when designing the D70 was to develop a camera that would not only satisfy the expectations of novice users straight-out-of-the box, but to also give more experienced photographers the opportunity to control the camera on any level they desire.

Externally the D70 appears very similar to its more expensive stable mate the D100, but if you are thinking that Nikon took the latter and shaved off a few features to meet the required price point you would be very much mistaken. To the contrary, the D70 has benefited from the rapid advances

The D70 with a wide-angle lens is the perfect combination for photo-graphing landmarks. However, tilting a wide-angle lens up causes a building's verticals to converge. Although not geometrically correct, this helps to emphasize the height of the building.

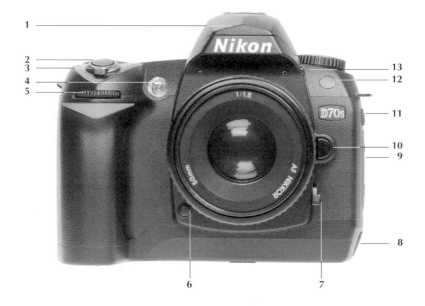

Front View

1. Built-in Speedlight
2. Shutter Release Button
3. Power Switch
4. Self-timer Lamp/AF-assist Illuminator/Red-eye Reduction Lamp
5. Sub Command Dial
6. Depth-of-Field Preview Button
7. Focus-mode selector
8. USB connector (under cover)
9. DC-in Connector (under cover)/Video Connector (under cover)
10. Lens Release Button
11. Remote cord connector (under cover—D70s only)
12. Infrared Receiver
13. Speedlight Lock Release Button/Flash Sync Mode Button/Flash Exposure Compensation Button

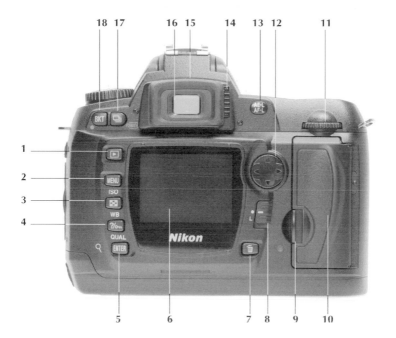

Back View

1. *Playback Button* 🔲
2. *Menu Button* 🔳
3. *Sensitivity (ISO) Button/*
 Thumbnail Button ISO 🔳
4. *White balance (WB)*
 Button/Protect Button/
 Help Button WB 🔳
5. *Image Quality/Image Size*
 Button (QUAL)/Playback
 Zoom Button/Enter Button
 QUAL 🔳
6. *Monitor*
7. *Delete Button* 🔳

8. *Focus Selector Lock*
9. *Memory Card Slot*
 Cover Latch
10. *Memory Card Slot Cover*
11. *Main Command Dial*
12. *Multi Selector Switch*
13. *AE/AF Lock Button*
14. *Diopter Adjustment Control*
15. *Viewfinder Eyepiece Cup*
16. *Viewfinder Eyepiece*
17. *Shooting Mode Button/*
 Format Button 🔳
18. *Bracketing Button* 🔳

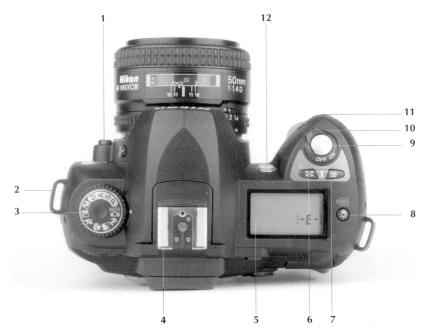

Top View

1. Lens Release Button
2. Eyelet for camera strap
3. Mode Dial
4. Accessory Shoe (Hot Shoe)
5. Control Panel
6. Metering Mode Button
7. Exposure Compensation Button

8. LCD illuminator Button/ Format Button
9. Shutter Release Button
10. Power Switch
11. Sub Command Dial
12. Self-timer Lamp/AF-assist Illuminator/Red-eye Reduction Lamp

in the dynamic technology of digital imaging. The redesign of the shutter, sensor, buffer memory, and processing algorithms have all contributed to a significant improvement in performance over the D100; the camera has even inherited a modified version of the exposure and flash metering system from Nikon's 'flagship' digital SLR, the D2H.

The D70 is an interchangeable lens, digital, single-lens reflex (SLR) camera that offers complete automation of exposure and focusing, as well as full manual control of all its features and functions. The camera body is 5.5 x 4.4 x 3.1 inches (140 x 111 x 78 mm) and weighs approximately 21 ounces (595g) without battery or memory card. It has a Nikon F lens mount with autofocus (AF) coupling and contacts; the greatest level of compatibility is achieved with either Nikkor AF-D, or AF-G type lenses. Other CPU and non-CPU Nikkor lens can be used but provide a variable level of compatibility dependent on the type of lens. Data storage is to either a Compact-Flash (Type I / Type II) card, or a Microdrive.

Power

A single EN-EL3 (7.4V 1400mAh) or EN-EL3a (7.4V 1500mAh) rechargeable lithium ion battery that weighs approximately 2.8 oz (80 g) powers the D70. Battery performance is dependent on a number of factors, including condition of the battery, the camera functions used and the ambient temperature. At a normal room temperature of 68°F (20°C) it is quite possible to make many hundreds of exposures on a single fully charged EN-EL3.

The camera can also accept three non-rechargeable CR2 lithium batteries in the MS-D70 battery holder supplied with the camera as an alternative power supply, but shooting capacity is reduced significantly. The Nikon EH-5 AC adapter can also support the D70 for extended periods of use.

Hint: All electronically controlled cameras very occasionally exhibit some strange behavior with unexpected icons or

characters appearing in the LCD display, or the camera ceases to function properly. This is usually due an electro-static charge. To remedy the situation try switching the cam-era off, removing and replacing the battery, or disconnect then reconnect the AC power supply, before switching the camera on again. If the problem persists, push the reset but-ton located toward the left end of the camera's base plate.

Sensor

The Charge Coupled Device (CCD) sensor used in the D70 is identical to the one used in the D70s, and it is unique to these two camera models. It is not the same six megapixel (Mp) sensor produced by Sony that is used in the D100, but a hybrid Nikon-Sony design. It has a total of 6.24 million pixels, of which 3008 x 2000 are image forming, giving the camera a maximum resolution of 6.1Mp. Each pixel site is 7 microns (mm) square, much larger than those on the sensors of the Nikon Coolpix range, which is why the D70 can pro-duce a far superior image quality compared with these con-sumer digital cameras.

The imaging area is 0.66 x 1 inches (15.6 x 23.7mm), which is smaller than a 35mm film frame of 1 x 1.5 inches (24 x 36mm) but retains the same 2:3 aspect ratio. Nikon refers to this as its DX-format and uses this designation to identify those lenses that can only be used on its digital SLR cameras. Due to the smaller size of the digital sensor, the effective focal length of a 35mm film format lens should be multiplied by 1.5x, although to be strictly accurate the factor is nearer to 1.52x.

In front of the CCD sensor is a filter array, which has four specific purposes.

Bayer Pattern Filter
The pixel sites on the CCD do not see in color—they can only detect a level of brightness. To impart color to the image, a series of minute red, green, and blue filters are

arranged over it in a Bayer pattern, named after the Kodak engineer who invented it. These filters are arranged in an alternating pattern of red/green on the odd-numbered rows, and green/blue on the even-numbered rows. The final image that comprises 50% green, 25% red, and 25% blue is reconstructed by interpolating the values at each pixel site.

Micro-Lens Layer

A CCD sensor is most efficient when the light striking it is perpendicular to its surface. To help realign the light rays projected by the camera lens into the pixel sites on the sensor the filter array contains a layer of micro-lenses.

Low Pass Anti-Aliasing Filter

When you take a picture of a scene that contains very fine detail (e.g. the weave pattern in a piece of material), it is possible that the frequency of this detail matches, or is close to that of the pixel sites on the sensor. This can lead to color fringes appearing between two areas of different color or tone on either side of a distinct edge. The low pass filter lowers the acuity of, or softens, the image formed on the sensor to reduce the risk of this occurring.

Infrared Filter

Although not visible to the human eye, infrared (IR) light is detected by a CCD sensor. This is a problem because IR light can cause a perceived loss of image sharpness, reduced contrast, and other unwanted effects. Therefore, a filter is incorporated into the filter array to remove most but not all IR light.

File Formats

The D70 offers two types of files: files compressed using the JPEG standard; and files compressed in Nikon's proprietary RAW Nikon Electronic File (NEF) format.

The files using the JPEG standard can be saved at three different sizes, Fine (low compression 1:4), Normal (medium compression 1:8), and Low (high compression 1:16).

Note: As the level of compression is increased there is a greater loss of detail in the image. Furthermore, all JPEG compressed files are saved to an 8-bit format, which reduces the tonal range of the image.

The highest quality results come from the NEF format files, as these contain the compressed data direct from the sensor, with no interpolation or camera processing. Nikon claims that the compression of the 12-bit NEF files is lossless, but in truth it is not. The in-camera compression averages out the highlight data to reduce the file size, and when this is converted back to a 12-bit form, highlight tones are restricted. However, since the human eye is unlikely to resolve this change, it would be fair to describe the system a visually lossless. To get the most out of NEF files you will need additional software such as Nikon Capture.

The narrow border around the outside of the rectangle is the portion of the frame area that you do not see in the viewfinder.

The Viewfinder

The D70's eyelevel finder is comprised of a fixed, optical pentaprism, which shows approximately 95% (vertical and horizontal) of the full frame coverage. It has an eyepoint of 18mm (-1.0m^{-1}), which is reasonably good for users who wear eyeglasses, plus there is a built-in diopter adjustment between –1.6 to +0.5m^{-1}. To set the diopter, mount a lens on the camera and leave it set to infinity. Point the camera at a plain surface that fills the frame. Shift the sliding button to the left of the viewfinder eyepiece up or down until the AF brackets appear sharp. It is essential to do this to ensure you see the sharpest view of the focusing screen.

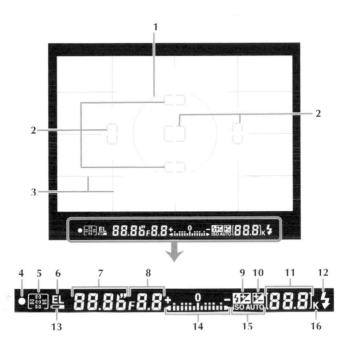

Viewfinder Display

1. 8mm (0.31") reference circle for center-weighted metering
2. Focus brackets (focus areas)/ Spot metering targets
3. Reference grid (displayed when On is selected for Custom Setting 8)
4. Focus indicator
5. Focus area/AF-area mode
6. Autoexposure (AE) lock/ FV lock indicator
7. Shutter speed
8. Aperture (f/number)
9. Flash compensation indicator
10. Exposure compensation indicator

11. Number of exposures remaining/Number of shots remaining before memory buffer fills/Preset white balance recording indicator/ Exposure compensation value/Flash compensation value/PC mode indicator
12. Flash-ready indicator
13. Battery indicator
14. Electronic analog exposure display/Exposure compensation
15. Auto sensitivity indicator
16. "K" (appears when memory remains for over 1000 exposures)

25

Since the built-in correction is not particularly strong, optional eyepiece correction lenses are available between –5 to +3m^{-1}.

Note: The rubber eyecup must be removed to fit optional correction lenses.

The focusing screen is fixed and the viewfinder provides a magnification of approximately 0.75x. The Viewfinder Display includes essential information about exposure and focus, including focus confirmation, shutter speed, lens aperture, battery status, and flash ready signal. The screen is marked with a central 8mm reference circle for the Center-Weighted Metering pattern, five focus brackets (AF area/spot meter reference zones), and a user-selectable reference grid, which is very useful for aligning critical compositions and keeping horizons level (see diagram of Viewfinder Display on page 25). The D70 is supplied with the DK-5 eyepiece cap, used to prevent light from entering the viewfinder eyepiece.

Autofocus

The autofocus system is based on the CAM900 AF module used in the Nikon N80/F80 film SLR and D100 digital SLR cameras. It features five sensors arranged in a cross array. The central sensor is a cross type, whereas the other four (top, bottom, left, and right) are single line sensors. This makes focusing on subjects at the center of the frame fast and positive. However, there can be a tendency for the AF system to "hunt" when using the outer four sensors with certain subjects, particularly in low light.

The detection range of the AF system is –1 to +19EV, which Nikon curiously specifies at an ISO 100 although the camera's base sensitivity is ISO 200! In low-light levels there is an AF assist lamp, which has an effective range from 1 foot, 8 inches to 9 feet, 10 inches (0.5 to 3m). The system has three focusing modes, Single-area AF, Dynamic-area AF, and Dynamic–area AF with Closest Subject Priority. The camera will automatically detect if a subject is moving and initiate focus tracking.

Note: Nikon states that they have made improvements to the AF system of the D70s in terms of its speed and low-light accuracy. While these changes are technically measurable, however, it is unlikely that a user will be able to discern a difference between the D70 and the D70s.

Exposure Modes

The D70 offers a fully automatic exposure mode, AUTO ▲, that does not allow any adjustments by the user. There are an additional six automatic modes that Nikon refers to as Digital Vari-Program modes: Portrait *, Landscape ▲, Close-up ☘, Sports ☆, Night Landscape ▲, and Night Portrait ▲. In addition, four user controlled exposure modes are also available: Auto Multi Program (P); Aperture-Priority Auto (A); Shutter-Priority Auto (S); and Manual (M). It is this choice of exposure modes that underpins the flexibility of the D70 to be used as either a simple point-and-shoot camera or a fully-fledged tool for creative photography

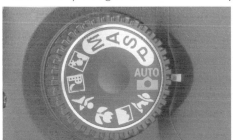

Use the Mode Dial to select from an array of exposure modes that allow you to capture excellent photos in all types of shooting conditions.

Exposure Control

The D70 offers three light metering options to cope with a variety of different lighting situations.

3D Color Matrix Metering ▣
The D70 uses a 1005-pixel RGB sensor within the camera's viewfinder to control this metering method, and with either a D-type or G-type Nikkor lens mounted, the system takes into account information about the focused distance, which

indicates to the camera where the main subject is located within the frame area.

Note: Standard Color Matrix Metering is performed if other CPU lenses are mounted.

Center-Weighted Metering ⊙
The camera meters from all the frame area, but at its default setting assigns a bias to a central 0.31-inch (8mm) diameter circle in a ratio of 75:25.

Note: The diameter of the circle can be altered via CS-11.

Spot Metering ⊡
The camera meters a 0.09-inch (2.3mm) circle centered on the selected (active) focus area brackets.

The 3D Matrix and Center-Weighted metering systems have an exposure value (EV) range of 0 to 20EV, and 3 to 20EV for Spot metering (ISO 100).

Exposure compensation can be set over a range of –5 to +5 stops in increment s of 1/3 or 1/2EV, and exposure and/or flash exposure bracketing is available for either 2 or 3 frame sequences in increments of 1/3 or 1/2EV.

In the user controlled modes that are partially automated (P, S, and A), the exposure settings can be locked with the AE-L/AF-L button located on the rear of the camera to the left of the viewfinder eyepiece.

Hint: If you set the D70 to AUTO Mode, or one of the six Digital Vari-Program modes, the camera restores the default exposure setting for the selected mode. You surrender all exposure control to the camera, and have no say in the choice of metering system, or use of the flexible program, exposure compensation, bracketing, and flash bracketing functions. However, the Auto-Exposure Lock feature does operate in these modes.

White Balance

The D70 offers several choices for white balance control. There is a fully automatic option **A** that uses the same 1005-pixel RGB sensor in the viewfinder as the metering system. There are also six user-selectable manual modes for specific lighting conditions: Tungsten ☀ for incandescent lighting; Fluorescent ☰ for fluorescent lighting; Direct Sunlight ☀ ; Flash ⚡ for lighting by both the internal and external flash units; Cloudy ☁ for daylight under an overcast sky; and Shade ☁ for daylight in deep shade. Each setting can be fine tuned to impart a slightly warmer (red) or cooler (blue) tone. There is also a Pre-set **PRE** option that can be utilized by taking a reading from a white or gray card under the prevailing lighting conditions.

Image Processing

In P, S, A, and M modes, image attributes including sharpening, contrast, color mode, saturation, and hue are selected automatically for a range of pre-set options: Normal, Vivid, Sharp, Soft, Direct Print, Portrait, or Landscape. There is also a Custom option for photographers to define their own values. Nikon calls this system Optimizing Images. Note that when the Digital Vari-Program mode is selected, the D70 automatically assigns a set of values according to which mode is active and the photographer has no independent control over this feature.

The Shutter

The D70 has a combined mechanical and electronic shutter: all shutter speeds up to 1/250 are controlled mechanically; all speeds above this are controlled electronically by opening the shutter for 1/250 and then switching the sensor on and off to simulate the effect of the shutter opening and closing. This system has a beneficial side effect of allowing a high flash sync speed of 1/500.

The shutter speed range runs from 30 seconds to 1/8000 and can be set in increments of 1/3 or 1/2EV. There is a bulb option for exposures longer than 30 seconds.

Shooting Modes

The shooting mode determines when the camera makes an exposure. In Single Frame the camera takes a single photograph each time the Shutter Release Button is fully depressed. In Continuous mode the camera shutter cycles up to a maximum rate of three frames per second but this can be limited by a number of factors, including the camera functions that are active, the selected shutter speed, and the capacity of the remaining memory buffer.

Self-Timer Mode
The camera has a self-timer option with a variable time delay that is set via CS-24; the default is 10 seconds. This feature is useful for self-portraits, or reducing loss of sharpness caused by the effect of camera vibration. The shutter of the D70 and D70s can be released remotely using an infrared remote control, either the ML-L3, or the ML-L1 Remote Release. In addition, the D70s model (not the D70) can be fitted with the MC-DC-1 Remote Release cord.

LCD Monitor

On the rear of both the D70 and D70s models is a 130,000 pixel color LCD Monitor which, unlike the viewfinder, displays 100% of the image file. The D70 has a 1.8-inch screen, and the D70s has a 2-inch screen. The brightness of the monitor can be adjusted via the Setup Menu.

Pictures can be reviewed as either a single image or in multiples. By using the Multi Selector Switch you can scroll through a range of pages containing shooting information, which are superimposed on images reviewed in single-image playback. These include two pages of shooting data, and single pages

showing file information, a histogram, or a highlight warning option that causes potentially over exposed areas to flash. You can edit your pictures while they are still held in the camera by reviewing them on the LCD Monitor, with the option to delete them, or protect them from being deleted unintentionally.

In addition to the image playback the LCD Monitor is used to display the various camera menus from where the photographer can activate or deactivate functions and features.

Menus

Although most of the principle controls of the D70 can be easily accessed and operated by buttons or dials located on the camera body there are some core functions that must be set via the camera's four menus: Playback ▶, Shooting ●, Custom Settings ✐, and Setup ♈. To open the menu display you press the Menu button **MENU** on the rear panel of the camera to the right of the LCD Monitor. First select the appropriate menu by using the Multi Selector Switch. The various options and sub-options are color coded to facilitate navigation and selection of the required setting.

Control Panel

This small monochrome LCD display on the top plate of the D70, which Nikon calls the Control Panel, should not be confused with the color LCD Monitor on the rear. If the power is switched OFF, the only information shown is the number of remaining frames available with the installed memory card, and if no card is inserted the display shows "E" to indicate empty. As soon as the camera is powered on, the display shows a range of camera control settings, including battery status, shutter speed, aperture, shooting mode, active focus sensor and focus mode, white balance, audible warning, and image quality and size. Other controls will be indicated as and when they are activated.

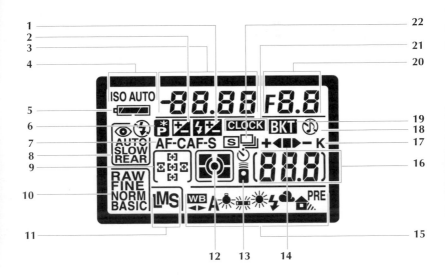

Control Panel

1. Flash compensation indicator
2. Shutter speed/Exposure compensation value/Flash compensation value/White balance adjustment/Number of shots in bracketing sequence
3. Exposure compensation indicator 🔀
4. Sensitivity (ISO) indicator
5. Battery indicator 🔋
6. Flexible program indicator +◀▮▶−
7. Autofocus mode
8. Flash sync mode
9. Focus area/AF-area mode
10. Image quality
11. Image size
12. Metering mode
13. Self-timer indicator ⏲ / Remote control indicator 📷⎟⎟

14. Bracketing progress indicator 🔋
15. White balance mode
16. Number of exposures remaining/Number of shots remaining before memory buffer fills/Preset white balance recording indicator/Remote control mode indicator
17. "K" (appears when memory remains for over 1000 exposures)
18. "Beep" indicator 🔋
19. Aperture (f/number)/Bracketing increment/PC mode indicator
20. Bracketing indicator 🔳
21. Clock battery indicator 🕐🕐🕐🕐
22. Shooting mode

Built-In Speedlight (Flash)

Nikon always refers to their flash units, whether built-in or external, as Speedlights. The D70 has a pop-up Speedlight housed above the viewfinder. In AUTO, Portrait, Close-up, and Night-Portrait Modes, the flash will activate automatically if the camera determines the light level is sufficiently low to require additional light. In P, S, A, and M modes, the flash can be activated manually by pressing the Speedlight lock-release button 🔳 on the left side of the viewfinder head. At full output the guide number (GN) of the Speedlight is 49/15 (ft/m, ISO 200) in automatic mode and GN 56/17 (ft/m, ISO 200) in manual mode and it can be used with any CPU lens with a focal length of 20 – 300mm, and non-CPU (Ai-S, Ai, or Ai modified) lenses with a focal length of 20 - 200mm.

Note: The minimum distance at which the Speedlight can be used is 2 feet (0.6m). However, with certain lenses the minimum distance is greater because the lens may prevent the flash from illuminating the entire subject.

Nikkor Lens Limitations with the Built-In Flash

AF 18-35mm f/3.5-4.5	35mm focal length at 2.3 ft. (0.7m) or longer shooting distance
AF 20-35mm f/2.8	35mm focal length at 3.9 ft. (1.2m) or longer shooting distance
AF 24-85mm f/2.8-4	35mm or longer focal length; and at 35mm, 2.6 ft. (0.8m) or longer shooting distance
AF-S 24-85mm f/3.5-4.5G ED	28mm or longer focal length; and at 28mm, 2.3 ft. (0.7m) or longer shooting distance

Nikkor Lens Limitations with the Built-In Flash (contd)

AF-S VR 24-120mm f/3.5-5.6 G ED	35mm or longer focal length; and at 35mm, 3.9ft. (1.2m) or longer shooting distance
AF 24-120mm f/3.5-5.6	28mm or longer focal length; and at 28mm, 8.2 ft. (2.5m) or longer shooting distance; at 35mm, 2.6 ft. (0.8m) or longer shooting distance
AF 28mm f/1.4	3.0 ft. (0.9m) or longer shooting distance
AF-S 28-70mm f/2.8 ED	50mm or longer focal length; and at 50mm, 3.9 ft. (1.2m) or longer shooting distance
AF 28-80mm f/3.5-5.6	At 28mm, 2.3 ft. (0.7m) or longer shooting distance
AF 28-100mm f/3.5-5.6 G	At 28mm, 3.9 ft. (1.2m) or longer shooting distance
AF 28-200mm f/3.5-5.6	35mm or longer focal length
AF 35-70mm f/2.8	At 35 mm, 3.9 ft. (1.2m) or longer shooting distance
AF Micro 70-180mm f/4 5-5.6 ED	At 70mm, 2.3 ft. (0.7m) or longer shooting distance
AF-S VR 70-200mm f/2.8G ED	At 70mm, 9.8 ft. (3m) or longer shooting distance

The built-in flash is fully compatible with Nikon's latest i-TTL flash exposure control system for balanced fill flash, but defaults to standard i-TTL flash when Spot Metering or M Exposure Mode is selected. The D70 is also compatible with the Nikon SB-800 and SB-600 Speedlights, including their Advanced Wireless Lighting control.

Shooting close-ups often requires small apertures and therefore slower shutter speeds. Use a tripod to increase your options of exposure settings.

External Ports

On the left hand edge of the D70 there is a pair of rubber port covers. Under the larger of the two is one port for connecting the FH-5 AC adapter, and another for connecting the camera to a TV set for image playback. Under the smaller cover is the port for connecting the camera to a computer or other data storage device. The external interface ports of both the D70 and D70s support standard USB (1.1) with a data transfer rate of 12 Mbps. The D70s has an additional, third port, located above the other two that is used to connect the MC-DC1 remote release cord.

Note: Early editions of Nikon's instruction manual to the D70 state incorrectly that the D70 supports High-speed USB (2.0). This error has been amended in later editions.

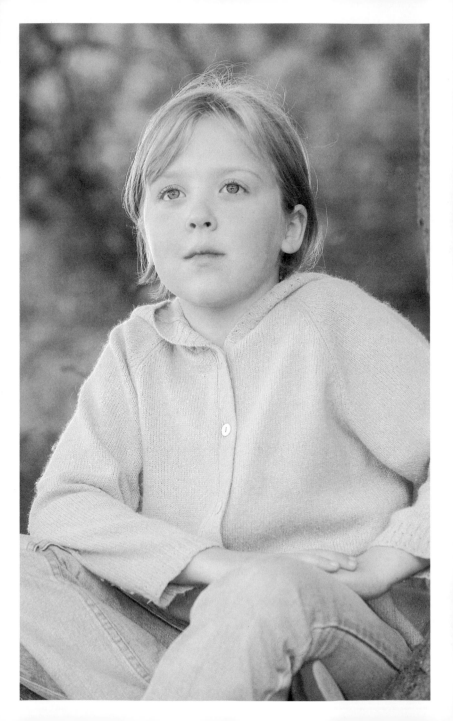

Using Your D70s/D70

Quick Start—Getting Ready to Shoot

As you lift your new D70 from its box you will no doubt be eager to take some pictures. However, before doing so there are a few basic steps that you need to take to prepare the camera. It is also well worth spending a little time to acquaint yourself with the principle controls and functions.

Attaching the Camera Strap

For camera safety, it is essential to first attach the camera strap because it helps prevent the camera from being dropped accidentally and keeps it positioned for fast picture taking. Thread one end of the strap from the outside through the left strap lug and feed it through the keeper-loop. Then pass it through the inside of the buckle under the section of the strap that already passes through the buckle, before pulling it tight. Adjust the length, and then thread the other end through the right strap lug and repeat as described above.

Inserting the Battery

The D70 is entirely dependent on electrical power, so at the risk of stating the obvious, it is crucial that the EN-EL3/3a battery is fully charged. There is no need to pre-condition the battery, but for its first charge, leave it connected to the MH-18 charger until it is cool to the touch. Do not be tempted to remove it as soon as the charge indicator lamp on the MH-18 has stopped flashing.

Make sure the camera power switch is set to OFF. Turn the camera over and slide the battery-chamber cover lock

The D70's Portrait Digital Vari-Program Mode selects wider aper-tures to limit depth of field. This creates an out-of-focus background that does not compete with the subject.

Make sure the battery charge cycle is completely finished by allowing the battery to cool in the charger before you remove it to insert into the camera.

toward the center of the camera. Open the cover and insert the battery, making sure its two contacts face the battery-chamber cover and enter first. Lower the battery into place and then press the chamber cover down until it locks; you should hear it click into place. Now turn the camera power switch to ON, and check the battery-status indicator in the Control Panel (located in the top left corner) to confirm the battery is fully charged.

Choosing a Language

The first time the D70 is switched ON, the language selection dialog box, from the Setup Menu, will be shown in the LCD monitor, and the **CLOCK** icon will flash in the Control Panel. Scroll through the list of languages by pressing the up and down arrows on the Multi Selector Switch. Once the desire language is highlighted, press the right arrow on the Multi Selector Switch to select it.

Note: OK is displayed next to the name of the highlighted language.

Setting the Internal Clock

The D70 has an internal clock powered by an independent rechargeable battery.

Note: This battery is not accessible by the user but is charged from the camera's main power source, either battery or AC supply. See page 69 for full details.

Once you have selected a language, the Date menu from the Setup Menu will be displayed in the LCD Monitor. The *Year* will be highlighted against a white background. To change it, use the up and down arrows on the Multi Selector Switch; select the correct year by pressing the right arrow on the Switch. Now a *Month* will become highlighted. Scroll through the remaining boxes setting the appropriate *Month*, *Day*, *Hour*, *Minute*, and *Seconds*. To confirm language and calendar/clock settings, press the [ENTER] button.

Note: This also turns the monitor off.

Hint: Unless you complete the language and calendar/clock set-up as described above, the Shutter Release Button will remain disabled and no other camera functions can be performed.

Hint: The internal clock is not as accurate as most wrist-watches and domestic clocks. So it is important to check it regularly.

Mounting a Lens

To access all the functions and features of the D70, you will require either a G-type or D-type Nikkor lens (see page 107 for more details).

Whenever you attach or detach a lens from the D70, ensure that the camera is turned off. Identify the mounting index-mark on the lens and align it with the mounting index-mark next to the bayonet ring of the camera's lens mount. Enter the lens bayonet into the camera and rotate the

To mount a lens, align the white index marks and gently insert the lens into the camera body. Rotate the lens counter-clockwise until it click-locks in place.

lens counter-clockwise until it locks into place with a positive click.

Apart from G-type lenses that lack a conventional aperture ring, it is necessary to set and lock all other types of Nikkor lens with a CPU to its minimum aperture value (highest f/number).

Hint: If you turn ON the camera after mounting a lens and flashing *FE E* appears in the Control Panel and Viewfinder Display, the lens has not been set to its minimum aperture value. In this state the shutter release is disabled and the camera will not operate.

Holding the Camera

Whenever you take pictures with a hand-held camera, it is essential to practice good camera technique to reduce the risk of pictures being blurred due to camera shake. Regardless of whether you want to take a horizontal or vertical shot, the camera should be held firmly but not in an over tight grip. Hold the handgrip in your right hand with your right index finger resting lightly on the shutter release but-

Practicing good handholding technique is the best way to eliminate results that are less than perfect due to lack of sharpness.

ton. Cup your left hand under the camera so that your left index finger and thumb can rotate the zoom/focus ring of the lens. Keep you elbows tucked in towards your body, and stand with your feet shoulder-width apart.

Using the Memory Card

The D70 can accept either solid-state (no moving parts) CompactFlash (Type I/II) cards, or a Microdrive, which is a miniature hard disk drive that has moving parts.

The only difference between a Type I and Type II Compact-Flash card is their physical thickness (Type I cards are 3.3mm, and Type II cards are 5mm). Microdrives are mounted inside a Type II, 5-mm thick CompactFlash card case. The card port of the D70 can accommodate one card at a time.

Inserting the Memory Card: Regardless of whether you choose to use a CompactFlash card or a Microdrive to store your digital pictures, the procedure for using them is identical.

First, ensure the camera is switched OFF. Open the card port door by pushing its spring-catch to the right and swinging the door open. Insert the card with its contacts pointing toward the camera and rear label facing the LCD monitor. The card will slide in so far and then you will feel a slight resistance. Keep pushing the card so the green memory card access lamp illuminates briefly, and the eject button pops up. Finally, close the card port door.

The Control Panel on top of the camera displays an array of useful information when the camera is ON. When the camera is switched OFF, an 'E' shows in the Panel if there is no memory card in the slot.

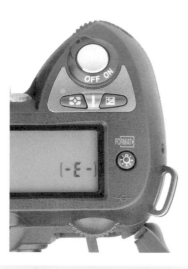

Hint: To help reduce the depth of the D70 camera body, the designers set the card port slot at an angle. Be sure to match the card to this angle when inserting it

Formatting the Memory Card: All new memory cards must be formatted before first use.

To format a card using the D70, insert a card and then switch the camera ON. Press and hold the ⚏ (⚙ and 🖻) buttons for approximately two seconds, until *For* appears, flashing, in the Control Panel at the location of the shutter speed, together with a flashing frame count display. Then push both buttons again to initiate formatting.

Note: If you press any other button, the function is cancelled and the formatting process does not occur.

Alternatively, you can use the format command in the Setup Menu, but this method is slower to perform and involves using the LCD monitor, which increases power consumption.

During formatting, *For* appears continuously within the frame-count brackets of the Control Panel display. Once formatting is complete, the frame-count display shows the approximate number of photographs that can be recorded at the current size and quality settings.

Note: You should never interrupt the power supply to the camera during formatting.

Hint: It is good practice to format a card each time you insert it into the camera, even if you have deleted the card's contents using a computer. If you do not do this there is an increased risk of problems occurring with the communication between the memory card and the camera.

Removing the Memory Card: To remove a memory card you must make sure that the green memory card access lamp has gone out before switching the camera OFF. Open the card port door and push the eject button towards the camera. The memory card will be partially ejected, and can then be pulled out by hand.

If the D70 has no memory card inserted when a charged battery is installed, or it is connected to an AC supply, [-E-] appears in the exposure count brackets.

Camera Care
Keeping your camera and lenses in a clean, dry environment is very important. But however scrupulous you are about doing this, dust and dirt will eventually accumulate on your equipment.

Since prevention is better than cure, always keep body and lens caps in place when not using equipment. Always switch the D70 OFF before attaching or detaching a lens to prevent particles being attracted to the low-pass filter by the electrical charge of the sensor. Remember, gravity is your friend! Whenever you change lenses, get into the habit of holding the camera body with the lens mount facing downwards. Do not carry or store your D70 on its back, as particles already inside the camera will settle on the low-pass filter.

It also helps to periodically vacuum the interior of your camera bag. It is amazing how much debris can collect there! Sealing you camera body in a clear plastic bag, which you then keep within your camera case, will add another valuable layer of protection in very dusty or damp conditions. It helps to add some sachets of silica gel since they will absorb moisture from the atmosphere within the bag.

Hint: Put together a basic cleaning kit with the following: a soft, 1/2-inch (12mm) sable artist's paint brush for general cleaning, a microfiber lens cloth for cleaning lens elements, a microfiber towel (available form any good outdoors store) for absorbing moisture when working in damp conditions, and the rubber-bulb from a blower brush for use with lenses and the low-pass filter.

Always brush or blow material off equipment before wiping it with a cloth. For lens elements and filters, use a microfiber cloth and wipe surfaces in short strokes, not a sweeping circular motion. Turn the cloth frequently to prevent depositing the dirt you have just removed back on the same surface! For any residue that cannot be removed with a dry cloth, you will need to resort to a lens cleaning fluid suitable for photographic lenses. Apply the fluid to the cloth not directly to the lens as it may seep inside and cause damage. Wipe the residue away and then buff the glass with a dry area of the cloth. The lens cloth should be washed on a regular basis to keep it clean.

Cleaning the Low-Pass Filter: Dust and any other material that settles on the low-pass filter in front of the CCD sensor will

appear as dark spots in your pictures. The exact nature of their appearance will depend on their size and the lens aperture you use. At very large apertures (f/1.4), it is possible that most very small dust specks will not be visible. However, at small apertures (f/22) they are likely to show up as well defined black spots.

To inspect and/or clean the low-pass filter, the D70 has a mirror lock-up feature accessed via the Setup menu. Open the menu and scroll to *Mirror lock-up*, then press the Multi-Selector Switch to the right, highlight *Yes*, and press the Multi Selector Switch to the right again. A dialog box will appear instructing you to press the Shutter Release Button. Once it is pressed, the mirror will rise and stay in its up-position.

Note: The Control Panel display will show a series of dashes that flash, and all other information will disappear.

Keep the camera facing down so any debris falls away from the filter; look up in to the lens mount while shining a flashlight on to the low-pass filter. Remember the photosites on the D70's CCD are just 7.8-microns square (one micron = one thousandth of a millimeter) so your eyes will not be able to resolve many of the offending particles.

Nikon expressly recommends that you should have the low-pass filter cleaned by an authorized service center. However, this is often impractical for both logistical and financial reasons! Furthermore, they state that under no circumstances should you touch or wipe the filter.

To clean the low-pass filter yourself, keep the camera facing down, and use the rubber bulb from a blower brush to gently puff air towards the filter. Take care that you do not insert any part of the bulb into the camera. Never use a brush or canned compressed air to clean the filter as they can leave a residue, or damage the filter's surface. Once you have finished cleaning, switch the camera OFF to return the mirror to its down position.

If the blower bulb method fails to remove stubborn material, I recommend having the sensor cleaned professionally.

The safest way to clean the low-pass filter is with a blower brush. Make sure that you puff gently and do not touch anything inside the camera.

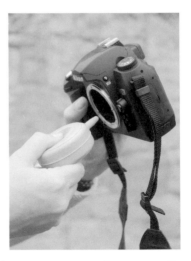

For users with plenty of confidence, sensor swabs are available that can be used to wipe the filter clean. It must be stressed that you do this entirely at your own risk, and it is essential that the camera's battery be fully charged before you attempt this procedure. Preferably, use the EH-5 AC adapter to ensure a continuous power supply. If the power supply fails the shutter will close and the mirror will return to its down position, with potentially dire consequences!

Finally, if you have Nikon Capture software you can use the Dust Reference Photo feature of the D70 to remove the effects of dust particles on the low-pass filter by masking their shadow electronically (see page 137), however this is only available for NEF files.

Point and Shoot Photography

The Nikon D70 is designed to operate in many ways like a 35mm film SLR, and has many features in common with other Nikon SLR cameras, both film and digital models. At its simplest level the D70 can be used for straightforward "point-and-shoot" photography, in which the camera controls most of the settings according to the shooting conditions that prevail. As well as its fully auto-

matic exposure mode, AUTO 📷, there are six subject-specific modes in which the camera attempts to automatically tailor its settings to suit the nature of the subject. While these Digital Vari-Programs, as Nikon calls them, may appear tempting to the less experienced photographer, it is important to remember a camera cannot "think for itself" – only photographers can do that!

You must appreciate that by using one of these modes you not only relinquish virtually ALL exposure control to the camera but you are also locked out of altering several key functions, including white balance, metering mode, exposure compensation, exposure bracketing, and flash exposure compensation. In my opinion, the Digital Vari-Program modes are potentially more of a hindrance than a help to any photographer seeking to develop their photographic skills, because you can never be sure what settings the camera is using. Still, Nikon has seen fit to include these options, and I am sure a great many owners of this camera will be content to use them. Plus, they will be helpful for other family members and friends for casual shooting. Therefore, this section provides a quick-start guide to using the D70 as a fully automatic camera.

Mode Dial

Once you have prepared the camera, as described in the previous section, it is ready to take pictures. Rotate the Mode Dial to 📷. Other Digital Vari-Programs can be selected by turning the Mode Dial so that their icon is aligned with the white index mark on the side of the viewfinder head.

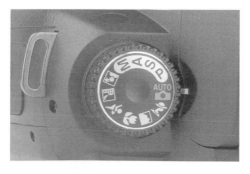

The Mode Dial is located on the left top of the camera.

Check the Camera

Switch the camera ON. Check that the battery indicator in the Control Panel shows the battery is fully charged and note the remaining number of available exposures in the frame counter. If the installed memory card has reached it capacity the figure "0" will flash in the frame counter brackets and the shutter speed display will show the word "Full". Generally in this state the camera cannot take any more pictures until either one or more pictures is deleted or another memory card is installed. However, it may be possible to take further pictures if you reduce the image quality and size settings.

Focusing

Set the Focus Mode Selector Switch to AF (Autofocus). If you press the Shutter Release Button halfway, the camera will focus automatically. However, since the 🄰🄾 Mode sets Single-servo AF with Closest Subject Priority, the camera will automatically select the focus area containing the subject closest to the camera. Once the camera has acquired focus, the audible warning will "beep", the active focus area will be highlighted, and the in-focus indicator (●) will appear in the Viewfinder Display. If the camera is

The Focus Mode Selector Switch on the lower left front of the camera can be set at either Autofocus (AF) or Manual focus (M).

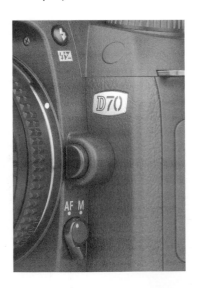

unable to achieve focus, the in-focus indicator will flash, and the shutter release will be disabled (see page 96 for more information).

Hint: Remember the D70 shows approximately 95% of the full frame in its viewfinder. There is a narrow area around all four sides that you cannot see but will appear in the final picture.

Exposure

In ⏱ mode, the D70 automatically selects a shutter speed and aperture as soon as you press the Shutter Release Button halfway.

Note: The flexible program option is disabled in ⏱ Mode, so it is not possible to alter the combination of shutter speed and aperture.

Check these values, which are displayed in the viewfinder. If the light level is such that the picture would be overexposed, **Hi** will be displayed. In this case your only option is to fit a neutral density (ND) filter. If the picture would be underexposed, the built-in Speedlight flash unit will lift automatically. Provided the batteries are in a good state of charge, the ⚡ flash ready indicator will appear in the viewfinder within a couple of seconds.

Note: The shutter release is disabled until the flash is fully charged and ⚡ is displayed.

To make an exposure gently squeeze the Shutter Release Button down; to prevent camera shake avoid 'stabbing' it with your finger.

Hint: To conserve battery power always return the Speedlight to its closed position when it is not in use, otherwise it will continue to draw power so that it remains in a charged state.

Digital Vari-Program Modes

AUTO AUTO

This mode is designed as a universal "point and shoot" mode. The camera attempts to select a combination of shutter speed and aperture that will be appropriate for the current scene. It does this by using information from the D70's TTL metering system about the color and intensity of the light, together with the focus distance. This mode is most effective for general-purpose "snapshot" photography, such as family events, or vacations, as it will most probably produce the highest success rate for users with little, if any knowledge of photography.

In AUTO, camera settings are automatically adjusted to the following values:

- **Image Quality:** Normal—Pictures are compressed (1:8) using the JPEG standard.

- **Image Size:** Large (L)—images are 3,008 x 2,000 pixels in size.

- **Sensitivity:** 200 – approximately equivalent to ISO 200

- **Shooting Mode:** Single frame—one exposure is made each time you press the shutter release.

In this mode, the D70 uses 3D Color Matrix metering with D-type, or G-type lenses, and selects Single-servo Dynamic AF with Closest Subject Priority as the default focus mode, which means the shutter can only be released once the camera has acquired sharp focus.

Hint: The Digital Vari-Programs, including AUTO, require a lens with a CPU to be fitted to the D70. If you attach a non-CPU lens the shutter release will be disabled (see page 190 for more details).

Note: You can select an alternative focus mode via Custom Setting 3, but any changes made are only retained while the camera is set to the current mode.

The built-in Speedlight will be turned on automatically in backlit or low-light situations. The camera automatically selects an appropriate shutter speed between 1/60th and 1/500th second and sets the flash for Auto Front-Curtain Sync. Alternatively, you can select ⬚ Auto with Red-eye Reduction, or ⓧ Off Flash-off. Other flash modes are not available.

Hint: It is important to make sure your subject is within the shooting range of the flash. The built-in Speedlight has a guide number (GN) of 49/15 (ft/m, ISO 200), which means that at an aperture of f/4, and the base sensitivity (equivalent to ISO 200) of the D70, the maximum effective range of the flash unit is 13feet (4m). If the ⚡ flash symbol in the viewfinder blinks after the flash has fired, the shot may be underexposed. In this case, either set a higher sensitivity or move closer to the subject.

Portrait

The Portrait Mode is designed to select a wide aperture in order to produce a picture with a very shallow depth of field. Generally, this renders the background out of focus, preventing it distracting the viewer from the subject, although the effect is partially dependent on the distance between the subject and the background. This mode is most effective with telephoto or telephoto zoom lenses, and when the subject is relatively far away from the background.

Hint: In shooting portraits, the best results are often achieved when the subject fills most of the frame. It is essential to make sure the subject's eyes are in sharp focus, so be sure the active focus area covers at least one of them.

In this mode the D70 uses 3D Matrix metering with D-type, or G-type lenses, and selects Single-servo Dynamic AF with Closest Subject Priority as the default focus mode, which means the shutter can only be released once the camera has acquired sharp focus.

Note: You can select an alternative focus mode via Custom Setting 3, but any changes made are only retained while the camera is set to the current mode.

The built-in Speedlight will be turned on automatically in backlit or low-light situations. The camera automatically selects an appropriate shutter speed between 1/60th and 1/500th second and sets the flash for Auto Front-Curtain Sync. Alternatively, you can select 🔲 Auto with Red-eye Reduction, or ⓢ Off Flash-off. Other flash modes are not available.

Landscape

The Landscape Mode is designed to select a small aperture in order to produce a picture with an extended depth-of-field. Generally, this renders everything from the foreground to the horizon in-focus, although this will depend to some degree how close the lens is to the nearest subject. This mode is most effective with wide-angle or wide-angle zoom lenses, and when the scene is well lit.

Hint: When using wide-angle focal lengths, try to include some element of interest in the foreground of the scene as well as the middle and far distances.

In this mode the D70 uses 3D Color Matrix metering with D-type or G-type lenses, and selects Single-servo Dynamic AF with Closest Subject Priority as the default focus mode, which means the shutter can only be released once the camera has acquired sharp focus.

Note: You can select an alternative focus mode via Custom Setting 3, but any changes made are only retained while the camera is set to the current mode.

Note: There are no flash modes available in the Landscape Mode. The built-in Speedlight and AF-assist lamp are turned off.

Close-Up

The Close-up Mode is designed to select a small aperture in order to produce a picture with an extended depth-of-field

with subjects such as flowers, insects, and other small objects. Generally, when working at very short focus distances, depth of field is limited even at small apertures, so this program endeavors to render as much of the subject in focus as possible. To some degree the final effect will be dependent on how close the lens is to the subject, because depth of field will be reduced at shorter focus distances. This mode is most effective with lenses that have a close-focusing feature, or dedicated Micro-Nikkor close-up lenses.

Hint: Due to the emphasis this mode places on using a small aperture, the shutter speed can quite often be relatively slow. To prevent pictures being spoiled by camera shake, use a tripod in conjunction with either the self-timer function, or ML-L3 Remote Release.

In this mode the D70 uses 3D Color Matrix metering with D-type, or G-type lenses, and selects Single-servo Single-area AF as the default focus mode, which means the shutter can only be released once the camera has acquired sharp focus.

Note: You can select an alternative focus mode via Custom Setting 3, but any changes made are only retained while the camera is set to the current mode.

The built-in Speedlight will be turned on automatically in backlit or low-light situations. The camera automatically selects an appropriate shutter speed between 1/125th and 1/500th second and sets the flash for Auto Front-Curtain Sync. Alternatively, you can select 💡 Auto with Red-eye Reduction, or 🚫 Flash-off. Other flash modes are not available.

Sports

The Sports Mode is designed to select a wide aperture in order to maintain the highest possible shutter speed to "freeze" motion in fast–paced sports or everyday action such as lively children. It also has a beneficial side effect as this combination produces a picture with a very shallow depth of field that helps to isolate the subject from the background.

This mode is most effective with telephoto or telephoto zoom lenses, and when there are no obstructions between the camera and the subject that may cause the Closest Priority function to focus on something other than the subject.

In this mode the D70's autofocus system will automatically track a moving subject and attempt to predict where it will be for each shot, provided you keep the shutter release pressed halfway. The active focus area will be highlighted in the viewfinder, but if the subject moves out of this sensor's coverage, the focus will shift to the next AF sensor area. This makes it possible to follow the action and shoot a sequence pictures as it occurs.

Hint: The D70 has a shutter lag of about 100ms, that is to say that there is a slight but perceptible delay between pressing the shutter release button and the shutter opening. Therefore, it is important to anticipate the peak moment of the action to record it. If you see it in the viewfinder you will have missed the shot!

In this mode the D70 uses 3D Color Matrix metering with D-type, or G-type lenses, and selects Continuous-servo Dynamic AF with Closest Subject Priority as the default focus mode, which means the shutter can be released even if the camera has not acquired sharp focus.

Note: You can select Single-servo AF via Custom Setting 2, and an alternative focus mode via Custom Setting 3, but any changes made are only retained while the camera is set to the current mode.

Note: There are no flash modes available in the Sports Mode. The built-in Speedlight and AF-assist lamp are turned off .

Night Landscape
The Night Landscape Mode is designed for use in low light conditions such as the pre-dawn or twilight periods of daylight, when the foreground and sky areas still retain some color. It is also effective with artificial lighting, such as a floodlit building, or a scene lit by street lighting.

Hint: Due to the ability of this mode to select a long shutter speed you should consider using a tripod or some other form of camera support to prevent pictures being spoiled by camera shake. If you do not have a tripod, resting the D70 on a solid surface such as a table or a wall will be just as effective. To prevent touching the camera, use either the self-timer function, or ML-L3 remote control to release the shutter.

Hint: If the camera indicates a shutter speed of 1 second or longer, switch on the Long Exposure Noise Reduction feature from the Shooting Menu to help reduce the level of electronic "noise" in the picture.

In this mode the D70 uses 3D Color Matrix metering with D-type, or G-type lenses, and selects Continuous-servo Dynamic AF with Closest Subject Priority as the default focus mode, which means the shutter can be released even if the camera has not acquired sharp focus.

Note: You can select an alternative focus mode via Custom Setting 3, but any changes made are only retained while the camera is set to the current mode.

Note: There are no flash modes available in the Night Landscape Mode. The built-in Speedlight and AF-assist Lamp are turned off.

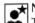

Night Portrait
The Night Portrait Mode is designed to capture properly exposed pictures of people against a background that is dimly lit. It is most effective when the background is in low light as opposed to near dark conditions. For example a city scene lit by artificial lighting, or a landscape at twilight. For a foreground subject that is in particularly low light, the built-in Speedlight or an external Speedlight such as the SB-600 can be used to supplement the ambient light.

Hint: Due to the ability of this mode to select a long shutter-speed, you should consider using a tripod or some other form of camera support to prevent pictures being spoiled by camera shake. If you do not have a tripod, resting the D70 on a

solid surface such as a table or a wall will be just as effective. To prevent touching the camera use either the self-timer function, or ML-L3 remote control to release the shutter.

Hint: If the camera indicates a shutter speed of 1 second or longer, switch on the Long Exposure Noise Reduction feature from the Shooting Menu to help reduce the level of electronic "noise" in the picture.

In this mode the D70 uses 3D Color Matrix metering with D-type, or G-type lenses, and selects Single-servo Dynamic AF with Closest Subject Priority as the default focus mode, which means the shutter can only be released once the camera has acquired sharp focus.

Note: You can select an alternative focus mode via Custom Setting 3, but any changes made are only retained while the camera is set to the current mode.

The built-in Speedlight will be turned on automatically in backlit or low-light situations. The camera automatically selects an appropriate shutter speed between 1 second and 1/500th second and sets the flash for Auto Slow-sync. Alternatively, you can select 🔲 Auto Slow-sync with Red-eye Reduction, or ⚡ Flash-off. Other flash modes are not available.

Summary Information: Digital Vari-Program Modes
The following conditions are common to all Digital Vari-Program Modes:

• All photographs are recorded in the sRGB color space

• All shooting modes (single, continuous, remote, and remote-delay) can be used

• If the light levels exceed the sensitivity of the D70 either *H i* (scene too bright), or *L o* (scene too dark) will appear in the Viewfinder Display and Control Panel.

The following table lists the values that the D70 applies to optimize images shot in the Digital Vari-Program modes

Digital Vari-Programs	AUTO	🎿	▣	🌷	🏃	🏞	👤
White balance	Auto	Auto	Auto	Auto	Auto	Auto	Direct Sun
Finetuning	0	0	0	0	0	0	0
Sharpening	Auto	Medium Low	Medium High	Normal	Medium High	Medium Low	Medium Low
Tone comp.	Auto	Auto	Auto	Normal	Auto	Normal	Normal
Color mode	Ia (sRGB)	Ia (sRGB)	IIIa (sRGB)	IIIa (sRGB)	Ia (sRGB)	Ia (sRGB)	IIIa (sRGB)
Saturation	Normal	Normal	Normal	Normal	Normal	Normal	Normal
Hue	0	0	0	0	0	0	0

Image Playback

Any image stored on the memory card can be played back, together with a variety of information about the picture, on the LCD Monitor. This is without doubt the greatest advantage SLR digital photography has over a 35mm film photography. You can review your picture immediately, allowing you to not only assess it for aesthetic merit, but also analyze it for technical quality as well.

Simple Playback

At default, the D70 will automatically display the picture on the LCD Monitor while recording to the memory card. The image will remain on the monitor for 20 seconds (default), but the duration of the display can be adjusted via Custom Setting 22. If you wish to view the picture again press ▣ .

Note: The camera will display the most recent picture. To view other pictures, use the Multi Selector Switch; pressing it down scrolls through pictures in the order in which they were taken, pressing it up shows them in reverse order.

Single-Image Playback

The swiftest way to review a single image is to press the ▣ button. This switches the LCD monitor on to display either the most recently taken or most recently displayed image. If you have used the LCD monitor since taking a picture, the D70 will show the last image that you viewed. However, if you have taken a picture since you last used the playback, the camera will show the most recently taken picture.

Note: If no images have been stored on the memory card in the current folder, the following message is displayed on the monitor – FOLDER CONTAINS NO IMAGES.

As soon as you have finished reviewing the image, you can either press the ▣ Button, or the Shutter Release halfway to switch the monitor off. Alternatively, you can let the auto power-off feature (set via Custom Setting 6) cancel the monitor display after the pre-set "meter-off" time has elapsed.

Note: The latter option is not good practice if you expect to review a lot of images, since it will use a significant amount of battery power.

Image Review: Once you have an image, or images, stored on the memory card in the camera, you can browse through them by pressing ⊙ on the Multi Selector Switch. When your selected image is displayed, you can summon the image data by scrolling through a series of five information pages by pressing ⊙ on the Multi Selector switch. The pages are displayed in the following order:

Page 1: Folder and file name, image size and quality, frame counter (shown in the top right corner; the first figure is the frame number, the second is the total number of frames currently stored in the folder.)

Page 2: Camera, date, time, metering mode, shutter speed, lens aperture, exposure mode (plus any compensation factor), and flash mode (if used).

Page 3: Image Optimization setting, ISO, white balance value, image size and quality, sharpening, tone, hue, and saturation.

Page 4: Shows HIGHLIGHTS to warn of possible overexposure.

Page 5: Shows the HISTOGRAM graph of tone distribution.

Viewing Multiple Images

You can display multiple images as small thumbnails by pressing the ▣ button. If you press this button while you have a single image showing, it will display four images on the LCD screen; press it again and 9 images will appear.

Note: The size of the thumbnail changes depending on whether four or nine are shown. If the folder contains fewer than either four or nine images, the thumbnails are still shown at the same size as four per page.

When multiple images are displayed, the currently selected image has a yellow border, and pressing the Multi Selector Switch in any direction shifts selection to another image.

Note: You cannot access the information pages when images are displayed as thumbnails, even if only one image is displayed on the LCD monitor.

To display a single image, continue to press the ▣ button until it appears.

Image Review Zoom Function

The D70 allows you to see a magnified view of the image displayed in the LCD monitor. Start by pressing the $\boxed{\text{ENTER}}$ (Q) button. Then press and hold the $\boxed{\cdot}$ button, which superimposes a thumbnail of the full frame on the main image. Within the thumbnail image is a smaller frame with red borders and blue corner sections. By pressing the Multi Selector Switch, this frame can be moved around inside the area of the thumbnail. Once you have framed the area of the image you wish to magnify, continue to hold down the $\boxed{\cdot}$ button, and now rotate the Main Command Dial and the size of the red/blue reference frame can be adjusted to select the precise area of the image to be magnified. Finally, release the $\boxed{\cdot}$ button and the selected area is magnified to fill the LCD monitor screen. If you wish to navigate around the image press the Multi Selector Switch and the enlarged image will move according to the direction in which the Multi Selector Switch is being pressed. To exit this function and return to a display of the full frame, press the $\boxed{\text{ENTER}}$ (Q) button at any time.

The buttons on the back of the D70 to the left of the LCD Monitor are placed for easy access, allowing you to make multiple settings quickly.

Protecting Images

If you want to protect a displayed image from accidental deletion, press the 🔳 button. A 🔳 appears in the top left corner of the image to indicate it is protected.

Note: Protected files are marked as read-only even when they are transferred to a computer, or other storage device.

To remove protection, simply press the 🔳 button again, and the 🔳 will disappear.

Deleting Images

You must press the Delete button two times to delete an image file from the memory card.

To delete an image, first display it on the LCD Monitor, either as a full frame image or as thumbnail (make sure the thumbnail of the image you wish to delete is highlighted by a yellow border). Then press the 🗑 button. A "Delete? Yes" message is displayed. Press the 🗑 button again to confirm and effect the deletion.

Automatic Speedlight Function

If the D70 determines that additional lighting is required in 🔳, 🔳, 🔳, and 🔳 modes, the built-in Speedlight will pop-up automatically when the Shutter Release is pressed halfway. Once raised, the D70 will only take a photograph if the 🔳 flash-ready indicator is displayed in the viewfinder. If it does not appear, the flash is still charging. Wait until 🔳 appears before pressing the shutter release again.

Flash operation can be cancelled, if you wish, by pressing and holding down the ⚡ Flash Sync Mode Button on the left side of the viewfinder head, and then rotating the Main Command Dial until 🚫 appears in the Control Panel. Alternatively you can use the same method to select 👁⚡ Auto-flash with Red-eye Reduction to reduce the effect of light reflecting from the retinas of a subject's eyes.

Hint: To conserve battery power always return the Speedlight to its closed position by pressing it down gently when you no longer require it.

◁ *Don't be afraid to shoot from a low vantage point. Often a slightly different view of a subject creates a much more interesting composition.*

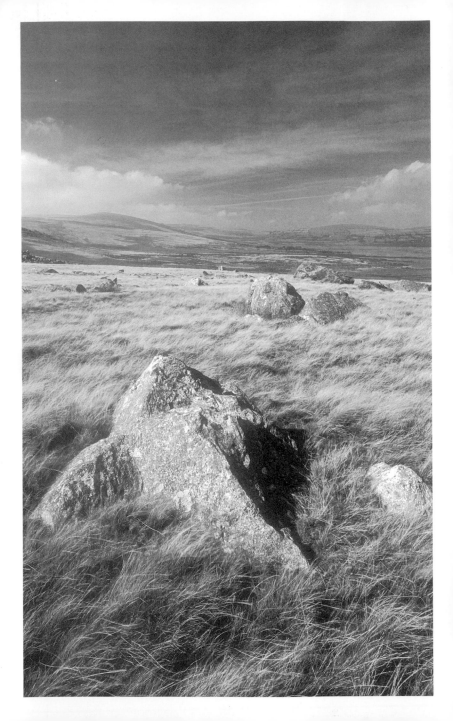

D70s/D70 Shooting Operations in Detail

Powering the D70s/D70

The D70s/D70 is powered by a variety of sources. The most common choices are is either the EN-EL3 (7.4V 1400mAh) or the EN-EL3a (7.4V 1500mAh) rechargeable Lithium-ion batteries, each of which weigh approximately 2.8 oz (80 g). Both batteries are designed so that they can only be inserted into the camera correctly. Either can be charged using the dedicated MH-18 or MH-18a Quick Chargers, as well as the MH-19 Multi-Charger. A fully discharged battery can be completely recharged in approximately 120 minutes using the MH-18 or MH-18a. Unlike some other types of rechargeable batteries, the EN-EL3 and EN-EL3a do not require conditioning prior to first use. However, it is advisable to ensure that the initial charge cycle for a new battery is continued until the battery cools down before removing it from the charger. Do not be tempted to remove it as soon as the indicator lamp on the charger stops flashing.

Using the EN-EL3/EN-EL3a Battery
To insert the battery:
1. Make sure the power switch is in the OFF position. Invert the camera and push the small button on the battery chamber lid toward the tripod socket. The battery chamber lid should swing open.
2. Open the lid fully and slide the battery into the camera, observing the diagram on the inside of the chamber lid.
3. Press the lid down (you will feel a slight resistance) until it locks (you will hear a slight click as the latch closes).

The D70 is a great camera to take on a day-shoot. All you need are memory cards and battery power. Make sure the camera battery is fully charged and that you have ample back-up power.

To remove the battery:

1. Repeat Step 1 (from page 65).
2. Hold the lid open, turn the camera upright, and allow the battery to slide out taking care that it does not drop.
3. Close the battery chamber lid.

Whenever you insert or remove a battery, it is essential that you set the power switch of the D70 to the OFF position. If you make any changes to the camera settings and then remove the battery while the power switch is still set to the ON position, the D70 will not retain the new settings. Likewise, if the camera is still in the process of transferring data from the buffer memory to the storage media when the battery is removed and the power switch is set to ON, image files will be corrupted, or lost.

To charge an EN-EL3/EN-EL3a:

1. Connect the MH-18/MH-18a to an AC power supply. (The MH-18/MH-18a can be used worldwide, connected to any AC outlet, at any voltage from 100V to 250V, via an appropriate socket adapter).
2. Align the slots on the side of the battery with the four lugs (two each side) on the top of the MH-18/MH-18a and lower the battery before sliding it toward the indicator lamp until it locks in place. The charge lamp should begin to flash immediately, indicating that charging has commenced. A full charge of a completely discharged battery will take approximately 120 minutes.

The MH-18/MH-18a will recharge a depleted Lithium ion battery in about two hours.

Battery Tips

- To ensure the battery has recharged fully, do not remove it from the charger as soon as the charge lamp stops flashing. Leave the battery in place until it has cooled to the ambient room temperature.

- Lithium batteries do not exhibit the 'charge memory' effects associated with NiCd batteries, therefore a partially discharged EN-EL3/3a can take a "top-off" charge without any adverse consequences to battery life or performance.

- If you carry a spare EN-EL3/3a, always ensure that you keep the semi-opaque plastic terminal cover in place. Without it there is a risk that the battery terminals may short and cause damage to the battery.

The MS-D70 battery holder with non-rechargeable CR2 Lithium batteries does not perform as well as the EN-EL3/3a rechargeable battery, but may come in handy as back-up power in remote locations.

Alternative Power Sources

In addition to the EN-EL3/3a battery, the D70 can also be powered by a set of three CR2 non-rechargeable Lithium batteries fitted in the supplied MS-D70 battery holder. This option should only be considered as a backup to the EN-EL3/3a since the shooting capacity of the D70 used with CR2 batteries is significantly reduced; typically to 30-40% of a fully charged EN-EL3/3a.

Hint: CR2 batteries should not be reused once the camera's battery indicator has suggested they are exhausted. Although removing and re-inserting them may suggest they have recovered some charge, they will be prone to sudden drops in voltage that will cause operating errors with the camera.

You can review pictures immediately after shooting to make sure you captured the image you wanted.

The Nikon EH-5 AC adapter, which is available separately, can also power the D70; this option is particularly useful for extended periods of shooting, image playback, or data transfer direct from the camera to a computer. Any interruption to the camera's power supply during recording or data transfer to an external device may lead to files becoming corrupted or lost. The adapter connects to the DC-In socket, located under a rubber cover on the left side of the camera. The EH-5 is also useful to prevent the camera from powering off while the reflex mirror is raised for inspection or cleaning of the CCD filter array.

The Clock/Calendar Battery

The D70 has an internal clock/calendar that is powered by a rechargeable battery that is charged automatically by either the EN-EL3/3a, CR2, or EH-5 AC adapter. Nikon states that 72 hours of charging is sufficient for about four weeks of clock/calendar backup power. If the **CLOCK** symbol flashes in the Control Panel, the clock/calendar battery is exhausted and the date/time will have reverted to 2004.01.01 00:00:00. It will need to be reset via the Date option in the Setup Menu.

Battery Performance

Obviously the more functions the camera has to perform the greater the demand for power. Reducing the number of functions and the duration for which they are active is fundamental to reducing power consumption. Since operation of the D70 is totally dependent on an adequate electrical power supply, the following suggestions tell you how to preserve battery power.

- A fully charged EN-EL3/3a battery, in good condition, will retain its full capacity over a period of a few days. If the battery is unused for a month or more, expect it to suffer a substantial loss of charge, so recharge it fully before use.

- Using the D70's color LCD Monitor increases power consumption significantly. Unless you need it, turn the monitor OFF. Consider setting CS-7: Image Review to OFF (Note: the default setting is ON).

Hint: If the Image Review feature is set to ON, as soon as you have checked the picture, press the shutter release button lightly. This prepares the camera to take another picture by immediately switching the LCD Monitor off.

- While the autofocus function uses relatively little power, the Vibration Reduction (VR) feature available with some Nikkor lenses reduces battery life by approximately 10% when active.

- A CompactFlash card requires significantly less power than a Microdrive; therefore you will be able to record more images per battery charge with the former.

- Low temperatures cause a change to the internal resistance of a battery regardless of its type, which impairs performance. However, Lithium batteries are fairly resilient to cold conditions. If you are shooting in cold conditions, keep a spare battery in a warm place such as an inside pocket and as the performance of the battery in the camera dwindles, exchange it with the warm one. Allow the used battery time to warm-up again and keep rotating between the two batteries to maximize their shooting capacity.

Image Resolution and Processing

Image Storage

CompactFlash Cards: These solid-state cards are capable of retaining data even when they are not powered. As they have no moving parts they are reasonably robust. Obviously you should treat any card with as much care as you would your camera but a minor knock, or exposure to the natural elements should not cause any problems. Although total immersion in water should be avoided! Typically, they have a temperature operating range of -4F° to 167°F (-20°C to 75°C), and no altitude limit.

Microdrives: As their name implies, Microdrives are miniature hard disk drives that have a platter that spins as an arm with a recording head tracks across it to write the data to the disk. As such, they are more susceptible to damage as a result of an impact, and are certainly far less resistant to the effects of moisture. They also have a considerably narrower temperature operating range of 41°F to 131°F (5°C to 55°C), and can become unreliable above an altitude of about 9,000 feet (3,000m).

There are several other issues concerning Microdrives that you should be aware of:

- Microdrives consume far more power compared with CompactFlash cards.

- Microdrives produce relatively high levels of heat during extended periods of use, which will inevitably increase the internal temperature of the camera. This may have undesirable consequences in terms of generating electronic noise.

- Microdrives can fail, potentially due to wear and tear of their mechanics.

Hint: When handling Microdrives always hold the card by its edges. Do not pinch them in the center of their two largest surfaces as this can damage the internal mechanism.

For optimal memory card performance, it is best to reformat the card in the camera before reusing it.

Formatting: The memory of a storage card has a similar structure to that of a hard disk drive, with a file directory, file allocation table, folders, and files. As data is written to and erased from the card, small areas of its memory can become corrupted, and files can become 'fragmented', particularly if you delete individual files (pictures). By formatting the card in the camera the effect of fragmentation is cleaned up.

Nikon states in the D70 instruction book that formatting a memory card "permanently deletes any data they contain." This is somewhat misleading, because the process of formatting actually causes the existing file directory information to be over-written so that it no longer points to the image data held on the card. It does not erase all the data as Nikon implies. That said, once formatted it is difficult to recover previously written data from the card. So always save you images to a computer or other storage device *before* formatting a card.

Image Format, Quality, and Size

The D70 saves images in two file formats, Joint Photographic Experts Group (JPEG) and Nikon Electronic File (NEF). The JPEG format uses compression algorithms to reduce the size of the image file, but in doing so loses sensor data. The NEF format used in the D70 also uses compression, so it does not retain the full range of sensor data, but it is described by Nikon as being "visually lossless." To eek out every last ounce of quality the D70 has to offer, shoot in the NEF format!

Note: Not all software is capable of reading NEF files. The Nikon View application supplied with the camera is capable of some basic NEF processing, including conversion of files to JPEG or TIFF formats. To extract the most out of your NEF files you will need an application such as Nikon Capture, v4.1 or higher.

It is important to understand the fundamental difference between the JPEG and NEF format. Images saved in the JPEG format are processed by the D70 from the sensor data and the settings you selected, whereas NEF format files are not subjected to any processing, other than compression, by the camera.

As the D70 saves a file in the JPEG format, two key things happen to the data:

1) The 12-bit data from the sensor is converted to 8-bit as part of the JPEG processing. This will reduce the tonal range of the picture, which can be significant if you intend to perform a lot of processing on an image at a later stage.

2) The settings you make on the D70, such as the white balance value, are assigned to the JPEG file by the camera. If, inadvertently, you select the wrong setting, you will need to try and undo your mistake by post processing in a computer, but there is no guarantee this will be successful.

JPEG Format: You can process and print images using JPEG files, with best results achieved at the higher size and quality settings. This format is paticularly useful if you want to post pictures to a web site or send them as an attachment to email because they can be read by a very wide variety of computer applications, and the format is supported by HTML, the standard computer language used to create web pages.

The D70 allows you to save JPEG files at three sizes:
L – Large (3008 x 2000 pixels)
M – Medium (2240 x 1488 pixels)
S – Small (1504 x 1000 pixels)

For each file size you can assign one of three levels of compression (sometimes considered as levels of quality):
FINE – uses a low compression of 4:1
NORMAL – uses a moderate compression ratio of 8:1
BASIC – uses a high compression ratio of 16:1

Note: Since the JPEG compression standard 'loses' data a file saved at the FINE setting is visually superior to a file saved at the BASIC setting.

Note: JPEG compression can generate visual artifacts; the higher the compression ratio, the more apparent these become. If you are shooting for web publication this is unlikely to be an issue, but if you intend to make prints from your JPEG file pictures you will probably want to use the Large FINE settings.

You can configure the D70 to save your image as JPEG files by using the Shooting Menu:

Press **MENU** and use the Multi Selector Switch to open the Shooting Menu. Navigate to Image quality and press the ⊙ to open the options page. Scroll down the list, highlight your choice and press the ⊙ to select it.

Stay in the Shooting Menu and select Image size then press the ⊙ to open the options page. Scroll down the list, highlight your choice and press the ⊙ to select it.

Hint: Alternatively, and in my opinion, by far the more convenient and quicker way, is to use the button and dial method. Press and hold the 🔲 button then rotate the Main Command Dial to select image quality and the Sub-Command Dial to set image size; as you do this the values are displayed in the Control Panel.

NEF Format: The NEF format file that Nikon also refers to as a RAW file uses a compressed version of the raw data from the CCD sensor. Nikon describes the compression applied to these files as being "visually lossless," by which they mean it is impossible to differentiate them from the original data. In fact Nikon uses a partial-compression scheme that only works on certain image data while leaving other data unaffected. Once the analog signal from each pixel site on the D70's CCD sensor has been converted to digital data, it has one of 4096 possible values (described as a 12-bit depth). A value of 0 represents black (there is no data), and a value of 4095 represents pure white. Before the Nikon compression is applied, the camera separates the values that represent the very dark tones from the rest of the data. The data with values that represent the remaining tones is then divided into groups of varying size. The compression is then applied. The values of the very dark tones are not affected, but the multiple values in each group that represent the lighter tones is rounded by the compression process, resulting in the loss of data.

When an application such as Nikon View or Nikon Capture opens a NEF file it reverses this compression. However, the data discarded by the compression process leaves gaps in the tonal range of the image. Before you panic, let me put this data loss into perspective. First, our eyes are incapable of resolving the very minor changes that take place (remember Nikon's phrase – "visually lossless"). Second, since most popular printers require 12-bit files to be

reduced to 8-bit files, the data loss due to the compression process is of no consequence.

Shooting NEF format files allows you to make the most of your D70:

• You will get far smoother transitions of tone due to the much wider tonal range of the 12-bit NEF files, compared with the 8-bit JPEG files.

• Image attributes such as sharpening, white balance, tone, and hue are all irreversibly embedded in a JPEG file. Images saved in the NEF format can have these attributes modified in post-capture processing using appropriate software.

To set the D70 to record images in the NEF format follow the instructions given (page 74), for selecting the JPEG format but highlight and select the NEF option instead.

Note: there is no Image size option with NEF files since the D70 always uses the full 3008 x 2000 pixel resolution of the sensor.

White Balance
Unlike film that has a fixed response to the range of wavelengths of light, the sensor in a digital camera can be adjusted to record specific ranges of wavelengths. This adjustment is known as the "white balance" setting.

All sources of light emit a range of different wavelengths, which determines the color of the light. Light that contains primarily short wavelengths, within the visible spectrum, will appear blue (or cool), whereas light that consists mainly of longer wavelengths will appear red (or warm). The color of light is expressed, as color temperature in units of Kelvin, for example many daylight films are balanced to a color temperature of 5400K. However, this is a somewhat arbitrary value since many factors influence the color temperature of daylight, such as time of day and year, altitude, and atmospheric conditions.

Although the color temperature of 5400K is fixed for film, digital cameras can have their sensors balanced for a variety of color temperatures. The D70 has eight principle white balance settings (the approximate color temperature is given in parentheses):

 Automatic: Nikon suggests that the D70 will measure any color temperature between 3500K and 8000K automatically, which is fine if you do not shoot indoors under normal domestic lighting that typically has a color temperature of less than 3500K!

 Incandescent: Use this indoors in place of Automatic since its color temperature is close to most tungsten based lighting. (3000K)

 Fluorescent: This setting is rather a hit and miss affair due to the variability of color and intensity of light emitted from a fluorescent source. (4200K)

 Direct Sunlight: For subjects or scenes photographed in direct sunlight during the middle part of the day. At other times, when the sun is lower in the sky, the light is redder, which gives a 'warmer' appearance to your pictures. (5400K)

 Flash: For any picture lit principally by flash (5400K).

 Cloudy: This white balance is for shooting under overcast skies. Typically this type of lighting has a relatively high color temperature imparting a rather cool appearance to subjects. (6000K)

 Shade: Is intended for those situations when your subject is in open shade beneath a clear, or nearly clear blue sky. In this instance the lighting will be biased towards blue, as it comprises principally of light reflected from the blue sky. (8000K)

PRE **Preset**: this option allows you to set, manually, a white balance value measured from the lighting on a specific subject or scene. This feature is selected from the Shooting Menu and provides two methods of selecting a white balance value, either from a white or gray card target measured by the D70, or by using the white balance value from a previous exposure as a reference.

Note: Nikon suggests you can use either a white or gray card as a reference target for the **PRE** option. I suggest you only use a gray card, because a white card is likely to cause exposure problems, unless you are confident about your ability to measure this.

Hint: You do not have to follow the white balance settings slavishly according to the prevailing light conditions – use them creatively. For example, shoot a sunlit scene with the Shade setting, and your picture will have a strong red/yellow cast akin to you having used a pale amber (Wratten 81c) filter. As ever the great appeal of digital photography is the ability to experiment!

Fine Tuning White Balance: In addition to the fixed color temperature values for the D70's white balance settings (i.e. all except A), the camera allows you to fine-tune the white balance by increasing or decreasing these values. Rather than express the fine-tuning factor in Kelvin, Nikon uses a completely counter-intuitive system of whole numbers between -3 and +3, where negative numbers set higher color temperatures and positive numbers reduce the color temperature. When using this as compensation, negative numbers will render an existing scene warmer (redder) and positive numbers will make it cooler (bluer). If this seems confusing, consider the analogy of using Tungsten-balanced film (3200 to 3400K, a lower color temperature number) outdoors in daylight, which has the effect of rendering the scene bluer than it would appear naturally, or using Daylight-balanced film (5500K, a higher color temperature number) under typical tungsten indoor lighting, which will render a picture with a warmer cast.

The approximate values for the fine-tuned white balance settings are:

	Incandescent	Fluorescent	Direct sunlight	Flash	Cloudy (daylight)	Shade (daylight)
+3	2,700K	2,700K	4,800K	4,800K	5,400K	6,700K
+2	2,800K	3,000K	4,900K	5,000K	5,600K	7,100K
+1	2,900K	3,700K	5,000K	5,200K	5,800K	7,500K
±0	3,000K	4,200K	5,200K	5,400K	6,000K	8,000K
−1	3,100K	5,000K	5,300K	5,600K	6,200K	8,400K
−2	3,200K	6,500K	5,400K	5,800K	6,400K	8,800K
−3	3,300K	7,200K	5,600K	6,000K	6,600K	9,200K

Hint: Because a wide variety of lighting types fall into the Fluorescent category, the adjustment increments cover a broader range (from 2,700K to 7,200K) than the other types of lighting. If you are unsure about which fine-tune factor to set, you can activate WB Bracketing via Custom Setting-12 (see page 153 for more details).

Setting White Balance: On the D70, white balance can be selected in one of two ways:

Press **MENU** and use the Multi Selector Switch to open the Shooting Menu. Navigate to White bal. and press the ⊙ to open the options page. Scroll down the list, highlight your choice and press the ⊙ to open the Fine-tune page. Use the ⊙ to set any fine-tune factor required, and press the ⊙ to set the white balance.

Alternatively, and by far the quicker way is to use the **?/⊶** Button. Press and hold the **?/⊶** Button, then rotate the Main Command Dial to select a white balance setting and the Sub-Command Dial to set the fine-tune factor. As you do this, the values are displayed in the Control Panel.

Optimizing Images

In addition to white balance, the D70 has several other controls that affect the appearance of your pictures. In the Digital Vari-Program modes these controls are assigned automatically to optimize the image. In an effort to make things easier for the user, Nikon has clustered the same controls together in a series of preset options that can be applied to images shot in P, A, S, and M exposure modes.

The options available are: Normal, Vivid, Sharp, Soft, Direct Print, Portrait, Landscape, and Custom.

It is important to understand that the Custom option is the only one that allows you to set controls manually. The other seven options all assign controls automatically, with no alternative settings according to the following table:

	Sharpening	Tone	Color Mode	Saturation	Hue
Normal	Auto	Auto	Ia	Normal	0
Vivid	Auto	Auto	IIIa	Normal	0
Sharp	High	Auto	Ia	Normal	0
Soft	Medium Low	Auto	Ia	Normal	0
Direct Print	Medium High	Auto	Ia	Normal	0
Portrait	Medium Low	Auto	Ia	Normal	0
Landscape	Medium High	Auto	IIIa	Normal	0

Hint: You will most probably have noticed that all of the preset options use the sRGB color space, and apply sharpening, and tone control. To maximize image quality, I strongly recommend that you use the Custom option. As described later, no single level of sharpening or tone control is universally applicable. Furthermore, this is the only way you can select color mode II (Adobe RGB) on the D70, which is the mode you will want to use to express the widest range of colors in your pictures.

To select any of the Optimize Image controls, open the Shooting Menu and navigate to the *Optimize image* option

and press ⊙ on the Multi Selector Switch to select it. This opens a page with a list of the controls. Use ⊙ to scroll to the required control then press ⊙ to select it.

If you select *Custom,* this action will open a further menu from which you can set each control option by pressing the ⊙ , scroll to the setting you require and select it by pressing ⊙ . Finally, navigate to *Done* and press ⊙ to lock your settings. If you do not carry out this last step the settings will not be saved.

Sharpening: Sharpening is a process applied to digital data that increases the apparent sharpness (acuity) of a picture. This is not a method for rescuing an out-of-focus picture—remember, once out-of-focus always out-of-focus!

Sharpening is used to correct certain side effects of converting light into digital data. This can cause distinct edges between colors, tones, and objects in a digital picture to look poorly defined or fuzzy. The D70 uses a technique that identifies an edge by analyzing the differences between neighboring pixel values. Then the process lightens the pixels immediately adjacent to the brighter side of the edge, and darkens the pixels adjacent to the dark side of the edge. This causes an increase of local contrast around the edge that makes it look sharper.

The D70 offers seven levels of image sharpening:

A Auto – the D70 applies a level of sharpening that varies according to how the camera analyzes the image data.

Note: Nikon gives no indication as to the sharpening parameters the D70 applies at this setting.

◇ 0 Normal – apparently the camera applies a moderate amount of sharpening. I say "apparently," because again Nikon does not provide specific values for the level of sharpening.

◇-1 Medium Low – a lesser amount of sharpening is applied than **Normal.**

◇-2 **Low** – sharpening level is slightly less than **Medium Low.**

◇+1 **Medium High** – sharpening level is slightly higher than **Normal.**

◇+2 **High** – the D70 applies an aggressive level of sharpening.

✎ **None** – no sharpening is applied to the image data.

Hint: No single level of sharpening is suitable for all picture-taking situations. Likewise, the level of sharpening should also be based on your ultimate intention for the image, (i.e. display on a web page, publication in a book or magazine, or producing a print for framing).

It is often preferable to apply sharpening in post-processing on a computer, so I would make the following suggestions when shooting with the D70:

• For general photography, using JPEG format files, set sharpening to Low or Medium Low.

• If you shoot in the NEF file format, set sharpening to None.

Note: Although the data in a NEF file is not sharpened by the D70, any sharpening level that is set will be stored in the file's EXIF data, which means that sharpening can be applied when you convert the image in another application.

• On those occasions when you need to expedite the output of pictures for publishing on a web page or in newsprint, setting the sharpening level to **Normal** or **Medium High** is probably prudent, as it will save valuable time in post processing.

Tone Compensation: Tone compensation (contrast control would be a better name!) allows you to adjust the contrast of an image. It works by applying a curve control similar to those used in post processing applications that alter the distribution of tones from the sensor data to fit the selected contrast range as defined by a contrast curve.

A Auto – the D70 uses its Matrix metering system to assess the differences between the levels of brightness in the scene. If these are significant the camera assumes the scene has high contrast and applies a compensation to lower it. Conversely if scene contrast is assessed to be low, the D70 will increase image contrast.

◑ 0 **Normal** – the D70 applies a standard contrast curve that produces images with contrast between the extremes of **Low** and **High** contrast.

◑-1 **Medium low** – image contrast is slightly lower than **Normal**.

◑-2 **Low contrast** – this setting produces images with noticeably less overall contrast, which can affect the density of very dark tones with the result that they lack depth.

Note: If you expect to perform post processing on your pictures you may wish to consider setting Low contrast as it is easier to increase contrast than reduce it at this stage.

◑+1 **Medium high** – image contrast is slightly higher than **Normal.**

◑+2 **High contrast** – image contrast is boosted producing images with deep, rich blacks and pure white, with a reduced tonal graduation between these two extremes. However, there is a risk that highlight detail will be burnt out.

◑∅ **Custom** – this option is only applicable if you have access to Nikon Capture 4.1 (or later) software, because it allows you to write your own contrast curve and upload it to the camera.

Color Mode

The D70 offers a choice of three different color modes, or color spaces. These determine the range of colors in the image and how they will be interpreted. Select a color mode based on how you intend to use the image.

Mode Ia (sRGB) – this is the default setting that Nikon recommends for portrait pictures.

Mode II (Adobe RGB) – this color mode offers a wider gamut of colors than either of the two sRGB modes (Ia and IIIa). It is the mode most often utilized by photographers because it provides the greatest number of options when it comes to the subsequent use of the image. You can always covert an Adobe RGB image to sRGB, but going from sRGB to Adobe RGB will not give you as good of a result.

Note: With this color mode there is a tendency for colors to look dull when displayed on a computer monitor, its full benefits will not be revealed until you make a print.

Mode IIIa (sRGB) – this setting enhances the rendition of green and blue. Nikon recommends that it be used for "nature or landscape shots."

The two sRGB color modes use a restricted gamut of colors most appropriate to display on a computer monitor. They produce rich, saturated colors but with an overall reduction in tonal range. If you are shooting pictures specifically for website use, or using a direct printing method with no intention of post-processing, sRGB may be a good choice. Otherwise, I recommend using the Adobe RGB color mode because it gives you more subtle control of image color.

Note: Although the D70 system records images in Mode II (Adobe RGB) based on EXIF and DCF, it does not strictly confirm with these standards so it may be necessary to select the color space manually for the device or application in use.

Note: JPEGs taken in Mode II with the D70s are EXIF 2.21 and DCF 2.0 compliant. Applications and printers that support these standards will select this color space automatically.

Hint: It is essential that your image-processing application be set to the same Adobe RGB color space you're shooting with, otherwise the application will more than likely assign its own default color space and you will lose control over the rendition of color.

Saturation

Adjusting the saturation changes the overall vividness of color (chroma) without affecting the brightness (luminance) of an image.

⊛0 **Normal** – this is the default setting and is probably the option to use for most situations, since the camera offers very limited control compared with a post-processing application.

⊛- **Moderate** – the vividness of colors is reduced but Nikon provides no information as to the level of adjustment that is applied.

⊛+ **Enhanced** – the vividness of colors is increased but Nikon provides no information as to the level of adjustment that is applied.

Hue

The color model used by the D70 to produce images is based on combinations of red, green, and blue light. By mixing any two of these, a variety of different colors can be produced. If the third color is introduced, the hue of the color is altered. The proportions of these colors determine the warmth or coolness of the color.

The Hue control on the D70 allows you to manage the warmth or coolness of colors by setting an adjustment of +/- 9° in increments of 3°. For example, if the level of red and green data is increased relative to the blue data, the hue

shifts (positive adjustment) to a "warmer" (red/yellow) rendition. If you apply a negative adjustment, the hue shifts to a "cooler" (blue/violet) rendition.

Hint: Both saturation and hue can be controlled to a far greater degree using an image processing application on a computer. I would recommend that both of these controls be left set to Normal and 0° respectively.

Placing light pressure by pressing part way down on the Shutter Release Button activates both the metering and the autofocus systems.

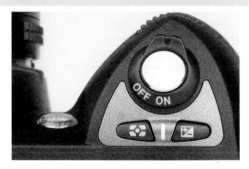

Shutter Release

The Shutter Release Button of the D70 is located, conventionally, on the front, right, top of the camera. If the camera is switched ON a light pressure on the Shutter Release Button (pressing it halfway down), will activate the metering system and initiate autofocus. Once you release the button, the camera remains active for a fixed period, the duration of which depends on the selection made within Custom Setting-23 (6-seconds at the default setting).

If you continue to press the Shutter Release Button through its full range of travel, the shutter mechanism will operate and an exposure will be made. There is a short delay between the time you press the button all the way down and when the shutter opens, which is usually referred to as "shutter lag." The lag time of the D70, approximately 100 milliseconds, is comparable to many 35mm film cameras, and equal to that of the D100.

However, the release of the shutter can be delayed further, and in some cases prevented, if certain features and functions are in operation at the time the Shutter Release Button is pressed. The following are some of the reasons for causing shutter delay:

- The capacity of the D70's buffer memory is probably the most common cause of shutter delay. It does not matter whether you shoot in Single Frame or Continuous Mode (see page 88 for description); once the buffer memory is full, the D70 must write data to the memory card before any more exposures can be made. As soon as sufficient space is available in the buffer memory for another image, the shutter can be released.

- If the camera is set to Single-servo Autofocus Mode, the shutter is disabled until the D70 has acquired focus. In low light, or low contrast scenes, the autofocus system can often take longer to achieve focus (see page 103 for a full explanation), adding to the delay.

- In low-light situations, the D70 will activate the AF-assist Lamp, provided it has been instructed to do so via Custom Setting-4, which introduces a short delay while the lamp illuminates and focus is acquired.

Note: The AF-assist Lamp only operates in Single-servo AF Mode.

- The Red-eye Reduction function, which is one of the Flash modes available on the camera, introduces an additional and significant one-second delay between pressing the shutter release button, and the exposure being made. This is the time the lamp used to reduce the size of a subject's eye pupils is lit, before the shutter opens and the Speedlight fires.

*Press the Shooting
Mode Button on
the upper left of the
back of the camera
and turn the Main
Command Dial to
choose your desired
shooting mode.*

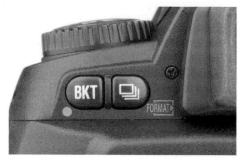

Shooting Modes

Obviously, unlike a 35mm camera, the D70 does not have to transport film between each exposure, so in that sense it does not have a motor drive. However, the shutter mechanism still has to be cycled. The camera offers two shooting modes, Single-frame and Continuous, plus a Self-timer option, and a Remote Shutter release feature.

To set the shooting mode, hold down the ⊡ button (the Shooting Mode Button, located to the left of the viewfinder eyepiece) and rotate the Main Command Dial until the required mode icon, ⑤ Single-frame, ⊒ Continuous, ⟳ Self-timer, ⓘ Remote with delay, or ⓘ Remote with immediate release, appears in the Control Panel. Release the ⊡ button to select the required mode.

⑤ Single-Frame

A single image is recorded each time the Shutter Release Button is pressed. To make another exposure, the button must be pressed again; you can continue to do so until the buffer memory is full, in which case you must wait for data to be written to the memory card, or the memory card becomes full.

Hint: You do not have to remove your finger from the shutter release button completely between frames; by raising it slightly after each exposure, maintaining a slight downward pressure on the shutter release button, you can keep the camera active and be ready for the next shot.

Single-frame mode is an ideal choice for static subjects.

Hint: If you want to take a rapid sequence of pictures in Single-frame Mode avoid 'stabbing' your finger down on the Shutter Release Button. Keep a light pressure on it and roll you finger over the top of the button in a smooth action. This will reduce the risk of camera shake spoiling your pictures.

Continuous

In this mode if you press and hold the Shutter Release Button down, the D70 will continue to record images up to a maximum rate of 3 frames per second (fps).

Note: Nikon quotes the 3-fps rate based on the D70 being set to manual focus, manual exposure, and a minimum shutter speed of 1/250th second. It is important to remember that buffer capacity, auto-exposure modes, and autofocus (particularly in low-light) can, and often does, reduce the frame rate significantly.

Note: All pictures taken in Continuous Mode are recorded in the orientation of the first frame in the sequence. This applies even if you have activated the Rotate All option within the Playback menu and change the orientation of the D70 as you shoot a series of pictures.

Self-Timer

The D70 offers a self-timer function with variable delay. Many users automatically associate such a feature with taking self-portrait pictures as the delay between pressing the shutter release and the exposure being made allows the photographer to position himself or herself in the composition. Personally, I find this mode more useful for releasing the shutter without having to touch the camera and thereby risk causing camera shake.

The duration of the self-timer delay is set via Custom Setting-24 (there are options for 2, 5, 10, or 20 seconds). After you press the shutter release, Self-timer Mode activates and the AF-assist Lamp, located on the front right of the camera, flashes until two seconds before the exposure is made, at which point the lamp remains on constantly as a warning that the picture is about to be taken.

Here are some tips for getting good results when using the D70's self-timer:

- In normal shooting the user's eye is placed to the viewfinder eyepiece. However, when the D70 is used remotely, light will enter the viewfinder and influence auto exposure settings. Therefore, you should fit the DK-5 eyepiece cover supplied with the camera (see pages 113 and 194 for more details.)

- The D70 will attempt to acquire focus as soon as you press the shutter release, so if you, or anyone else, is standing immediately in front of the camera when this operation is activated, there is a good chance that your picture will be out of focus! Furthermore, if the camera does not acquire focus in the Self-timer Mode, it will not

take a picture, even in Continuous-servo AF Mode. Generally, I find the most reliable method of taking pictures with the self-timer is to select Manual focus, and prefocus the lens on the subject, or the anticipated position of the subject.

- In Self-timer Mode the D70 makes a single exposure and then resets itself to either Single-frame or Continuous Mode, depending on which of the two modes was last selected before the self-timing option was set.

Using a Remote Release

The D70 uses the Nikon ML-L3, wireless infrared (IR) remote release that is common to other Nikon cameras such as the N65/F65 and N75/F75. Pressing the transmit button on the ML-L3 sends an IR signal to the receiver, which is mounted behind a small widow on the upper, front left side of the D70, just above the camera's badge. The system has a maximum effective range of approximately 16 feet (5m).

The Nikon ML-L3 Remote Release is handy to use when a long exposure is required and you want to eliminate camera shake.

Hint: Nikon claims in their instruction manual that there must be a clear, unobstructed line of sight between the ML-L3 and the D70's receiver. This is not necessarily the case, because it is quite possible to bounce the IR signal from the ML-L3 off a reflective surface such as a wall or window, which increases the potential of this feature.

Note: Nikon also support the use of the ML-L1 wireless infrared (IR) remote release; it works in an identical manner to the ML-ML3.

The ML-L3 can be used to release the shutter in two different ways, a quick and a delayed response.

Quick-Response Remote
The shutter is released as soon as you press the transmit button on the ML-L3 remote control. This function is set by holding down the ▣ button and rotating the Main Command Dial until ▮ remote with immediate release appears in the Control Panel.

Delayed Remote
The shutter is released with a delay of two seconds after you press the transmit button on the ML-L3 remote control. This function is set by holding down the ▣ button and rotating the Main Command Dial until ▮ remote with delayed release appears in the Control Panel.

Regardless of which remote mode you choose, the D70 will automatically cancel it after a fixed period of camera inactivity. At the default setting this period is one minute, but you can also set it to 5, 10, or 15 minutes, via Custom Setting-25.

Note: The ML-L3 can be substituted by the ML-L1 infrared remote release if required.

Hint: If you want to make extremely long exposures with the D70 you can use the **buLb** setting (Manual Exposure Mode only) in conjunction with the ML-L3. This works in both remote release modes. Used this way, **buLb** is replaced by **- -** and the exposure is started by the first press of the transmit button on the ML-L3, and finished with a second press of the button. A single flash of the AF-assist Lamp confirms completion of the exposure.

Note: The D70 will end the exposure automatically after 30 minutes.

Using a Remote Release Cord
Unlike the D70, which lacks a socket for either a mechanical or electric cable release, the D70s can be used with the

MC-DC1 Remote Release cord. It is a little over three feet (1 m) long, and features a lockable shutter release button, which is useful for continuous shooting or long exposures. To attach the MC-DC1 to the D70s, open the rubber cover at the top of the left side of the camera and insert the plug of the cord into the socket.

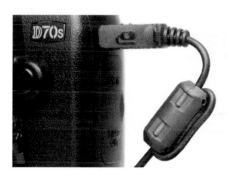

The MC-DC1 connects to a socket beneath a hinged rubber cover on the left side of the D70s.

In Single-Frame mode the shutter will be released each time you press the button on the MC-DC1. If the camera is set to Continuous mode, it will continue to record images up to a maximum rate of 3 fps while the button remains depressed. For making exposures longer than 30 seconds using the **bulb** setting, the shutter can be locked open by pressing the release button on the MC-DC1 and sliding the locking collar forward. To end the exposure slide the locking collar backwards and allow the Shutter Release Button to return to its normal position.

The Memory Buffer
The D70 has a memory buffer that provides temporary storage of image files. This allows the camera to continue recording pictures while data is written to the memory card. As soon as the memory buffer is full, the Shutter Release is disabled, and no further pictures can be taken until sufficient data has been moved to the memory card to make room for another image. The number of pictures that can be stored in the memory buffer depends on the settings selected for image quality and size (see following table).

Buffer Storage

Quality	Size	Capacity
RAW	—	4
FINE	L	9
	M	7
	S	19
NORM	L	12
	M	7
	S	27
BASIC	L	19
	M	7
	S	49
RAW + BASIC	L	4

Long Exposure Noise Reduction

Image quality	Image size	No. of shots
RAW	—	3
FINE	L	7
	M	5
	S	17
NORM	L	10
	M	5
	S	25
BASIC	L	17
	M	5
	S	47
RAW + BASIC	L	3

The number of pictures that can be stored in the memory buffer is reduced, slightly, if the Long Exposure Noise Reduction feature, set from the Shooting Menu, is active (see table).

The number of images that can be stored in the memory buffer, at the current quality and size settings, is shown in the exposure counter brackets in both the Control Panel and Viewfinder Display while the Shutter Release Button is pressed. For example, ⌐ ∂ ⎁ indicates that four images can be stored in the memory buffer.

The Autofocus System

The D70's autofocus (AF) system is derived from the systems in the N80/F80 film camera and D100 digital SLR. It uses five sensors, arranged in a cross formation. Their approximate position is indicated by the five pairs of brackets marked on the Viewfinder Display. The actual area covered by each sensor is more linear than the area delineated by the brackets (see illustration of viewfinder below). These sensors

The center cross-type sensor surrounded by the four single direction sensors.

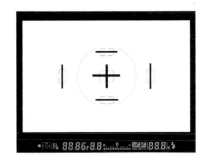

measure contrast in the subject, and signals are sent to the focusing motor in the camera, or the motor built-in to AF-S and AF-I type lenses. These motors cause the point of focus to be shifted until the maximum level of contrast is attained, at which point the subject should be in sharp focus.

It is very important to understand that of the five autofocus sensors, the central one differs significantly from the other four. The center sensor is a cross-type that is equally sensitive to vertical and horizontal patterns or detail. Generally, the other four sensors are only sensitive to detail or patterns in a single direction. Consequently, these sensors are not as effective at acquiring focus in subjects with detail or patterns in the same orientation as the sensor.

Furthermore, the center sensor area (cross-type) has two sets of sensors, which increase its ability to work in a wider range of light levels. This sensor area is far more sensitive in low light than the single line-type sensors in the other four sensor areas.

Once focus has been achieved the confirmation signal (●) appears in the Viewfinder Display.

Focusing Options

The D70 has two focusing options: Autofocus (AF) and Manual Focus (M). The AF Mode Switch, located on the side of the lens mount below the lens release button, is used to select these.

Autofocus (AF): If you select Autofocus (AF), the lens is focused automatically when the shutter release button is pressed halfway, or fully depressed. Depending on which focus mode is selected the shutter will either be disabled until focus is acquired, or operate regardless of whether the camera has achieved focus. As soon as focus has been achieved, and provided the Shutter Release Button remains half way down, the D70 will either lock focus at that distance, or begin to track a moving subject until the Shutter Release is pressed fully.

Manual Focus (M): The Manual Focus (M) option requires the user to physically turn the focusing ring of the lens to achieve focus. There is no restriction on when the shutter can be operated, and the focus confirmation signal still functions, which is particularly useful in low light or low contrast. The Focus Mode Selector Switch must be set to M with most AF-Nikkor lenses. However, if the lens you are using has a switch that allows you to set an M/A (manual/autofocus) mode, you need only touch the focusing ring and the lens can be focused manually. As soon as you release the focusing ring it will revert to autofocus operation. The Focus Mode Selector Switch on the D70 can be left set to AF.

Despite the autofocusing capabilities for the D70, there are occasions when focusing manually is preferable:

• In close-up photography, controlling the depth-of-field is often critical, so accurate focusing is essential. Since many subjects are relatively static, by focusing manually you can place the plane of focus with precision.
• In numerous sports, competitors pass through a fixed point such as a section of track, a jump, or finish line. By manually pre-focusing on these positions and releasing the shutter just a fraction of a second before the subject reaches them, you can capture the peak moment in action shots.
• You may have some earlier manual focus Nikkor lenses that you want to use with the D70.

Note: If you attach a non-CPU lens to the camera, the TTL metering system will not function.

- There are circumstances in which the AF system may become unreliable (see page 103—Limitations of the AF System); in these cases switch to Manual Focus and use the electronic rangefinder as a focusing aid. When focus has been achieved, the Focus Confirmation Signal (●) will light up in the viewfinder.

Autofocus Modes

There are two distinct focus modes available on the D70, which are selected via Custom Setting-2. They are: Single-servo Autofocus (AF-S), and Continuous-servo Autofocus (AF-C).

AF-S—Single-Servo Autofocus: While the Shutter Release Button is pressed halfway down, the D70 focuses and then locks at the focus distance. The shutter can only be released once focus has been acquired (check the in-focus signal is displayed in the viewfinder). If the subject was moving when the shutter release was first pressed half way, the camera will track the subject until focus is achieved, and then the shutter can be released (see page 90—Predictive Focus Tracking). If the subject stops moving before the shutter is released, the D70 focuses, and then locks at the focus distance.

AF-C—Continuous-Servo Autofocus: While the Shutter Release Button is pressed halfway down, the D70 focuses continuously. In addition to tracking a subject that was originally moving when the Shutter Release was first pressed half way, AF-C Mode will also initiate tracking if it detects that the subject begins to move after the Shutter Release Button was first pressed.

There is a fundamental difference between these two modes. In AF-S, referred to by Nikon as "focus priority," the shutter cannot be released until focus has been acquired. Conversely, in AF-C, which Nikon calls "release priority," the shutter will operate immediately on pressing the Shutter Release Button regardless of whether focus has been achieved. Some photographers mistakenly believe that if you release the shutter before the camera has apparently focused, the picture will be out of focus. In fact the camera is often capable of predicting where

the subject will be within the frame and shifting the focus point accordingly, all within the split second between the mirror lifting and the shutter opening. Even if the camera's calculations are still slightly out, the depth of field can often make up for minor focusing errors. In AF-C, it is imperative that you allow the camera time to establish a starting point for the focusing action by pressing the Shutter Release Button half way and holding long enough for it to do so, otherwise it is likely the picture will be out of focus.

Predictive Focus Tracking: It is important to understand the distinction between how the autofocus tracking system works in AF-S and AF-C modes. In AF-S mode, Predictive Focus Tracking is initiated if the camera detects the subject is moving at the time the shutter release is first pressed half way. If the subject stops, focus will be acquired and the lens locked at that focus distance. Any subsequent movement by the subject will have no effect of the AF system. In AF-C mode, predictive focus tracking is initiated regardless of whether the subject was moving at the time the shutter release was first pressed half way. If the subject was static, or moving at this point in time, and it subsequently stops, the D70 will acquire but continue to monitor focus. If the subject begins to move again, the camera will commence focus tracking once more to follow the subject

Focus Area Modes
The D70 has three modes that define how the five autofocus sensors are used by the camera. These are known as the AF Area Modes, and are set via Custom Setting-3 (see page 148 for more details).

[ꞔ]***Single Area AF:*** The D70 uses the autofocus area you, the operator, select for focusing; the camera takes no part in choosing which sensor to use. The selected area is highlighted in the viewfinder.

[·ᐤ·]***Dynamic Area AF:*** To start, the D70 uses the autofocus area you select for focusing, but if it detects that the subject is moving, the camera evaluates information from the other

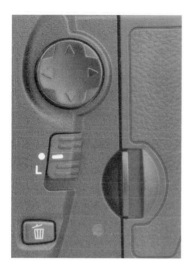

In order to change Focus Area modes, you must release the Focus Selector Lock by shifting it upward. Use the Multi Selector Switch to select a new AF Area mode.

autofocusing areas and will shift focusing to another sensor if necessary. The selected area is highlighted in the viewfinder and remains highlighted even if the subject leaves it.

To select the AF area that the D70 will use as the initial focus point:
1. Shift the Focus Selector Lock upwards to unlock it.
2. If the camera is not already active press the shutter release half way and let go of it.
3. Press the Multi Selector Switch up, down, left, or right to change between the five sensors.

Note: you can get the selection of the AF area to wrap round, by selecting Wrap via Custom Setting-17)

■ *Closest-Subject Priority AF:* The camera always focuses with the sensor area that detects the object closest to the camera. I say "object" rather than "subject" because this is frequently not the subject! The user has no control over which sensor area is used for focusing.

AF System Operation

Custom Setting-2 (Autofocus)	Custom Setting-3 (AF-area Mode)	Control panel	View-finder	Active focus area	Focus-Area selection
AF-S	Single area	[[]]	[[]]	Shown in viewfinder and control panel	Manual
	Dynamic area	[+ [•] +]	[· [•] ·]	Shown in viewfinder and control panel	Manual
	Closest subject	[+ + +]	[· · ·]	Not shown	Automatic
AF-C	Single area	[[]]	[[]]	Shown in viewfinder and control panel	Manual
	Dynamic area	[+ [•] +]	[· [•] ·]	Shown in viewfinder and control panel	Manual
	Closest subject	[+ + +]	[· · ·]	Not shown	Automatic

The built-in AF-assist lamp is located on the front of the camera next to the Sub Command Dial.

AF System Overview

If you are new to Nikon's AF system it will take a while to get used to the functionality of Focus Mode and Focus Area Mode. Therefore, you may wish to re-read the sections above and refer to the following table that sets out, in summary, the various autofocus operations.

AF-Assist Lamp: The D70 has a small, built-in white light known as the AF-assist Lamp, which is designed to facilitate autofocusing in low light conditions. Whatever the intentions were of the D70's design team, this feature is largely superfluous!

Here are a few reasons why you may as well go to Custom Setting-4 and select the option that cancels the lamp's operation.

- The lamp only works if you have an autofocus lens attached to the camera, the focus option set to AF-S (Single-servo) with either the center focus area, or Closest-Subject Priority active.

- It is only usable with focal lengths between 24mm – 200mm

- The operating range is restricted to between 1 feet 8 inches to 9 feet 10 inches (0.5 – 3.0m)

- Due to the lamp's location, many lenses obstruct its output, particularly if they have a lens hood attached.

- It is disabled with all VR-type telephoto zoom lenses, and the AF-S and AF-D versions of the 80-200mm f/2.8 Nikkor lenses.

- The lamp overheats quite quickly (6 to 8 exposures in rapid succession is usually sufficient) and will automatically shut down to allow it to cool. Plus, at this level of use it also drains battery power.

Hint: Attach an SB-600 or SB-800 Speedlight to the D70 and operation of the lamp is disabled, as the Speedlights use their built-in (far more effective) red AF-assist lamp. If you want to use either the SB-600 or SB-800 off camera, the SC-29 TTL flash lead has a built-in AF-assist lamp.

Focus Lock: Once the D70 has achieved focus it is possible to lock the autofocus system as follows:

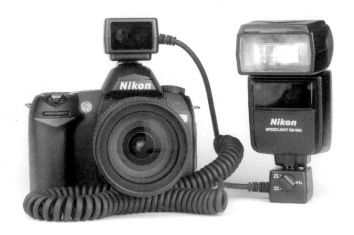

The SC-29 dedicated connecting cord retains full i-TTL capability, and incorporates an AF-assist lamp to help improve the accuracy of autofocus when the SB-600 Speedlight is taken off camera.

AF-S—Single-Servo Autofocus: pressing the Shutter Release Button halfway will activate autofocus, which will lock automatically as soon as focus is acquired, and remain locked at the same focus distance until you let go of the shutter release button. Alternatively, you can lock focus if you press and hold the 🔘 Button. You no longer have to press the Shutter Release Button.

AF-C—Continuous-Servo Autofocus: the autofocus system remains active, constantly adjusting the focus point, while you press and hold the shutter release button halfway down. Press and hold the 🔘 Button to retain focus lock. You no longer have to press the shutter release button.

Hint: Use Custom Setting-15 to assign the lock function of the 🔘 Button (exposure & focus, exposure only, or focus only).

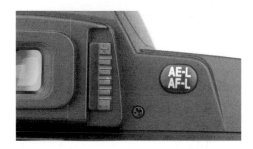

Limitations of the AF System

Although the autofocus system of the D70 is very effective, there are some circumstances or conditions that limit its performance:

• Low light

• Low contrast

• Highly reflective surface

• Subject too small

• Fine detail in AF bracket

• Regular geometric patterns

• High contrast within autofocus area

If you find that the autofocus system hunts (i.e. the focus shifts back and forth without locking on to a subject) in these situations, switch to M, Manual Focus, and use the electronic rangefinder as a focusing aid.

Note: The AF system in the D70s has been enhanced to improve in overall speed and operation, both in low contrast and low light situations. However, while the change is technically measurable, it is unlikely that a user will be able to discern a difference between the D70 and the D70s.

Exposure

Regardless of whether you are content to let the D70 make decisions about exposure or you prefer to take control of your camera and make them for yourself, it is essential to understand how the camera sees, evaluates, and processes light.

Sensitivity

Film requires you to make a decision about which ISO (sensitivity) rating to use in order to cope with the prevailing or expected lighting conditions. Once loaded in the camera, the entire roll of film must be exposed at the same sensitivity value. One of the great advantages of digital photography is that digital cameras generally allow you to adjust the sensitivity from picture to picture. The D70 is no exception, offering sensitivity settings (in ISO equivalent values) from 200 to 1600 in increments of one-third stop. In addition to this, the camera has an ISO Auto feature that is intended to vary the sensitivity value according to the light conditions.

I use the word sensitivity advisedly since the CCD in the D70 actually has a fixed sensitivity, equivalent to ISO 200. The higher ISO values are achieved by amplifying the data from the sensor within the camera's analog-to-digital converter (ADC).

Setting the ISO Value: To set the sensitivity value on the D70 you can take two different routes:

- Open the Shooting Menu and scroll to ISO, press the ▶ to open the sub-menu of values, then scroll down using the Multi Selector Switch, highlight the required value and press the ▶ again to set it.

- As an alternative you can adjust the sensitivity (ISO) by pressing and holding the ISO button on the rear of the camera, and then turning the Main Command Dial. The selected value is displayed in the Control Panel.

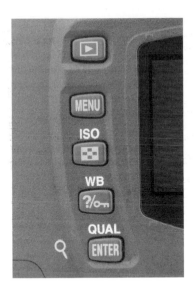

There are often multiple ways to select a function or setting by using the various buttons and dials. One way to choose your ISO is to hold the ISO Button while turning the Main Command Dial.

There is a further analogy with film in that the images show an increasing amount of digital noise at higher sensitivity settings. However, this noise is not random like the distribution of grain in film, and reduces the tonality of pictures. As the sensitivity value is hiked higher and higher, so the saturation of color and level of image contrast are reduced.

For the optimum image quality, keep the D70 set to 200. The 400 setting is almost as good with just a slight increase in graininess induced by a higher noise level. At 800 it is highly likely that you will see color shifts in your pictures, and once again saturation and contrast are affected. The highest setting of 1600 reduces color saturation and contrast significantly, and should be considered only when no other option (wider aperture, or slower shutter speed) will get the picture.

Hint: If the light level begins to drop as you shoot, you can either raise the ISO setting or use a longer shutter speed. Confronted with this situation, I recommend putting the camera on a tripod and selecting a longer shutter speed in combination with the long exposure Noise Reduction feature available in the Shooting menu.

ISO Auto: I dislike this option so much that I will begin this section by suggesting you ignore it, completely! Why? Well, it is important to understand that it does not work in quite the way I expect most users imagine.

In Auto Multi Program (P), Aperture-Priority Auto (A), and the seven Digital Vari-Program Modes, the sensitivity will not change until the exposure reaches the limits of the shutter speed range. The upper limit is always 1/8000 second but the lower limit can be adjusted within Custom Setting-5, in increments of one-stop, between 30 seconds and 1/125 second.

In Shutter-Priority Auto Exposure Mode (S), the sensitivity is shifted when the exposure reaches the limit of the available aperture range. Indeed, this is the only exposure mode with which ISO Auto might be useful, because it will raise the sensitivity setting and thus maintain the pre-selected shutter speed, which in this mode is probably critical to the success of the picture.

In Manual Exposure Mode (M), the sensitivity is shifted if the selected shutter speed and aperture cannot attain a correct exposure as indicated by central '0' in the analog display of the viewfinder.

The biggest problem with the ISO Auto Mode is that you can never be sure of exactly what sensitivity value the D70 has set. Although a warning appears in the Control Panel to indicate this function is active, there is no indication of what value (ISO) has been set.

TTL Metering

The D70 has three metering options that will be familiar if you have used a Nikon AF camera before. To select a metering mode, press and hold the ▣ Metering Mode Button while turning the Main Command dial. The appropriate icon will be displayed in the Control Panel display.

▣ *Matrix Metering:* The metering pattern for this mode divides most of the image area into a matrix, or series of segments, and assesses the difference in brightness between them. (The

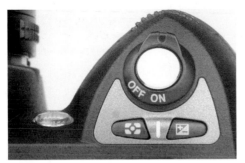

To choose the type of metering you want to use, use the Metering Mode Button on top of the camera, to the rear and left of the Shutter Release Button.

extreme edges of the frame area are not included in this metering pattern.) These values are compared against a data-base of reference patterns of brightness before the camera suggests an exposure setting. The meter in the D70 is a very sophisticated tool that uses a 1005-pixel CCD located in the viewfinder to measure light values. In fact it is a modified version of the same system used in Nikon's flagship D2H digital SLR camera.

When using a D-type or G-type Nikkor lens, you will gain the most from the D70's metering capabilities. These lenses provide additional information about the focus distance, which assists the D70 in estimating the sort of picture you are taking by suggesting where in the frame the subject is likely to be (the camera assumes the subject is in the plane of sharp focus).

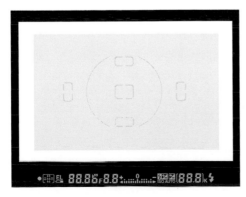

Matrix metering gives extra consideration to the area surrounding the active AF sensor because it is logical to assume that the sub-ject is located in this part of the frame.

Matrix Metering uses four principle factors when calculating an exposure value:

- The overall brightness level of the scene

- The ratio of brightness between the matrix pattern segments

- The active focus area, which suggests the position of the subject in the frame

- The focused distance, provided by the lens (D or G-type only)

Hint: The D70 will endeavor to preserve highlight values over shadow values, because, like transparency film, once the highlight detail is over exposed it is lost and no amount of subsequent image manipulation will recover it. However, it is possible to recover shadow detail from underexposed areas. Therefore, if the scene you photograph has a wide contrast range (large variation in brightness) do not be surprised if it looks as though it has been underexposed. Fortunately, the D70 has a couple of features that help you to evaluate an exposure—histogram and highlights. I describe these in the next section.

Center-Weighted Metering: The Center-Weighted Metering pattern harkens back to the very first TTL metering systems used by early Nikon SLR film cameras. In these cameras the frame area was usually divided in a 60:40 ratio with the bias

The area designated by the circle is given 75% emphasis in calculating the exposure in Center-Weighted Metering.

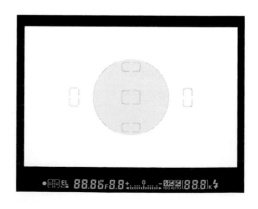

being placed in the central portion of the frame. The D70 uses a stronger ratio of 75:25, with 75% of the exposure reading based on the central area of the frame and the remaining 25% based on the outer area. Using Custom Setting-11 you can alter the diameter of the central metering area; at its default value of 8mm it corresponds to the circle marked in the center of the D70's focusing screen.

Hint: Center-Weighted Metering is the least accurate of the three metering patterns available on the D70. Matrix will do an excellent job in most situations and for particularly tricky lighting, the Spot meter is more useful than the Center-Weighted pattern.

* ***Spot Metering:*** Spot Metering is extremely useful for measuring a highly specific area of a scene. For example, with a subject against a virtually black background (which would more than likely cause the Matrix Metering system to overexpose), the Spot meter allows you to take a reading from the subject without it being influenced by the background. The Spot metering function of the D70 centers a circle, approximately 2.3mm in diameter, on one of the five AF-sensor area brackets, so the metering area is actually larger than the AF-sensor bracket. The metering area corresponds to the active AF-sensor area, unless Closest Subject Priority is selected, in which case only the center AF-sensor area is used.

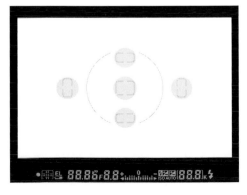

The Spot Meter uses the small 2.3 mm circular area surrounding the active AF sensor to measure light for exposure calculation.

Hint: It is essential to remember that every TTL metering system measures reflected light, and is calibrated to give a correct exposure for a mid-tone gray. When using the Spot Meter, you must make sure that the part of the scene you meter represents a mid-tone, otherwise you will need to compensate the exposure value.

Hint: In Dynamic Area AF, the D70 will attempt to follow a moving subject and may shift focus control between any of the five AF-sensor areas. If this occurs, the Spot Metering also shifts, following the active AF-sensor area. If in doubt switch to Manual focus as the D70 will always use the active AF-sensor area for Spot Metering.

Exposure Modes
The D70 has four, principle exposure modes in addition to the Digital Vari-Program modes offered by the camera (see page 50 for more information).

The Mode Dial

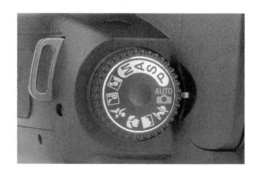

To select an exposure mode, turn the Mode Dial on the left top of the camera to the required position (P, A, S, or M).

Note: For P, A, or S modes to operate, you must have a CPU lens attached to the camera. Attaching a non-CPU lens will cause **F‑ ‑** to appear in the Viewfinder Display and Control Panel. The Shutter Release Button is also disabled. You can use Manual Exposure Mode with non-CPU lenses and set the aperture value via the aperture ring on the lens. However, the TTL metering system of the D70 will not work.

With Program Mode and Matrix metering you will get good exposures even with subjects of slightly unusual reflectance such as this.

P—Auto Multi-Program: Program Mode (P), as it is often referred to, automatically adjusts both the shutter speed and lens aperture to produce a correctly exposed image. The combination of settings is based upon the meter reading and analysis of predetermined values stored in the camera. The D70 also takes into consideration the focal length of the lens, which it divides into three broad groups, wide-angle/standard (<70mm), short/medium telephoto (70-200mm), and telephoto (>200mm). Using this information the D70 will keep the lens open at its maximum aperture until a threshold shutter speed can be attained; thereafter the aperture and shutter speed values are increased together. For wide-angle/standard focal lengths, the threshold speed is 1/8 second, for short/medium telephoto it is 1/125 second, and for telephoto it is 1/1000 second.

If you decide that a particular combination chosen by the camera is not suitable, you can override the Program Mode settings by turning the Main Command Dial when the camera meter is activated. ▣ appears in the Control Panel, but there is no indication in the Viewfinder that you have over-ridden the mode, other than the altered shutter speed and aperture values. The two values change in tandem, so the overall exposure remains the same (increasing the shutter speed decreases the aperture).

Hint: If you override the Program Mode it will remain locked to its new settings for shutter speed and aperture, even if the meter auto-powers off, and is then switched on again by pressing the Shutter Release Button halfway. To cancel the override, you must change the exposure mode, turn the power switch to OFF, or perform a camera reset.

Hint: In my opinion, Program Mode is little better than the Digital Vari-Program modes because you relinquish control of exposure to the camera. If you want to make informed decisions about shutter speed and aperture for creative photography, do not use Program Mode!

A—Aperture-Priority Auto Exposure: In this mode the photographer selects an aperture value and the D70 will choose a shutter speed to produce an appropriate exposure. The aperture is controlled by the Sub-Command Dial (default) and is changed in increments of 1/3-stop (default). The shutter speed the D70 selects will also change in increments of 1/3-stop (default).

S—Shutter-Priority Auto Exposure: In this mode the photographer sets the shutter speed and the D70 automatically chooses the aperture to produce an appropriate exposure. The shutter speed is controlled by the Main Command Dial (default) and is changed in increments of 1/3-stop (default). The aperture value the D70 selects will also change in increments of 1/3-stop (default).

*The rubber eyecup
must be removed
before the DK-5 cover
can be fitted to the
viewfinder eyepiece.*

Hint: If you use the D70 remotely, without having your eye
to the viewfinder when you make an exposure, as you would
when taking a self-portrait or using the ML-L3 Remote Con-
trol to release the shutter, you must cover over the
viewfinder eyepiece. The metering sensor of the D70 is
located within the viewfinder-head; therefore, light entering
the viewfinder eyepiece will affect exposures made in P, A,
and S, modes. Nikon supplies the D70 with the DK-5 eye-
piece cover for this purpose, but to use it the rubber eyecup
fitted on the camera must be removed first. Personally, I find
attaching the DK-5 a fuss, so I keep a small square of thick,
black felt fabric in my camera bag, and drape this over the
camera to block light from the viewfinder eyepiece.

M—Manual Exposure: This mode offers the photographer total
control over exposure, and is probably the most useful if you
want to learn more about the effect of shutter speed and aper-
ture on the final appearance of your pictures. You choose and
control both the shutter speed (Main Command Dial) and lens
aperture (Sub-Command Dial), while an analog display shown
in the viewfinder indicates the level of exposure your settings
would produce.

Note: The priority of the two command dials can be changed
via Custom Setting-14.

Auto-Exposure Lock

If you take a meter reading in any of the three auto-exposure modes, P, A, or S, and recompose the picture after taking a reading, the metering area will now fall on an alternative part of the scene and produce a different exposure value.

The D70 allows you to lock the initial exposure reading while you reframe and take the picture. Start by positioning the part of the scene you want to meter within the appropriate metering area (one the five AF-sensor area brackets for Spot Metering, and the center AF-sensor bracket for Center-Weighted Metering), press the shutter release half way to acquire a reading, and then press and hold the **AE-L/AF-L** Button. You can now recompose and take the picture at the metered value.

Note: **EL** will appear in the Viewfinder Display while this function is active.

Hint: While this function works with all three metering modes, it is generally most effective with Center-Weighted and Spot Metering. These two modes are most useful in difficult lighting conditions, when a more accurate exposure reading can be to taken from a specific area of the scene, which may otherwise 'fool' Matrix metering.

Exposure Compensation

As with all TTL metering systems, the D70 works on the assumption that it is pointed at a scene with a reflectivity equivalent to mid-gray. But what does mid-gray equate to? I have it on good authority from senior engineers at Nikon that contemporary Nikon camera meters are calibrated to their own "in-house" standard. Nikon does not calibrate to either the American National Standards Institute (ANSI) standard. As a consequence, if you take a picture of a Kodak 18% gray card and look at the histogram produced by the D70, you will see the tonal peak is left-of-center (i.e. underexposed). Although subjective, my tests would indicate that the Nikon calibration target has an equivalent reflectivity of about 14% to 15%, in other words approximately 1/3-stop less than 18% gray. So bear in mind that if you use a gray

card to check your exposure readings you need to adjust the exposure by about + 1/3-stop.

Many scenes will not reflect 14% to 15% of the light falling on them. For example a landscape under a blanket of fresh snowfall is going to reflect far more light than a mountain covered with black volcanic rock. Unless you compensate your exposure, both the snow and rock will be reproduced as mid-gray in your pictures.

To set a compensation factor hold down the Exposure Compensation Button, located to the rear and right of the shutter release button. Turn the Main Command Dial until the required value is shown in the Control Panel. The value is also displayed in the viewfinder while the button is held down.

The Exposure Compensation Button is to the right and rear of the Shutter Release Button.

Note: The value will change +/- by increments of 1/3 or 1/2-stop depending on which increment you have selected in CS-9.)

In Manual Exposure Mode, the mid '0' point of the analog display "shifted" so that it accounts for the compensation factor you have set. If you adjust the exposure settings so the display is set to the mid '0' the exposure will actually be made with the compensation applied. If you push and hold the Button, the analog display reverts to showing what the exposure value would be without the compensation factor.

Once you have set a compensation factor it will remain locked until you hold down the Exposure Compensation Button and reset the value to 0.0.

Automatic Exposure Bracketing

It is important when shooting digital pictures to expose as accurately as you can. Overexposure causes the loss of highlight detail and underexposure degrades image quality due to electronic noise and lack of detail in dark areas.

The TTL meter of the D70 is very effective but not infallible. To increase the chances of getting the most ideal exposure in difficult lighting conditions, it is often wise to bracket exposures (take a series of pictures at slightly different settings).

The automatic bracketing system in the D70 allows you to take a sequence of two or three exposures varied by increments of 1/3-stop or 1/2-stop. It also has a feature to bracket white balance for images shot in the JPEG standard. However, exposure and white balance values cannot be bracketed simultaneously.

The Bracketing button is on the back of the camera in the upper left corner.

To set the bracketing function hold down the ⓑⓚⓣ button and turn the Main Command Dial until ⒷⓀⓉ appears in the Control Panel. Bracketing is now active. Next, you need to instruct the D70 on how many exposures to take and what incremental change to make. Hold down the ⓑⓚⓣ button and rotate the Sub-Command Dial until your required selection appears in the Control Panel.

Use Custom Setting-9 to select the required increment. Nikon rounds increments of a third stop to 0.3, and two-thirds stop to 0.7. Custom Setting-13 can be used to alter the order in which the various exposure values are taken.

To switch bracketing off, press and hold the **BKT** button then turn the Main Command dial so **BKT** no longer appears in the Control Panel.

Custom Setting-9 (EV step)	Control panel display	No. of shots	Exposure increment	Bracketing order (EVs)
	3F 0.3 +◀▮▶-	3	±⅓ EV	0, –0.3, +0.3
	3F 0.7 +◀▮▶-	3	±⅔ EV	0, –0.7, +0.7
	3F 1.0 +◀▮▶-	3	±1 EV	0, –1.0, +1.0
	3F 1.3 +◀▮▶-	3	±1⅓ EV	0, –1.3, +1.3
	3F 1.7 +◀▮▶-	3	±1⅔ EV	0, –1.7, +1.7
	3F 2.0 +◀▮▶-	3	+2 EV	0, –2.0, +2.0
	+2F 0.3 +◀▮	2	+⅓ EV	0, +0.3
	+2F 0.7 +◀▮	2	+⅔ EV	0, +0.7
1/3 step (default)	+2F 1.0 +◀▮	2	+1 EV	0, +1.0
	+2F 1.3 +◀▮	2	+1⅓ EV	0, +1.3
	+2F 1.7 +◀▮	2	+1⅔ EV	0, +1.7
	+2F 2.0 +◀▮	2	+2 EV	0, +2.0
	--2F 0.3 ▮▶-	2	–⅓ EV	0, –0.3
	--2F 0.7 ▮▶-	2	–⅔ EV	0, –0.7
	--2F 1.0 ▮▶-	2	–1 EV	0, –1.0
	--2F 1.3 ▮▶-	2	–1⅓ EV	0, –1.3
	--2F 1.7 ▮▶-	2	–1⅔ EV	0, –1.7
	--2F 2.0 ▮▶-	2	–2 EV	0, –2.0
	3F 0.5 +◀▮▶-	3	±Ω EV	0, –0.5, +0.5
	3F 1.0 +◀▮▶-	3	±1 EV	0, –1.0, +1.0
	3F 1.5 +◀▮▶-	3	±1Ω EV	0, –1.5, +1.5
	3F 2.0 +◀▮▶-	3	±2 EV	0, –2.0, +2.0
	+2F 0.5 +◀▮	2	+Ω EV	0, +0.5
	+2F 1.0 +◀▮	2	+1 EV	0, +1.0
1/2 step	+2F 1.5 +◀▮	2	+1Ω EV	0, +1.5
	+2F 2.0 +◀▮	2	+2 EV	0, +2.0
	--2F 0.5 ▮▶-	2	–Ω EV	0, –0.5
	--2F 1.0 ▮▶-	2	–1 EV	0, –1.0
	--2F 1.5 ▮▶-	2	–1Ω EV	0, –1.5
	--2F 2.0 ▮▶-	2	–2 EV	0, –2.0

Exposure Bracketing Considerations:

- Using ⓢ Single-frame Mode, you have to press the Shutter Release Button to make exposure in the bracketing sequence. If you have set a three-shot sequence and $3F0.3$+◄■▶− is displayed in the Control Panel, a new sequence is ready to be taken. If you have set a two-frame sequence and either $+2F0.3$+◄■ , or $+2F1.0$+◄■ appears in the Control Panel, then, again a new sequence is ready to be taken. If the icon has any other configuration it indicates you are part way through a sequence.

- If you set the D70 to Continuous Mode, then press and hold the Shutter Release Button down, the camera will only take the number of frames specified in the bracket sequence. The camera stops regardless of whether the shutter release continues to be depressed.

- If you turn the D70 OFF, or have to change the memory card during a bracketing sequence, the camera remembers which exposure values are outstanding, so when you turn the camera ON, or insert a new memory card, the sequence will resume from where it stopped.

- You can combine a bracketing sequence with a fixed exposure compensation factor. For example, if you apply an exposure compensation of +1.0EV to deal with a scene such as a snow covered landscape that comprises predominantly of light tones, and then set a bracket sequence of $3F1.0$+◄■▶− three-frames at an increment of 1-stop, the actual exposures you make will be at, 0, +1EV, and +2EV.

- In Manual (M) Exposure Mode the D70 alters the shutter speed to achieve the variation in exposure. It is not possible to have the camera vary the lens aperture in this exposure mode.

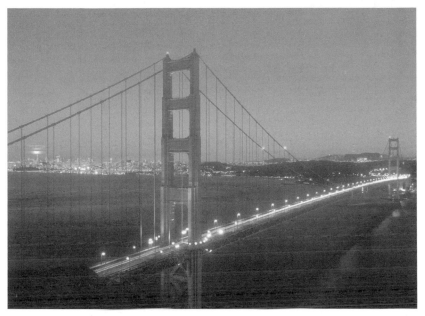

By using a smaller aperture (higher f/stop number) you will extend the depth of field in the photo and optimize sharpness of all the elements in the scene.

Aperture and Depth of Field

When a lens brings light to focus on a camera's sensor there is only ever one plane-of-focus that is critically sharp. However, in the two dimensional picture produced by the camera, there is a zone in front of and behind the plane-of-focus that is perceived to be sharp. This area of apparent sharpness is often referred to as the depth of field, and its extent is influenced by the camera-to-subject distance together with the focal length and aperture of the lens in use.

If the focal length and camera-to-subject distance are constant, depth of field will be shallower with large apertures (low f/ numbers) and deeper with small apertures (high f/ numbers). If the aperture and camera-to-subject distance are constant, depth of field will be shallower with a long focal length (telephoto range) and deeper with shorter focal

length (wide-angle range). If the focal length and aperture are constant, depth of field will be greater at longer camera-to-subject distances and shallower with closer camera-to-subject distances.

Depth-of-field is an important consideration when deciding on a particular composition as it has a direct and fundamental effect on the final appearance of the picture.

Depth-of-Field Preview: In order that the viewfinder image is as bright as possible for composing, focusing, and metering, modern cameras such as the D70 operate with lenses automatically set to their maximum aperture. The iris in the lens does not close down to the shooting aperture until after the shutter release has been pressed and the reflex mirror has lifted, just a fraction of a second before the shutter opens. However, this means that the image you see in the Viewfinder appears as if the photograph were to be taken at the maximum aperture. To assess the depth of field visually, you must close the lens iris down to the shooting aperture.

The circular Depth-of-field Preview Button is located beside the lens mount on the front of the D70.

The D70 has a depth-of-field preview button, which when pressed stops the lens down to the selected shooting aperture, allowing you to see the effect the aperture has on the depth-of-field. The viewfinder image will become darker as less light passes through the lens when the iris is closed down.

Hint: At apertures of f/11 or smaller, the viewfinder image will become very dark and difficult to see, even with brightly lit scenes. It is often better to make a general assessment of depth of field at f/8, and then stop down further to the aperture required for the final image.

Depth-of-Field Considerations: Probably the most important consideration concerning depth of field is that it is less for images shot on a D70 than those shot on a film camera. This is due to the smaller size of the sensor in the D70 (23.7 x 15.6mm) compared with a 35mm film frame (24 x 36mm); the digital picture must be magnified by a greater amount compared with 35mm film to achieve any given print size. Therefore, at normal viewing distances, detail that appears to be sharp in a print (i.e. within the depth of field) made from a film-based image may no longer look sharp in a print of the same dimensions made from a digital file. If you use the depth-of-field values given in tables for lenses used with 35mm film, you will find they do not correspond to images shot on the D70, assuming the same camera-to-subject distance and focal length apply. To guarantee that the depth of field in pictures taken on the D70 is sufficiently deep, use the values for the next larger lens aperture. For example, if set your lens to f/16, use the depth-of-field values for f/11 with the D70.

Apart from setting a small aperture (large f/number) to maximize depth of field in a landscape picture, it is worth remembering that at mid to long focus distances the zone of apparent sharpness will extend about 1/3 in front of the point of focus and 2/3 behind it. Therefore, by placing the point of focus about a third of the way into your scene you will maximize the coverage of the depth of field of the shooting aperture.

In portrait photography, is often preferable to render the background out-of-focus so it does not distract from the subject(s). The simplest way to achieve this effect is to use a longer focal length lens (a short telephoto of 70 to 105mm is ideal) in combination with a large aperture (low f/ number). You can assess the effect using the camera's depth-of-field preview feature.

In close-up photography, depth of field is limited, so convention suggests you set the lens to its minimum aperture (largest f/ number) value. However, I strongly recommend that you avoid doing this, because the effects of diffraction at, or near the minimum aperture of a lens cause a significant loss of image sharpness. Generally, you will achieve superior results at an aperture one-stop wider than the minimum value.

Note: It is likely that, even in good light, the shutter speed will be rather slow when shooting with a small lens aperture, so consider using a tripod or other camera support whenever possible.

Unlike the distribution of the depth-of-field zone for mid to long focused distances, at very short distances the depth of field extends by an equal amount in front of and behind the plane of focus. By placing the plane of focus with care you can use this fact to further maximize depth of field. Once again the camera's depth of field preview button will allow you to preview the depth of field in your composition.

Shutter Speed Considerations

If you handhold your camera, it is worth remembering a rule of thumb concerning the minimum shutter speed that is, generally, sufficient to prevent a loss of sharpness due to camera shake. Take the reciprocal value of the lens focal length (mm), and use this as the slowest shutter speed with that lens. For example, with a focal length of 200mm, set a minimum shutter–speed of 1/200th second.

Note: Longer focal length lenses, and higher subject magnification in close-up photography, amplify the effects of camera shake.

The shutter speed can be used for creative effect because it controls the way that motion is depicted in a photograph. Generally, fast shutter speeds are used if you wish to freeze motion in sports or action photography. Slower shutter speeds (1/30th second or longer) can be used to introduce a degree of blur that will often evoke a greater sense of movement than a subject that is rendered pin-sharp. Alternatively, you can pan the camera with the subject so that it appears relatively sharp against an increased level of blur in the background.

If you want a moving element to "disappear" in a picture of a static subject, a very long shutter speed of several seconds or more can often be very effective. While the subject is rendered properly, the moving element does not record sufficient information in any part of the frame to be visible. So next time you want to take a picture of a famous building and exclude the visitors from cluttering up your composition you know how!

Metering

If the D70 is your first digital SLR camera, and your previous photography has been done with a 35mm camera and color negative film, you may find controlling exposure with the D70 rather more demanding. Color negative (print) film is very tolerant to exposure errors, particularly overexposure. The automated processing machines used to produce your prints are capable of correcting exposure errors over a range of –2 to +3 stops while adjusting color balance at the same time. The chances are that you never saw your exposure errors when looking at finished prints!

Controlling exposure with a digital SLR is analogous to shooting transparency (slide) film—there is virtually no margin for error. Even moderate overexposure will blow out highlight detail, leaving no usable image data in these areas. The Matrix

Metering system of the D70 will attempt to hold highlight detail, but images can appear to lack contrast (look flat) and be underexposed. The easiest way of rectifying this issue is to make adjustments to the image data using a curve control in an image processing program such as Adobe Photoshop.

The Histogram and Highlights

The D70 has two very useful features that allow you to evaluate exposure after a picture has been taken.

What is a Histogram? The histogram is a graphical display of the tonal values recorded by the camera. The horizontal axis represents brightness, with dark tones shown to the left and bright to the right. The vertical axis represents the number of pixels that have that specific brightness value.

To display the histogram page, first take a picture. Press the ▣ button to switch on the LCD Monitor. The last recorded image will be shown. Now press ▶ on the Multi-selector switch and scroll through the pages until the histogram is shown superimposed over the image.

Assessing the Histogram: The shape and position of the histogram curve indicates the range of tones that have been captured in the picture. Dark tones will be distributed to the left of the histogram graph and light tones to the right. In a picture of a scene containing an average distribution of tones from dark shadow through mid-tones to bright highlights, the curve will start in the bottom left corner, slope upwards and then curve down to the bottom right corner. In this case a wide range of tones will have been recorded.

If the curve begins at a point some way up the left or right side of the histogram display, so the curve looks as though it has been cut off abruptly, the camera will not have recorded tones in either the shadows (left side) or highlights (right side), probably because the contrast level in the scene was beyond the capabilities of the camera. For example, an area of deep shadow in an otherwise brightly lit scene will hold no data and be recorded as solid black.

The histogram for a picture such as this, composed mainly of mid-tones, will be an evenly sloped curve that is predominantly in the mid-section of the graph.

Generally, controlling exposure to retain highlight detail is more important than capturing perfect detail in shadow areas. If the histogram curve is weighted heavily toward the right side of the graph and is cut-off at a point along the right-hand vertical axis, highlight data will have been lost. In this case reduce the exposure until the right-hand end of the curve stops on the bottom axis before it reaches the vertical one. Conversely, if shadow detail is important, make sure the curve stops on the bottom axis before it reaches the left-hand vertical axis.

Obviously not all scenes contain an even distribution of tones, because they have a natural predominance of light or dark areas. In these cases the histogram curve will be biased to the right (light scenes) or the left (dark scenes). However, provided the histogram curve stops on the bottom axis, before it reaches either end of the graph, the image will retain a full range of the highlight or shadow tones.

Scenes that are low in contrast will have a curve that appears as a rather narrow 'spike', and ends short of either the left or right-hand end of the bottom axis. You have two

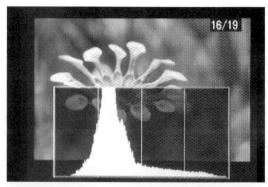

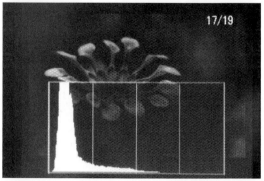

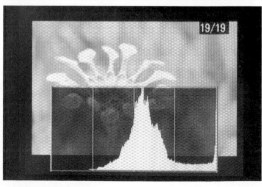

choices as to how to deal with this situation, either use the Tone Compensation function within the Custom option of the Optimizing Image control (see page 82 for further details) to have the contrast control performed by the camera, or adjust the contrast level at a later stage in an image processing application.

The three pictures shown opposite represent a range of exposures:
- Properly exposed (top), the left and right hand ends of the curve stop on the bottom axis at or closely approaching either side of the graph, indicating that all tones have been recorded.

- 2-stops underexposed (middle), the curve is heavily biased with a large peak on the left side and no graph on the right. This indicates that virtually no light tones were recorded. In this case, noise is likely to be emphasized.

- 2-stops overexposed (bottom), the curve is biased to the right half of the graph, with no exposure of dark tones and an extra peak that cuts-off on the right axis, showing that highlight detail will be "blown out" (not recorded). Such areas will appear pure white in the picture.

Highlights: Another of the information pages available when reviewing an image in the LCD Monitor is the Highlights function. This shows the location within the picture of pixels that have exceeded a threshold value by causing them to flash. If a significant area, or areas of the image flashes, you have probably overexposed the entire picture, and at the very least will have lost highlight detail. You will need to reduce exposure by setting a lower ISO value, a smaller (larger f/number) lens aperture, or a faster (shorter) shutter speed.

Digital Infrared Photography
Black-and-white infrared pictures typically exhibit a course grain, with glowing white highlights and solid black shadows, particularly those shot on Kodak's HIF film. It is possible to replicate this effect with the D70.

Many digital cameras have the ability to record light beyond the limits of the spectrum visible to the human eye, particularly in the region of near Infrared (IR) around a wavelength of 780nm (one nanometer = one millionth of a millimeter). Camera designers' work hard to exclude IR light from digital cameras, because it adversely affects apparent sharpness, reduces the contrast in skies, and can reveal unappealing features of skin that would otherwise not be visible.

The D70 and IR: The filter array in front of the D70's CCD includes a filter designed to reduce the transmission of IR light; it is this filter that produces the green tint when you look at the CCD in the camera. Although Nikon has reduced the sensitivity of the D70 to IR, it is still capable of recording IR light. First, you will need an IR filter to exclude most if not all the visible spectrum. These are available with a variety of different "cut-off" points (the wave length below which they do not transmit light), from several manufacturers (see table on next page). You will need to mount the camera on a tripod due to the relatively long exposure times that will be required even in bright sunlight, because these filters are either semi-opaque, or totally opaque to visible light.

The most favorable time for IR photography is on a bright sunny day, because the level of IR light will be significantly higher compared with overcast conditions. To compensate for the fact that IR light is focused in a different plane than visible light, stop the lens down to a small aperture (f/11 – f/16). Set the white balance to Direct Sunlight, and switch to manual focusing. Mount the camera to a tripod, compose the shot and lock the tripod head. Then attach the IR filter.

IR Filters: Generally, it is best to use an IR filter with a low cut-off point, such as the Heliopan RG695 (695nm), or Kodak Wratten 89B (695nm), because they transmit sufficient visible light to allow the D70's exposure meter to function accurately. Although you will be able to see very little, if anything, through the viewfinder, adjust the shutter speed to obtain a 'correct' exposure. Finally, release the shutter.

The picture will have a strong red cast but this can be corrected at a later stage in an image processing application.

Using a darker IR filter such as a Kodak Wratten 87 (780nm) reduces the red cast but requires the exposure to be increased by anything up to three or four stops, since filters of this type remove virtually all the visible light. Consequently, you should not rely on the reading suggested by the D70's exposure meter. The D70 will even respond with a visually opaque filter such as a Kodak Wratten 87C (830nm), but exposures become impracticably long with a distinct risk of causing hot pixels.

Hint: For shutter speeds in excess of one second it is advisable to set the Long Exposure Noise Reduction option to ON in the Shooting Menu (Note: image processing times will increase by more than double). The default setting is OFF.

Here is a list of some of the IR filters that are available from various manufacturers:

IR Filters

Filter Designation	Wavelength Cut-off (nm)	Manufacturer
RG695	695	Heliopan
89B	710	Kodak
BW092	710	B&W
IR72	720	Hoya
RG780	780	Heliopan
87	780	Kodak
87C	830	Kodak

Resetting Default Values

If you want to restore settings on the D70 to their default values, press and hold the 📷 and 🔲 buttons. The green dots beside each button are a reminder of their function for this feature.

Note: Options selected in the Custom Setting menu are not affected by this action.

The green dots next to the *and* BKT *Buttons signify that you can press both simultaneously to return to the D70's default settings.*

Option	Default
Shooting mode	Single frame[1]
Focus area	Center[2]
Metering	Matrix
Flexible program	Off
AE hold	Off[3]
Exp. Comp	+/- 0
Bracketing	Off

1. Mode is not reset in self-timer and remote control options

2. Not reset if Closest Subject is selected in CS-3

3. CS-15 (AE-L/AF-L) is not affected

Flash Sync Mode:

Option	Default
P, A, S, M	Front-Curtain Sync
🔄 🧑 🌷	Auto front-Curtain Sync
👤	Auto Slow Sync
Flash comp.	Off
FV Lock	Off[4]
LCD	Off

4. CS-15 (AE-L/AF-L) is not affected

Shooting Menu Options:

Option	Default
Image Quality	JPEG Normal
Image Size	Large
White Balance	Auto[5]
ISO	200
Optimize image	Normal

5. Fine tuning set to 0

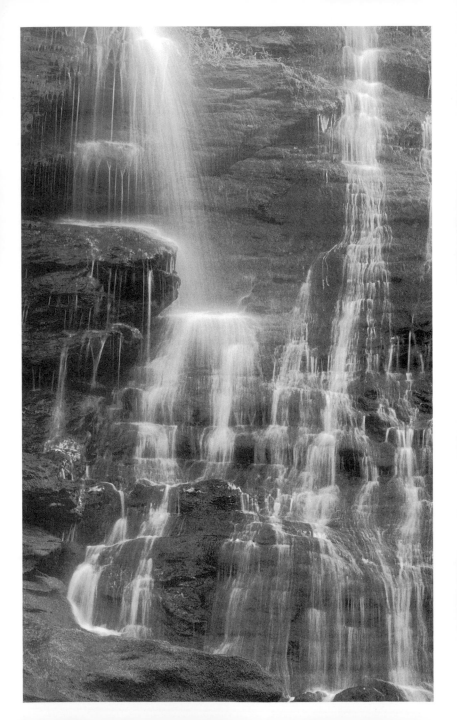

Menus and Custom Settings

The D70 makes extensive use of a menu system that is displayed on the LCD monitor. It is divided into four sections:

1) **Set-up Menu**—is used to establish the basic configuration of the camera.

2) **Shooting Menu**—is used to select more sophisticated camera controls.

3) **Playback Menu**—is used for managing the pictures stored on the memory card.

4) **Custom Settings Menu**—is used to select and set specific controls to fine tune camera operations.

To access any menu, push the [MENU] button and press ⊙ on the Multi Selector Switch to highlight one of the four tabs used to identify each menu: ♀ Setup Menu, ◘ Shooting Menu, ▶ Playback Menu, and ⊘ Custom Settings. Highlight the required menu tab by using the ⊙ and then press ⊙ to open it. You navigate to the specific option by using ⊙ on the Multi Selector Switch.

Note: Both the Custom Setting and Setup menus have multiple pages. Keep scrolling up or down using the Multi Selector Switch.

Many of the controls within the menu system are duplicated on the D70 and can be set by using buttons and dials located on the camera body. Where such an alternative route

↰ *The D70 allows you to tailor camera functions to your personal style of photography using its Custom Settings menus. The camera even offers a Help button that displays a brief explanation of each Custom Setting on the LCD Monitor.*

is available, I would recommend using it because this will reduce battery power consumption.

In this section I will deal with those features and functions controlled by the various menus that have not been discussed elsewhere in this book, and give page references to more detailed descriptions for the remainder.

Setup Menu

Folders

The D70 uses a folder system to organize images stored on the camera's memory card. If you do not use any of the options pertaining to folders, the camera creates a folder named 100NCD70 (abbreviated to NCD70 in the menu) in which the first 999 pictures stored on the card will be placed. If you were to exceed 999 pictures, the D70 creates a new folder named 101NCD70, and so on for each set of 999 pictures.

You can create your own folder(s), although their name will always be prefixed by a three digital number assigned by the camera, and be limited to a five-character title.

If you use multiple folders, you must select one as the active folder to which all images will be stored until an alternative folder is chosen or the active folder capacity of 999 pictures is exceeded, in which case the D70 will create a new folder using the same five-character suffix and assign a three-digit prefix with an incremental increase of one (e.g. if folder 100SPORT becomes filled, the D70 creates folder 101SPORT and pictures will now be stored in this new folder).

Folders can be renamed if you wish and empty folders can be deleted.

Hint: Folders may be useful if you expect to take pictures of a variety of subjects (i.e. you go away on a tour of Europe and want to file your images on the memory card location-by-location. You can create a folder for each location and select this as the active folder accordingly).

Hint: Personally, I find that using multiple folders is time consuming, potentially confusing, and fraught with danger! If you have more than one D-SLR camera and move cards between them, the individual cameras will not be able to handle images in folders created by another camera. If the second camera then creates a new folder, it will have a higher prefix number than the folder created by the first camera. Even multiple folders created by the D70 can present problems, as images will be saved to the currently selected folder with the highest prefix number. I would rather use a browser application such as Nikon View to transfer and organize my images.

File Number Sequence

Using this option you can specify when the D70 resets file numbers. There are three alternatives:

OFF—file numbers are always reset to 0001 whenever a new folder is created, when the memory card is formatted, or a new storage card is inserted in the camera.

ON—File numbers increase incrementally from the last number used until they reach 9999 whenever a new folder is created, when the memory card is formatted, or a new storage card is inserted in the camera. At this point a new folder is created and file numbering begins again from 0001.

Reset—similar to ON, except the next image taken is assigned a file number by adding one to the highest file number in the current folder. If the selected folder contains no pictures the file numbering is reset to 0001.

To select the File Sequence Numbering, highlight the option in the Setup Menu and press ⊙ on the Multi Selec-

tor Switch. Navigate to your chosen option and press ⊙ on the Multi Selector Switch to set it.

Format
See page 42 for detailed information.

CSM menu
This option allows you to select either the *Simple* (short) or *Detailed* (full) lists of the Custom Settings. See pages 145-146 for more information.

Date
See page 39 for detailed information.

LCD Brightness
To adjust the brightness of the LCD Monitor, highlight *LCD brightness* and press ⊙ on the Multi Selector Switch. This displays a gray scale and the current brightness setting. To adjust this, press ⊙ on the Multi Selector Switch.

Note: Since visual assessment of the image is unreliable due to the limitations of the LCD Monitor, this control is probably best left set to its default value of 0.

Mirror Lock-Up
See page 45 for detailed information.

Video Mode
Use this mode to select the video standard that matches your video device (i.e., a television or VCR). You can select either NTSC or PAL. (See page 200 for more details.)

Language
See page 38 for detailed information.

Image Comment
This option allows you to attach a brief (maximum 36-charater) comment to each image. Highlight *Image comment* and press ⊙ on the Multi Selector Switch. Then highlight *Input comment* and press ⊙ on the Multi Selector Switch

to open a page that displays the character set and a dialog box. To move the cursor around the dialog box, press ⬚ and rotate the Main Command Dial. Use the Multi Selector Switch to highlight the desired character and press ⬚ to enter that character into the comment field. To delete a character at the current cursor position, press the ⬚ button. Once you have composed the comment, press the ⬚ button, which returns you to the image comment menu.

To attach the comment to all subsequent images, highlight *Attach comment* and press ⊙ on the Multi Selector Switch. A checkmark will appear in the box next to *Attach comment*; then highlight *Done* and press ⊙ on the Multi Selector Switch to confirm the setting.

If you do not want the comment to be attached, uncheck the box next to *Attach comment*, highlight *Done*, and press ⊙ on the Multi Selector Switch to confirm the setting.

Hint: It would be very time consuming to change the comment on a regular basis; therefore you will probably want to settle on a universal comment that identifies the image as belonging to you, for example, © Simon Stafford 2004.

USB
See page 201 for detailed information.

Dust Reference Photo
This is used to acquire a reference frame that can be applied in the Image Dust Off function available in Nikon Capture 4.1 or later. You must have a CPU lens attached to the camera (Nikon recommends a focal length of 50mm of more).

Highlight *Dust ref photo* and press ⊙ on the Multi Selector Switch. This will display two options: Yes and No. Highlight *Yes* and press ⊙ on the Multi Selector Switch (select *No* and press ⊙ on the Multi Selector Switch to exit the function). A message will be displayed on the LCD Monitor, *Take photo of white object 10cm from lens,* and **rEF** will be shown in the Control Panel and the Viewfinder

Display. At this point, either pressing the button or turning off the monitor or power will cancel the function.

Point the lens at a bright, featureless target approximately 4 inches (10 cm) from the camera, ensuring that no shadow is cast on the target area. Then press the Shutter Release Button halfway (in Auto Focus Mode the lens will automatically shift to infinity; in Manual Focus Mode you must manually adjust the camera to infinity). Depress the shutter release button to make the exposure. If the target is too bright or too dark, the shutter will not operate and a warning message— *EXPOSURE SETTINGS NOT APPROPRIATE*—will be shown on the LCD Monitor. In this case, find an alternative target, and repeat the procedure.

The Dust Off Reference file shown below will be displayed on the LCD Monitor:

Firmware Version

To check the current version of the firmware installed on your D70, highlight *Firmware Ver.* and press ⊙ on the Multi Selector Switch. Press ⊙ on the Multi Selector Switch to return to the Setup menu.

138

Image Rotation

At its default setting the D70 will record, in the order taken, the orientation of the camera at the time of each exposure. The images will be displayed in the correct orientation when reviewed on the camera or observed within Nikon View and Nikon Capture software. This option can be switched off, if desired, when taking pictures with the lens pointing up or down, because in these circumstances the camera may not record the correct orientation.

To disable this function, highlight *Image rotation* and press ⊙ on the Multi Selector Switch. Highlight OFF by pressing ⊙ and then press ⊙ on the Multi Selector Switch.

Shooting Menu

Most of the Shooting Menu controls have been dealt with elsewhere; the relevant page numbers are given below as a reference.

Optimize Image

See page 80 for detailed information.

Long Exposure Noise Reduction

Although the D70 processes all images with an automatic noise reduction feature, for exposures in excess of one second a further control can be selected manually. In the Shooting Menu highlight *Long Exp. NR* and select ON followed by pressing ⊙ on the Multi Selector Switch to set it.

When this horizontal picture was made, the camera recorded its shooting position. This assures that it will be oriented properly when viewed on the camera's LCD Monitor or in the computer using Nikon View software.

After a picture has been taken, **Job nr** appears flashing, in both the Control Panel and Viewfinder Display, while the image data is being processed. During this time the shutter release is disabled. As soon as **Job nr** is no longer displayed, the shutter becomes active again.

Image Quality
See pages 73-76 for detailed information.

Image Size
See pages 73-76 for detailed information.

White Balance
See page 76 for detailed information.

Sensitivity (ISO)
See page 104 for detailed information.

Playback Menu

There must be a memory card inserted in the camera for the Playback Menu to be displayed. Many of the Playback Menu controls have been dealt with elsewhere.

Delete Images

This option allows you to delete images, either as a group or on selected images. It is therefore much quicker than deleting images individually. Highlight *Delete* in the Playback Menu and press ⊙ to select it. You have the option of deleting a selected set of images or deleting all the images in the selected folders in the Playback folder menu.

If you choose to select individual pictures, highlight *Selected* and up to six images will be displayed on the LCD Monitor. A yellow frame will surround one picture to highlight it. Use ⊙ to scroll through the images, and ⊙ to mark an image for deletion. Repeat this process for each image until all the required images are marked. Press the ⊞ button and a page will appear showing the total number of images to be deleted (shown in red), together with a *Yes/No* option to confirm the delete command. You will see this same page displayed with the same *Yes/No* option to confirm the delete command, if you select *All* in the Delete page.

Playback Folder

You can choose to have only those images in the current folder available for playback, or alternatively select images in all folders to be available.

Highlight *Playback fldr* in the Playback Menu and press ⊙ to select it. This will display a page with two options: *Current* and *All*. Highlight your chosen option and press ⊙ to select it. *Current* will display images in the folder currently selected for image storage. All will allow you to playback images in all folders created by cameras that comply with the Design Rule for Camera File System (DCF), which includes all Nikon digital cameras.

Rotate Tall

Use this option if you want to rotate pictures shot in the vertical (portrait) orientation to be displayed vertically on the LCD Monitor. Highlight *Rotate tall* and press ⊙ to select it. Highlight either *Yes* or *No*, and press ⊙ to set the option.

Hint: Due to the dimensions of the LCD Monitor, and the 3:2 aspect ratio of the full frame area, a picture displayed in the vertical orientation will be two thirds the size of one displayed in the horizontal orientation. Therefore, you may prefer to use the auto rotate command within Nikon View to perform this action once you have imported the images into your computer.

◁ *One of the best ways to improve pictures when shooting outdoors is by using a circular polarizing filter. In this case, a polarizer helped to accentuate the white cumulus clouds by deepening the blue sky and increasing the sky contrast.*

Slide Show Selections

To	Press	Description
Go forward or back one frame	(multi selector)	Press multi selector up to return to previous frame, down to skip to next frame.
View photo info	(multi selector)	Press multi selector left or right to change photo info displayed during slide show
Pause	ENTER	Press ENTER to pause slide show.
Exit to playback menu	MENU	Press MENU to end slide show and display playback menu.
Exit to playback mode	▶	Press ▶ to end slide show and return to playback with current image displayed in monitor
Exit to shooting mode	Shutter release	Press shutter-release button halfway to end slide show, turn monitor off, and return to shooting mode.

Slide Show

Images stored on the memory card can automatically be displayed in sequence. For a user-defined duration Highlight *Slide show* in the menu and press ⊙ to select the option. This opens a page with two further options: *Start* and *Frame intvl*. Selecting *Start* begins a slide show of all images in the folder selected in the Playback Fldr Menu. Pictures are shown in the order in which they were recorded, with a short pause between them. During the course of the slide show a number of operations can be performed:

After the last image has been displayed, or the ENTER button is pressed to pause the playback, a dialog box appears in the LCD Monitor showing two further options; press the ⊙ on the Multi Selector Switch to select *Restart* or *Frame Intvl*. To exit the slide show and return to the Playback Menu, press ⊙ on the Multi Selector Switch, or the MENU button.

To adjust the duration of display for each image, select *Frame Intvl* and scroll to the required time (2, 3, 5, or 10 seconds) to highlight it, and then press ⊙ to set the desired time.

Hide Image

The Hide Image option is used to conceal or reveal selected photographs. Any image that is concealed can only be viewed in the Hide Image Menu, and can only be deleted by formatting the memory card. Highlight *Hide image* and press ☺ to select it. A sequence of six images from the selected folders in the Playback *Fldr Menu* will be displayed on the LCD Monitor screen. Press the ☺ on the Multi Selector Switch. This will move a yellow frame border from image to image (continue to scroll though all the images in the folders, in this way), and use the ☺ on the Multi Selector Switch to set or remove the *hide* command. To confirm the action and exit the option, press the 🄴🄽🄃🄴🅁 button.

Print Set

See page 206 for detailed information.

Custom Settings

Many of the default settings for the various functions and features of the D70 can be superseded or altered. This is achieved by using a menu of Custom Settings (CS), but you will need to scroll through the list of 26 options (25 numbered settings plus one for reset) each time you want to make an adjustment for a particular shooting situation. Because unlike other Nikon digital SLR cameras, the D70 does not offer the opportunity to create a series of "banks" of settings.

Simple Menu

In an effort to simplify and speed-up this process, Nikon saw fit to offer two different levels of Custom Setting menus. The default menu only shows the first nine options of the entire list of 26. However, I find Nikon's idea of the nine most useful options is somewhat curious, because I consider items such as the bracketing set and self-timer delay to be more important than, say, automatic ISO adjustment and increment size of exposure value steps.

Detailed Menu

To work with to the full list, select the Setup Menu Tab 🌳 and scroll to CSM Menu. Press the Multi Selector Switch to the right and highlight *Detailed,* then select it by pressing the Multi Selector Switch to the right again.

Both Simple and Detailed menus, plus all Custom Settings, are selected using the same method. To view the selected menu, press the 🔲 button and, using the Multi Selector Switch, highlight the *Custom Setting Tab* 🖉 . Click the Multi Selector Switch to the right again and then use ⊙ to scroll through the menu

Note: Both menus wrap-around in a continuous loop in both directions as you scroll—just keep pressing the ⊙ .

To select a particular Custom Setting, use ⊙ . Then to view the sub-options within the setting, click the Multi Selector Switch to the right. Highlight the desired sub-option by using the ⊙ , and click the Multi Selector Switch to the right in order to select it.

Help Button

To save you from carrying and refering to the instruction manual every time you want to know what a particular Custom Setting does, Nikon has provided a help-function that displays a brief description of each setting on the LCD Monitor. Whenever you have a Custom Setting displayed on the Monitor, just press and hold the 🔲 button located on the camera back to the left of the monitor.

Menu Reset

All 25 numbered Custom Setting Menu options have a default value. If, at anytime, you wish to cancel all your user-set Custom Settings and restore the camera to its default values, you should select CS-R (Menu reset) and highlight *Reset* and press (⊙ + OK).

Note: This only resets the Custom Setting menu, it does not restore defaults in other camera menus.

For static subjects such as this landscape, leave the camera set to the default AF-S setting so that the camera will find focus before the shutter is released.

The Custom Settings

CS-1 Beep

Operation: The D70 emits an audible, electronic beep when it has performed certain functions: during self-timer operation; when focus has been acquired in AF-S; and an exposure made with the ML-L3 remote control.

Options: **ON**—The Control Panel shows ♪ (default)
OFF—The Control Panel shows ♫̸ (camera is silent)

Suggestion: Set this option to OFF because the beep can be a distraction in many shooting situations.

CS-2 Autofocus

Operation: The D70 has two different autofocus opera-
tions: Single-servo Autofocus (AF-S) or Continu-
ous-servo Autofocus (AF-C). The Control Panel
displays either AF-S or AF-C to indicate which
mode is active.

Options: **AF-S**—Single-servo AF (default)
AF-C—Continuous-servo AF (default only in the
Sports Vari-Program)

Suggestion: To make sure the camera finds focus before the
shutter is released, you will want to use AF-S,
so leave this option set to the default. The
exception is when you are shooting fast action
or sport when AF-C is probably more useful.
(For more information see page 97.)

CS-3 AF-Area Mode

Operation: The D70 has three different autofocus area
modes, which determine how the focus area is
selected in autofocus.

Options: **Single area** ⌷ —Focus area is selected manu-
ally and only this single active area is used to
find focus (Default for P, S, A, M and Close-Up
Vari-Programs).
Dynamic area —Focus area is selected
manually but the AF area shifts to follow a
moving subject.
Closest subject —The AF area with the
subject closest to the camera is automatically
selected by the camera. (Default for AUTO, Por-
trait, Landscape, Sports, Night Landscape, and
Night Portrait Vari-Programs.)

Suggestion: **1.** The default setting is probably the safest bet
for most situations since it is the most pre-
dictable method of using autofocus.

148

2. When shooting a moving subject that shifts erratically, Dynamic area is most useful as it tracks the subject by switching from the starting sensor area to the next most appropriate area, according to the subject's movement as predicted by the D70.
3. Take care when using Closest Subject Priority because it can fool the camera. If something suddenly moves in front of your main subject just as you are about to shoot, the camera will re-focus rendering the intended subject out-of-focus.

CS-4 AF Assist

Operation: The AF-assist Lamp, employed to aid the auto-focus system, lights automatically when the D70 determines that light levels are low and there is a risk that the AF system will not be able to acquire focus. However there are all sorts of limitations depending on the type of lens in use, and it has a maximum effective range of only 3m (9' 10").

Options: **ON**—Autofocus-assist Lamp functions (default)
OFF—The Lamp does not operate under any circumstances.

Suggestion: Very much a personal opinion, but I keep the lamp switched off as it is either a potential distraction, or of no value with the sort of subjects I shoot.

CS-5 ISO Auto

Operation: The D70 automatically adjusts the ISO (sensitivity) to a higher level in low-light situations. The camera displays ISO AUTO in the Control Panel and the Viewfinder Display when this option is selected, and the icon flashes as a warning that the camera has altered the ISO setting. However, there is no indication as to what ISO setting is in use! The activation of this function is also dependent on the exposure mode you have selected.

Options:	**OFF**—Auto ISO is not engaged. The camera retains the ISO (sensitivity) setting you select and will not alter it automatically (default). **ON**—Assuming certain exposure conditions, including the chosen mode, prevail and the built-in flash is not activated, the camera will shift the ISO setting upwards to cope with reduced light levels.

Suggestion: Leave it set to Off, which is the default—do not select On to utilize this function if you want to be sure of what the camera is doing. I have seen several photographers perplexed by this option, as they failed to understand why their exposures had altered, because they had not realized it had been active.

CS-6 No CF Card?

Operation: This function prevents you from believing the camera is recording pictures when in fact you have no memory card installed. In this case, the Shutter Release Button of the D70 is disabled when no memory card is in the camera. This control can be overridden to allow the camera to save pictures directly to a computer using Nikon Capture software.

Options: **Release lock**—The shutter will not operate if no memory card is installed (default).
Enable release—The shutter release will operate normally even with no memory card installed in the camera.

Suggestion: Leave this option set to the default. Otherwise, the D70 will appear to be operating normally but no pictures will be recorded!

CS-7 Image Review

Operation: The D70 is capable of displaying an image in the LCD Monitor after an exposure has been made.

Options: **ON**—Pictures are automatically shown on the LCD Monitor immediately after an exposure is made (default).
OFF—Pictures are not displayed on the LCD Monitor after an exposure unless the Playback Button ▶ is pressed.

Suggestion: Unless you are very concerned about conserving battery power, in which case set this option to OFF, it is generally useful to have the picture displayed to confirm an exposure has been made and to assess its quality using either the histogram or highlight warning screens. As soon as you have finished looking at the picture you can switch the monitor off by lightly pressing the Shutter Release Button.

CS-8 Grid Display

Operation: The D70 will superimpose grid lines on the Viewfinder Display to aid composition and alignment of the camera (e.g. to help ensure a horizon is level).

Options: **OFF**—No lines are displayed (default).
ON—Three horizontal and vertical lines divide the focusing screen into a grid.

Suggestion: This is a personal preference, as I know some people find the lines distracting. Personally, I think they are very useful (I have grid pattern focusing screens fitted to my other Nikon cameras that do not have this feature).

CS-9 EV Step

Operation: This determines the step increments for adjustments pertaining to exposure. The shutter speed, lens aperture, exposure compensation factor, and exposure bracketing function can be set to shift in one of two increments. The selected increment is used for all exposure settings on the D70.

Options: **1/3 step**—The D70 shifts exposure in increments of 1/3-EV (1/3-stop) (default).
1/2 step—The D70 shift exposure in increments of 1/2-EV (1/2-stop)

Suggestion: Leave the D70 at the default option to give you the finest level of control over exposure.

CS-10 Exp Comp

Operation: This option allows you to activate exposure compensation in a variety of ways.

Options: **OFF**—Push and hold the 🔳 button to set exposure compensation (default).
ON—Turning one of the Command Dials sets exposure compensation. There is no need to push the 🔳 button. However, choice of exposure mode and setting of Custom Setting-14 dictates which command dial you use.

CS-14 status	Exposure mode	Exposure Compensation set by
Off	A	Main-command dial
Off	S, P	Sub-command dial
On	A	Sub-command dial
On	S, P	Main-command dial

Suggestion: This option makes controlling the D70 unnecessarily complicated. Unless you always operate your D70 in the same exposure mode, this can become very confusing.

CS-11 Center Wtd

Operation: In Center-Weighted Metering Mode, the camera takes 75% of its evaluation from a circle in the center of the frame. You can set the diameter of this circle. The default value is 8mm, which corresponds to the central circle marked on the focusing screen. The other options are:

Options: 6mm, 8mm (default), 10mm, and 12mm diameters

Suggestion: Personally, I never use Center-Weighted Metering and leave this option set to its default value as I find Spot Metering far more useful.

CS-12 BKT Set

Operation: Exposure bracketing of the ambient exposure is performed by altering either the shutter speed or aperture, for flash exposure using flash output compensation, or a combination of both. It is also possible to bracket the white balance setting. This option allows you to choose the routine the D70 uses to perform exposure bracketing.

Options: **AE & flash**—If you are using a Speedlight for fill-flash work, this option adjusts the shutter speed/aperture values for the ambient exposure and the flash exposure compensation level (default).
AE only—This option adjusts either the shutter-speed or aperture values for the ambient exposure.
Flash only—Exposure is bracketed using only flash exposure compensation
WB bracketing—White balance values are bracketed for JPEG files. No exposure bracketing takes place and this option is not available for NEF, or NEF+JPEG file options.

Suggestion: Since changing exposure by varying the shutter speed or aperture produces a very different

appearance compared with changing the flash exposure level, you need to think carefully about this feature. If you use fully automated 3D Balanced Fill-Flash mode, the default may be worthwhile. However, if you prefer to set your own flash compensation level using Standard TTL flash control, I suggest setting this option to AE only.

Suggestion: White balance bracketing needs some care because if you set a WB bracket when you already have a white balance compensation dialed in, the camera brackets around this value and not the standard white balance value. For example, say you have a white balance of Cloudy −3 set on the camera and then select a white balance bracket of three frames over +/-2. The camera will record a sequence of pictures with white balance values of Cloudy −1, -3, and −5. Yet Nikon provides no information about what a value of −5 represents in terms of color temperature or MIRED (Micro Reciprocal Degree—a method of calculating color temperature) value. In short, each +/- increment is equivalent to a 10-MIRED shift. So assuming the picture is recorded with a neutral white balance at its '0' value, applying a -1 factor is like adding an 81 (pale amber) filter. Thus -2 is equivalent to an 81A filter, -3 is equivalent to an 81B, and so on. Therefore, the −5 value from our example bracket is equivalent to fitting an 81D filter.

When the CS-7 Image Review function is ON, the picture you just ▷ captured will automatically appear on the LCD Monitor so that you can review it for focus, composition, and exposure.

CS-13 BKT Order

Operation: This option allows you to select the order in which the camera makes exposures in a bracketing sequence (see page 116 for more information)

Options: **MTR>Under>Over**—'Correct' exposure followed by underexposed, and overexposed (default).
Under>MTR>Over—Underexposed frame is taken first, followed by 'correct', then overexposed.

Suggestion: These options are very much a case of personal preference.

CS-14 Command Dial

Operation: The D70 can be configured so that the each Command Dial can control either the shutter speed or the lens aperture.

Options: **No**—Main (rear) Command Dial controls shutter speed; the Sub (front) Command Dial controls the lens aperture (default).
Yes—Main (rear) Command Dial controls lens aperture, the Sub (front) Command Dial controls shutter speed.

Suggestion: Once again this option is very much a case of personal preference. If you use any other Nikon cameras that do not offer this option, I recommend that you leave the D70 set to the default; otherwise you are going to be confused when you change between cameras.

CS-15 AE-L/AF-L

Operation: The Auto-exposure Lock Button can be allocated a variety of functions using this Custom Setting:

Options: **AE/AF Lock**—Exposure settings and autofocus are locked when the button is pressed and held down (default).

AE Lock only—Exposure is locked but autofocus continues to operate when the button is pressed and held down.

AF Lock only—Autofocus is locked but exposure values continue to shift when the button is pressed and held down.

AE Lock hold– Exposure is locked when the button is pressed and remains locked until it is pressed again.

AF-ON—Camera will only autofocus when the button is pressed; pressing the shutter release button will not activate autofocus.

FV Lock—Pressing ⊛ button fires the monitor preflash sequence (no exposure is made) to calculate the required flash output. This value is then locked until the button is pressed again or the TTL meter switches off automatically

Note: When the exposure is made, no pre-flash sequence operates.

Suggestions: **AF Lock** only can be useful when you know where the subject is going to be but want auto-exposure to operate right up to the moment you make the exposure.

AE Lock only is probably the most useful option as you can take a reading from your chosen area, lock it, and then recompose the shot before releasing the shutter.

AF-ON has two distinct ways of being used:
First, it can be considered as an extension of the AF lock feature. Pressing the button (in Single-servo AF Mode) operates AF using the active AF sensor without having to press the shutter release button. If you continue to hold the button down, you can recompose the shot before releasing the shutter as many times as you wish.

Second, it can be used to release the shutter when the subject reaches a pre-focused distance. Set the D70 to Single-servo/Single-area AF Modes and select AF-ON. Set the lens to Autofocus Mode and select an appropriate AF sensor area for your shot. Pre-focus by selecting a point through which the subject will move, align this with the AF sensor area bracket then press and release the AE-L button. Recompose the shot and press and hold the shutter release button down all the way (remember focus is now locked). The shutter will be released as soon as the selected AF sensor area bracket detects an in-focus subject. For example, say you are photographing a hurdle race, you pre-focus on the bar of a hurdle and then recompose so the AF bracket covers an area just above the bar where the athlete will pass through. As the runner approaches the hurdle, press and hold the shutter release down, while keeping the active AF bracket centered on the subject. As soon as the D70 detects the hurdler is in focus the shutter operates.

FV Lock is useful since monitor pre-flashes are not emitted when you press the Shutter Release Button, making it possible to trigger non-dedicated wireless slave cells in conjunction with the D70's shutter operation (the pre-flashes would otherwise trigger the slave cells prematurely).

CS-16 AE Lock

Operation: Many cameras lock autoexposure when their Shutter Release Button is pressed half way. However, the D70 does not at its default setting.

Options: **AE-L Button**—The exposure is only locked when you press the AE-L button (default).
+ Release bttn—The exposure can be locked by either pressing the Shutter Release Button halfway, or the AE-L button.

Suggestion: To my mind it is simpler and quicker to have exposure locked by the Shutter Release Button, so set + Release bttn

CS-17 Focus Area

Operation: You select the AF area using the Multi Selector Switch on the back of the D70. At its default setting, repeated presses progressively shift sensor selection in the chosen direction to the farthest sensor, at which point selection stops.

Options: **No wrap**—Sensor selection stops at the extremity of the five-sensor array (default).
Wrap—Repeated presses continue selection in the same direction but 'wraps' around to the other side of the display.

Suggestion: In my opinion Wrap offers a much faster method of sensor selection, but try it for your self.

CS-18 AF Area Illm

Operation: The selected AF area is illuminated either by a solid black line, or initially highlighted in red before changing to solid black.

Options: **Auto**—The D70 decides which method to use based on its assessment of scene brightness; red is used in low light conditions to help make the AF bracket stand out against a dark background (default).
Off—Selected AF area is highlighted in black only.
On—Selected AF area is highlighted in red, initially, then black.

Suggestion: The Auto option is most probably the best compromise as it is useful in low light but conserves battery power in brighter conditions. If you need to eek out battery power, set this option to Off.

CS-19 Flash Mode

Operation: This option sets the Flash Mode for the built-in Speedlight. It does not affect external Speedlight units.

Options: **TTL**—The built-in flash operates in the i-TTL Mode and emits pre-flashes (default).
Manual—The flash output is fixed at a predetermined level selected from the sub-menu.
Commander—The built-in Speedlight only emits a trigger signal to remote Speedlight units. A further sub-menu requires you to select TTL, Auto Aperture (SB-800 only), or Manual (flash out put level is selected in another sub-menu).

Suggestion: The default TTL setting is the most adaptable option, but for a true multiple-flash TTL wireless system you need to use the Commander Mode in conjunction with up to three external Speedlights (SB-800, or SB-600 models only).

CS-20 Flash Sign

Operation: In P, A, S, and M Exposure Modes, the built-in Speedlight does *not* pop-up automatically when additional light is required to make an exposure. Instead, the ⚡ Flash Indicator flashes as a warning whenever the shutter speed drops below the value you select in CS-21.

Options: **On**— ⚡ flashes to recommend using the built-in Speedlight (default).
Off No warning is given.

Suggestion: If you are already making informed decisions about exposure in P, A, S, and M Exposure Modes, then you are unlikely to need the camera to remind you to use flash! To keep the viewfinder information as clear and uncluttered as possible, I set this option to Off.

CS-21 Shutter Spd

Operation: In P and A Exposure Modes, the D70 sets a lower limit on the shutter speed that can be used when either the built-in Flash, or an external Speedlight is in use with the camera. In both modes the default is 1/60th second. This can be adjusted to the following speeds:

Options: 1/60 (default), 1/30, 1/15, 1/8, and 1/4 second.

Suggestion: In order for the low level of ambient light in interiors to contribute towards the final exposure (for a more balanced appearance of background areas) when using flash as the primary light, you will probably want to select a slower speed than the default (I generally set 1/15).

CS-22 Monitor Off

Operation: This option sets the duration of the display on the LCD Monitor from the time of the last associated action (e.g. pressing the (icon 95) button). This assumes no other function that would otherwise turn it off is activated subsequently. The duration can be chosen from the following times:

Options: 10s (ten seconds), 20s (default) (twenty seconds), 1 min (one minute), 5 min (five minutes), and 10 min (ten minutes)

If you connect the D70 to an external power source such as the EH-5 AC adapter, the duration is automatically set to 10 minutes, which cannot be altered.

Suggestion: The LCD Monitor consumes a relatively high level of power, which you may wish to conserve by selecting a shorter duration than the default 20 seconds.

Note: The display can always be switched off by pressing the shutter release half way.

CS-23 Meter-Off (Duration of exposure meter function):

Operation: Normally, the camera's meter is active when you keep the Shutter Release Button depressed half way for 6-seconds after you release the button, or you make an exposure. The duration of the metering activity can be changed to the following values:

Options: 4s (four-seconds), 6s (default) (six-seconds), 8s (eight-seconds), 16s (sixteen-seconds), and 30 min (thirty-minutes)

Suggestion: The eight-second duration is generally long enough to view exposure data; any longer and battery drain may be significant during the course of a day's shooting.

CS-24 Self-Timer

Operation: You can select one of four different durations for the delay between pressing the shutter release button and the exposure being made via the self-timer function as follows:

Options: 2s (two-seconds), 5s (five-seconds), 10s (default) (ten-seconds), and 20s (twenty-seconds)

Suggestion: The two-second delay is ideal for releasing the shutter when you want to minimize camera vibration though touching it but you need to re-set the self-timer function for each exposure. Therefore, the ML-L3 IR remote release is a more practical option.

CS-25 Remote

Operation: This option allows you to determine the duration of the period in which the D70 can receive the IR signal from the ML-L3 remote control before it cancels the remote release function, automatically. The following delays are available:

Options: 1 min (default) (one-minute), 5 min (five-minutes), 10 min (ten-minutes), and 15 min (fifteen-minutes)

Suggestion: The camera is drawing more power than usual when it remains active awaiting the IR signal. Therefore, set the shortest duration according to the shooting conditions.

The Self-timer function is useful in reducing the risk of camera shake for close-up shots.

Nikon Flash Photography

Before we take a look at the flash capabilities for the D70, it is important that you understand a couple of basic principles of flash photography. Light from a flash unit falls off, as it does from any light source, by what is known as the "inverse square law." Put simply, if you double your distance from the light source, its intensity drops by a factor of four because it is now lighting an area four times the size as previously. Since a flash unit emits a precise level of light, it will only light the subject correctly at a specific distance, and that depends on the intensity of the light. If the flash correctly exposes the subject, then anything closer to the flash will be overexposed, and anything farther away will be increasingly underexposed. So, to produce a balanced exposure between the subject and its surroundings, you need to balance the light from the flash with the ambient (available or existing) light.

The D70 attempts to do this by balancing ambient light to the flash output, which it measures using a 1,005 pixel sensor located in the viewfinder head of the camera. The system used in the D70 is Nikon's third generation of TTL flash control, which they call i-TTL. This is part of a wider set of flash functions that Nikon refers to as its Creative Lighting System (CLS).

Note: Currently the internal Speedlight of the D70, as well as the SB-600 and SB-800 external Speedlights, are the only Nikon flash units to support CLS. So if you have an earlier DX-specification Speedlight you will not have access to TTL flash control with the D70.

Fill flash is easy the Nikon's i-TTL Balanced Fill-Flash technology. The built-in flash was used to reduce overall contrast and fill-in the shadows, which helped to reveal detail in the plumage of this European Eagle Owl.

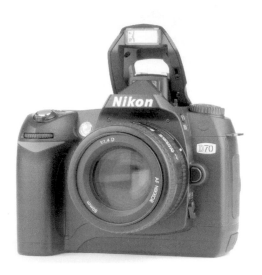

Built-In Speedlight

D70 has a built-in Speedlight (Nikon's proprietary name for a flash unit) that has a guide number of 49 feet (15m) [56 feet (17m) manual flash] and can synchronize with the shutter at speeds up to 1/500th second. It has a minimum distance of two feet (0.6m), below which the camera will not necessarily calculate a correct flash exposure. Apart from some of the Digital Vari-Program modes that activate the flash automatically, the Speedlight must be activated manually by pressing the ✦ button.

The Speedlight draws its power from the camera's main battery, so extended use of the flash will have a direct effect on battery life. As soon as the flash unit pops up, it begins to charge. The ✦ symbol appears in the viewfinder to indicate charging is complete and the flash is ready to fire. If the flash fires at its maximum output, the same ✦ indicator will flash for approximately three seconds after the exposure has been made, as a warning of potential under-exposure.

The Flash Lock Release and Flash Mode button.

Note: The flash-ready symbol ⚡ operates the same way with an external Speedlight.

Flash Modes

The D70 offers either TTL or manual flash control with its built-in Speedlight, both of which are selected and set via Custom Setting-19. A third, Commander Mode, is used for controlling remote external flash unit(s) (see page 180).

i-TTL Balanced Fill-Flash Mode: This is the default setting of the D70 with both the built-in and external SB-800 and SB-600 Speedlights. This mode requires a lens fitted with a CPU (strictly speaking these lenses do not have a CPU but a chip that communicates data to the camera body), so AI-P, AF, AF-D, AF-I, AF-S, and AF-G type Nikkor lenses are compatible.

The D70 calculates an exposure for the ambient light and the flash exposure, using information from the Matrix metering system, lens data (focal length, focus distance, and aperture), and combines this with its assessment of a series of rapid low-intensity light pulses (something Nikon calls "monitor pre-flashes") that are emitted immediately before

the main flash discharge. The camera then attempts to produce a balanced exposure with a slight bias toward the ambient light component.

Note: These pre-flashes are only effective over an approximate maximum distance of 25 feet (6 m).

Since all assessment of the flash output is performed before the shutter opens, should the lighting or nature of the subject's reflectivity alter in that split second after the pre-flashes are fired, the flash exposure may be incorrect. There is no TTL flash control during the actual exposure with the D70 as there is with some Nikon film cameras.

Standard TTL Flash Mode: The D70 automatically switches to this mode when it is set to M Exposure Mode, or when Spot Metering is selected in P, A, and S Exposure Modes. In Standard TTL Mode, the camera is only concerned about calculating a flash output that will expose the subject correctly. It bases its assumptions on focus information about where the subject is located within the frame, and does not take into account the lighting conditions from other areas of the frame (i.e. the foreground or background) as seen by the 1,005-pixel flash sensor.

Hint: Standard TTL is the best option if you want to shoot pictures with fill flash. In this mode any flash compensation you set will be applied to the exposure, unlike the automated i-TTL Balanced Fill-Flash mode that will most probably override any setting you make and apply an unknown amount of flash compensation.

Manual Flash Mode: In this mode the output of the Speedlight is fixed. It is necessary to calculate the correct lens aperture as determined by the flash-to-subject distance and the guide number (GN) of the Speedlight.

⟲ *Wireless TTL multiple flash was used for this studio portrait.*

At its base sensitivity of ISO 200 (equivalent), the D70's built-in Speedlight has the following GN values:

Power	GN (ft)	GN (m)
Full	56	17
1/2	39	12
1/4	28	8.5
1/8	20	62
1/16	14	4.25

Aperture = GN / Distance

So for example with the D70's Speedlight set to 1/4-power, and at a shooting distance of exactly 7 feet (3m), the lens aperture for a correct exposure of the subject will be f/4. (4 = 28/7).

Flash Sync Modes

On the D70 the Flash Synchronization (Sync) Modes determine when the flash is fired and how it interacts with the shutter. These apply to the built-in Speedlight, and the external SB-800 and SB-600 Speedlights.

The D70's built-in Speedlight pops up automatically when needed in Full AUTO mode.

*The D70 with an
SB-600 Speedlight.*

Front-Curtain Sync: The flash fires as soon as the shutter has fully opened. In P and A Exposure Modes, this will occur with a shutter speed between 1/60th and 1/500th second, unless a lower speed has been selected via Custom Setting-21. In S and M Modes, the Speedlight synchronizes with any shutter speed between 30 seconds and 1/500th second.

Red-Eye Reduction: The D70 uses the AF-assist Lamp on the front right side of the camera body to light for approximately one second before the main exposure in an effort to reduce the size of a subject's pupils.

Hint: This mode does cause an inordinate delay in the shutter's operation, by which time the critical moment has generally passed and you have missed the shot! Personally, I never bother with this feature.

Slow-Sync: As soon as the shutter has fully opened, the flash fires at all shutter speeds between 30 seconds and 1/500th second regardless of the exposure

mode used. Any image of a moving subject recorded by ambient light will appear to be in front of the flash-exposed subject.

 Slow-Sync with Red Eye: Same as Slow-sync Mode, except the Red-eye Reduction Lamp is switched on for approximately one second before the shutter opens in order to reduce pupil size.

Hint: The same advice applies – avoid this mode!

Rear-Curtain Sync: In S and M Exposure Modes the flash fires just before the shutter closes at all shutter speeds between 30 seconds and 1/500th second. Any image of a moving subject recorded by ambient light will appear to be behind it. Thus, motion blurs will trail realistically behind the subject.

Slow Rear-Curtain Sync - in P and A exposure modes, the flash fires at all shutter speeds between 30 seconds and 1/500th second just before the shutter closes. Any image of a moving subject recorded by ambient light will appear to be behind it.

To set a flash sync mode on the D70, press and hold the ❹ button. Turn the Main Command Dial to scroll through the various modes until the required icon appears in the Control Panel LCD.

Note: For details of the flash sync modes used by the camera in the Digital Vari-Programs, see page 215 for more information.

Flash Exposure Compensation
Flash exposure compensation can be set on the D70 by pressing and holding the ⊞ button while turning the Sub-Command Dial. Compensation can be set in increments of 1/3 or 1/2 EV over a range of +1 to –3 stops.

172

Flash was used to light the foreground while the strong, natural backlighting created a silhouette of the monument.

Hint: If you use the default i-TTL Balanced Fill-Flash mode, it will automatically set flash compensation based on scene brightness, contrast, focus distance, and a variety of other factors. The level of automatic adjustment applied by the D70 will often cancel any compensation factor you enter manually. Since there is no way of telling what the camera is doing, you will never have control of the flash exposure. To regain control, set the flash mode to Standard i-TTL by selecting M Exposure Mode, or Spot Metering in P, A, and S Exposure Modes.

FV Lock

If you want to take a flash-exposure with the main subject at the extremities of the frame area, it is possible that the flash metering system will not provide an accurate reading. Since flash output is based entirely on the assessment of the monitor

pre-flashes, a subject in this position may not reflect sufficient light. The FV Lock allows you to trigger the pre-flashes without the main flash discharging. To activate this, you will need to, navigate to CS-15, and select the FV Lock option.

Confirm that the flash-ready signal is displayed in the Viewfinder, and compose so that your subject is in the center of the frame, then press the shutter release half way to activate auto-focus. Now press the ● Button to trigger the pre-flashes and allow the camera to calculate the flash exposure. It will lock this output value and **EL** will appear in the Viewfinder Display.

You can now recompose the shot, and take as many expo-sures as you like, because the flash output level will be locked (provided the camera meter remains active—if it switches off you will have to repeat the process). To release the lock, press the ● Button again and confirm that **EL** is no longer displayed.

Flash Range, Aperture, and Sensitivity (ISO)

This table shows the distance range covered by the D70's built-in Speedlight at different apertures and different ISO values. For example, the Speedlight will illuminate from two to $12^{1/2}$ feet at an aperture of 8 and an ISO of 400.

| Aperture at ISO equivalent of | | | | | | | | | | Range | |
200	250	320	400	500	640	800	1000	1250	1600	m	ft
2	2.2	2.5	2.8	3.2	3.5	4	4.5	5	5.6	1.0–7.7	3´3˝–25´3˝
2.8	3.2	3.5	4	4.5	5	5.6	6.3	7.1	8	0.7–5.5	2´4˝–18´1˝
4	4.5	5	5.6	6.3	7.1	8	9	10	11	0.6–4.0	2´–13´1˝
5.6	6.3	7.1	8	9	10	11	13	14	16	0.6–3.8	2´–12´6˝
8	9	10	11	13	14	16	18	20	22	0.6–1.9	2´–6´3˝
11	13	14	16	18	20	22	25	29	32	0.6–1.4	2´–4´7˝
16	18	20	22	25	29	32	—	—	—	0.6–0.9	2´–2´11˝
22	25	29	32	—	—	—	—	—	—	0.6–0.7	2´–2´4˝

Maximum Aperture with Flash

In P, 📷, 🎯, 🌷, and 🔲 modes the maximum aperture is limited according to the sensitivity (ISO).

Mode	Maximum aperture at ISO equivalent of									
ISO	200	250	320	400	500	640	800	1000	1250	1600
P, 📷, 🎯, 🔲	2.8	3	3.2	3.3	3.5	3.8	4	4.2	4.5	4.8
🌷	5.6	6	6.3	6.7	7.1	7.6	8	8.5	9	9.5

Lens Compatibility

Due to the proximity of the built-in Speedlight to the central lens axis, there is a possibility that some lenses will obstruct the flash and cause uneven exposure.

Lens	Zoom position	Minimum distance
AF-S DX ED 12–24mm f/4G	20mm	2.5m/8´2″
	24mm	1.0m/3´3″
AF-S ED 17–35mm f/2.8D	20mm, 24mm	2.5m/8´2″
	28mm	1.0m/3´3″
AF-S DX IF ED 17–55mm f/2.8G	20mm, 24mm	2.5m/8´2″
	28mm	1.5m/4´11″
	35mm	0.7m/2´4″
AF ED 18–35mm f/3.5–4.5D	20mm	2.0m/6´7″
	24mm	0.7m/2´4″
AF 20–35mm f/2.8D	20mm	1.5m/4´11″
	24mm	1.0m/3´3″
AF-S VR ED 24–120mm f/3.5–5.6G	24mm	0.8m/2´7″
AF-S ED 28–70mm f/2.8D	28mm	3.0m/9´10″
	35mm	1.0m/3´3″
AF-S VR 200–400mm f/4G	200mm	4.0m/13´1″
	250mm	2.5m/8´2″
AF-S DX ED 18-70mm f/3.5-4.5G (IF)	18mm	1.0m/3´3″

Note: The peripheral illumination of the built-in Speedlight on the D70s has been increased. It can be used with any CPU lens with a focal length of 18-300mm, and non-CPU (Ai-S, Ai, or Ai modified) lenses with a focal length of 18-200mm.

External Speedlights

In addition to the built-in Speedlight, the D70 offers full i-TTL control with two external Speedlights: the SB-600 with a GN (at 35mm zoom-head position) 129/39 (ft/m, ISO 200) and the SB-800 with a GN (also at 35mm zoom-head position) 174/53 (ft/m, ISO 200).

Note: This system only works with Nikon CLS flash units. There is no support for TTL flash control with earlier Speedlights.

Expand your creativity with one of Nikon's sophisticated accessory Speedlight flash units.

Apart from being more powerful than the built-in unit, these two Speedlights are considerably more versatile since their flash heads can be tilted and swiveled for bounce flash. They also have an adjustable auto zoom-head (SB-800, 24-105mm) (SB-600, 24-85mm) that controls the angle-of-coverage of the flash beam, and a wide-angle diffuser for a focal length of 17mm (SB-800 only) and 14mm.

Hint: Unlike earlier Nikon Speedlights that cancelled monitor pre-flashes if the flash head was tilted or swiveled for bounce flash photography, the SB-800 and SB-600 emit pre-flashes regardless of the flash head orientation to help improve the accuracy of flash exposure.

Hint: The focal lengths indicated on Speedlight zoom heads assume the unit is attached to a film camera, and not a digital SLR like the D70 with its reduced angle-of-view due to the smaller sensor size. Therefore, if you don't compensate, the flash will illuminate a greater area than is optimal when used on the D70. This effectively reduces the distance range and squanders flash power. Use the following table to maximize the performance of an external Speedlight:

Focal length of lens (mm)	Zoom head position (mm)
14	20
18	24
20	28
24	35
28	50
35	50
50	70
70	85
85	105 [1]

[1] - Available on SB-800 only.

Additional Flash Modes (SB-800 and SB-600)

(AA) Auto Aperture (SB-800 Only): In this mode the SB-800 reads the sensitivity (ISO) setting and lens aperture from the D70 automatically, and receives the "fire flash" signal from the camera as well. It can be used in A and M Exposure Modes. When the flash is fired during the exposure, a sensor on the front panel of the Speedlight monitors the flash exposure and as soon as this sensor detects that the flash output has been sufficient, the flash pulse is quenched. If, between exposures, you decide to alter the focal length or change the lens aperture, the Speedlight will adjust its output accordingly to maintain a correct flash exposure. The problem with this option is that it is not TTL, so the sensor does not necessarily see the same scene as the lens, which can lead to inaccurate exposure.

(A) Automatic Non-TTL: This mode can be used in A and M camera exposure modes. Similar to the AA Mode, a sensor on the front of the SB-800 monitors flash levels and shuts off the flash when the Speedlight calculates that sufficient light has been emitted. However, the lens aperture and sensitivity (ISO) values must be set manually on the Speedlight to ensure the subject is within the flash shooting range. As with the AA Mode, the sensor does not necessarily see the same scene as the lens, which can lead to inaccurate exposure.

Taking Flash Off Camera

Mounting a flash on the hot shoe immediately above the lens places it in an unfavorable position because it produces flat, frontal lighting with no modeling. Generally, far better results can be achieved by taking the flash off the camera. To maintain full i-TTL control, Nikon produces the SC-28 TTL remote cord and the SC-29 TTL connecting cord with AF-assist Lamp, both 4.9 feet (1.5m) long.

The extra two contacts on the foot of the SB-600 Speedlight connect the AF-assist Lamp of the SC-29 to the Speedlight's power source.

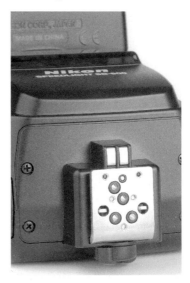

To connect the D70 to non-dedicated flash units such as AC powered studio lights via its standard flash sync, you will need to fit the AS-15 PC Sync adapter.

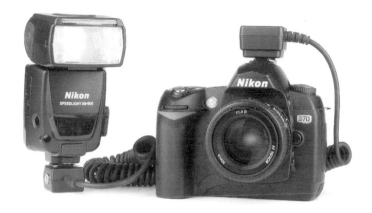

The SB-800 Speedlight can be used off camera and retain full i-TTL capability when it is connected to the D70 by an SC-28 dedicated connecting cord.

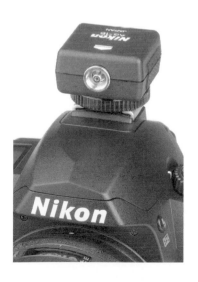

The AS-15 PC Sync adapter attaches to the hot shoe of the camera. It accepts standard PC plugs and allows the flash to sync properly with the camera through a connection in the hot shoe.

A long shutter speed of 2 seconds recorded the floodlit building. Flash in Slow-sync Mode was used to add light to the foreground. The Long Exposure Noise Reduction feature (accessible through the Shooting Menu) helped to reduce the level of electronic noise.

Wireless TTL Control

The third flash mode available via Custom Setting-19 is the Commander Mode, which allows three flash modes, TTL, AA, and M, to be controlled on one or more remote Speedlights by the D70's built-in Speedlight. The Speedlights (master and remote units) communicate with each other by transmitting/receiving a series of light pulses.

Note: This system does not use infrared light or radio signals as suggested by some.

In most instances you will want to select TTL Mode with either the SB-800 or SB-600 since this provides the most sophisticated level of flash exposure control. Although by using the D70's built-in Speedlight light you can remotely

control the flash units in either (AA) Auto Aperture (SB-800 only) or (M) Manual flash (SB-800 or SB-600).

Hint: Used in Commander Mode, the built-in flash of the D70 only triggers the remote Speedlight(s); it does not contribute to the main flash exposure.

Hint: Setting autofocus to Single-servo AF ensures that the flash will fire only after focus has been acquired, and the exposure mode has been set to (A) Aperture-priority, (S) Shutter-priority, or (M) Manual. Avoid (P) Program Mode due to the restriction it imposes on the permissible maximum lens aperture.

The practical limit to the number of Speedlights that the D70 can control is three, and using the D70's built-in Speedlight, the wireless control system is restricted to operating a single group of remote Speedlights, which means that all the remote flash units must be used in the same flash exposure control mode. Furthermore, you are limited to just one communication channel between the Command and remote Speedlight(s), Channel 3, so if another photographer is working with a similar system nearby you are likely to have interference problems and possibly trigger each others flash units.

Note: If you use an external SB-800 or SB-600 Speedlight as the Commander unit, you can control up to three sub-groups of remote Speedlights, each using a different flash exposure control mode if desired. You can also choose between four different communication channels to avoid interference problems from other photographers using Nikon's CLS wireless i-TTL flash control system.

Nikon recommends that you set each remote Speedlight unit (SB-600 and SB-800 only) so that its wireless control sensor, located on the lower right side of the main Speedlight body, has a line-of-sight to the D70's built-in Speedlight. Furthermore, they suggest that the remote Speedlight(s) should be no more than 33 feet (10m) in front of the camera and within 30° of the camera-to-subject axis; or no more than 16 feet

The sparklers were recorded at night by using a slow shutter speed and Slow Rear-curtain Sync Mode.

(5m) from the camera when the remote Speedlight(s) are between 30° and 60° from the camera-to-subject axis.

In practice I have found these recommendations to be somewhat conservative. Provided you are working with the remote flash at a relatively short range (no more than about 16 feet (5m), particularly where the level of ambient light is rather low, such as indoors), and there are surfaces in proximity to the remote flash unit from which the control signals of the master (Commander) flash unit can be reflected, it is possible to position the remote Speedlight or Speedlights out of sight of the camera. Though you will need to experiment with your proposed lighting set-up, it is possible to light a background or back-light a subject without a direct line-of-sight between the D70 and the remote Speedlight(s).

Once you have made the necessary settings, you can shoot away and move camera position (provided the trigger signal from the built-in Speedlight can be received by the sensor(s) on the remote Speedlight(s)), change focal length and/or lens aperture, and the system will maintain full i-TTL control of the flash exposure.

Hint: You must remember that the D70's built-in Speedlight can only control the remote units when they are set to Channel 3 and Group A.

Note: The full wireless CLS flash system using an external SB-800 or SB-600 Speedlight as the Commander unit normally supports three different groups of Speedlights and operates on four different channels.

Hint: Use a non-CPU lens on the D70 and the Commander Mode will only control remote flashes set to Manual flash exposure control.

Nikon Lenses
and Accessories

Nikon's 'F' mount for its Nikkor lenses is legendary, having been retained on all its 35mm film and digital SLR cameras, virtually unchanged, since the introduction of the original Nikon F SLR in 1959. As such, a great many of the lenses produced by Nikon over the past four decades can be mounted on the D70.

DX-Format Sensor

All Nikon digital SLR cameras made to date have the same size sensor, which Nikon refers to as the DX-format. At 15.6 x 23.7mm, it is smaller than a 35mm film frame. Because of this, the field-of-view seen by the D70 is reduced by about 1.5x compared with that seen by 35mm film camera.

The outside pale gray rectangle is the image area for a 35mm film frame (24 x 36mm), and the inner dark gray rectangle represents the area covered by the DX-format (15.6 x 23.7mm) sensor used in the D70. (Diagram not shown to scale).

Telephoto lenses are versatile tools for sports photographers because they not only allow you to get in close but also their limited depth of field adds to the drama of the image by isolating the subject from the background.

However, marketing people do not like to talk in terms of negative aspects; they much prefer positives! Hence, advertising hype such as "it's like getting a free 1.5x tele-converter" or "the 1.5x magnification of focal length" has instilled a notion (even among those who should know better) that the focal length of a 35mm format lens in some way magically increases by 1.5x when attached to a DX-format Nikon digital SLR. Wrong—a 300mm lens on a Nikon 35mm film camera is still a 300mm lens on the D70—no ifs or buts! Furthermore, a teleconverter generally reduces image sharpness and contrast, but since no extra glass is required to achieve the D70's image, these issues are irrelevant.

It is the field-of-view rather than the focal length that actually changes, and in fact is decreased (there's that negative aspect!). Consequently, a 35mm lens on the D70 "sees" a field-of-view equivalent to a focal length 1.5x greater. If you were to shoot two pictures of exactly the same subject with the same lens using a D70 and a film SLR, then cropped the film image to the same area as the sensor in the D70, you would end up with identical pictures.

The following table gives the approximate focal length equivalent for a 35mm format lens when mounted on the D70:

Picture angle	Approximate focal length (mm) in 35mm format (modified for picture angle)							
35mm film camera	17	20	24	28	35	50	60	85
D70	25.5	30	36	42	52.5	75	90	127.5
35mm film camera	105	135	180	200	300	400	500	600
D70	157.5	202.5	270	300	450	600	750	900

Zoom lenses are wonderful creative tools because they allow you to crop the picture exactly as desired. Cropping in-camera is always better than cropping in the computer because it creates a higher-resolution final image.

Choosing a Lens

There is a beneficial side effect of this reduced angle-of-view. Since the sensor of the D70 is only using the central portion of the total image projected by a lens designed for 35mm film cameras, the effects of optical aberrations and defects are kept to a minimum since these are generally more prevalent toward the edge of the image circle. All of the following tend to be significantly reduced if not eliminated altogether:

- Light fall-off toward the edge and corners of the image area
- Chromatic aberration
- Linear distortion – both barrel and pin-cushion
- Flat field focus
- Vignetting with filters

Wide-angle lenses offer a large field-of-view. Typically they are associated with landscape photography where they can be used to capture a sweeping vista, but wide-angles are great for many subjects. Their close-focusing ability, extended depth of field, and broad angle-of-view can be combined to create dynamic compositions with a dominant subject in the foreground set against an expansive backdrop.

Telephoto lenses provide a reduced angle-of-view that magnifies a subject, making them good for sport, action, and wildlife photography when it is usually difficult to get close to the subject. The optical effects of a telephoto can be used in many other areas of photography, such a portrait and landscape as they can help isolate a subject from its background due to their limited depth of field, particularly at large apertures.

Zoom lenses allow you to adjust the focal length, the range of which can be exclusively wide-angle, telephoto, or both. Zoom lenses are extremely versatile because you have several focal lengths available in one lens, which reduces the number of lenses you need to carry, letting you spend less time changing lenses. However, convenience comes at a price; many zoom lenses have smaller (large f/number) maximum apertures, often two-stops less compared with fixed-focal length lenses. This can be an issue when shooting in low light. Zoom lenses with large maximum apertures (small f/numbers) tend to be expensive due to the complexity of their optical engineering. For general photography with the D70, a couple of D or G-type zoom lenses that offer focal lengths between 18mm and 200mm will cover most shooting situations, and provide total compatibility with all the features and functions of the camera.

Nikon (Nikkor) makes a huge range of lenses. The following table provides details of the compatibility of the various types available:

Camera setting / Lens/accessory	Focus			Mode		Metering		
	AF	M (with electronic range finder)	M	DVP, P, S, A	M	3D	Color	•
CPU lenses								
Type G or D AF Nikkor [2] / AF-S, AF-I Nikkor	✔	✔	✔	✔	✔	✔	–	✔[3]
PC-Micro Nikkor 85mm f/2.8D[4]	–	✔[5]	✔	–	✔	✔	–	✔[3]
AF-S/AF-I Teleconverter[6]	✔[7]	✔[7]	✔	✔	✔	✔	–	✔[3]
Other AF Nikkor (except lenses for F3AF)	✔[8]	✔[8]	✔	✔	✔	–	✔	✔[3]
AI-P Nikkor	–	✔[9]	✔	✔	✔	–	✔	✔[3]
Non-CPU lenses								
AI-, AI-S, or Series E Nikkor / AI modified Nikkor	–	✔[9]	✔	–	✔[11]	–	–	–
Medical Nikkor 120mm f/4	–	✔	✔	–	✔[12]	–	–	–
Reflex Nikkor	–	–	✔	–	✔[11]	–	–	–
PC-Nikkor	–	✔[5]	✔	–	✔[11]	–	–	–
AI-type Teleconverter	–	✔[7]	✔	–	✔[11]	–	–	–
PB-6 Bellows Focusing Attachment[13]	–	✔[7]	✔	–	✔[11]	–	–	–
Auto extension rings (PK-series 11-A, 12, or 13; PN-11)	–	✔[7]	✔	–	✔[11]	–	–	–

1 IX Nikkor lenses can not be used.
2 Vibration Reduction (VR) supported with VR lens.
3 Spot metering meters selected focus area.
4 The camera's exposure metering and flash control systems do not work properly when shifting and/or tilting the lens, or when an aperture other than the maximum aperture is used.
5 Electronic range finder can not be used with shifting or tilting.
6 Compatible with AF-I Nikkor lenses and with all AF-S lenses except DX 12-24mm f/4G, ED 17-35mm f/2.8D, DX 17-55mm f/2.8G, DX ED 18-70mm f3.5-4.5G, ED 24-85mm f/3.5-4.5G, VR ED 24-120mm f/3.5-5.6G and ED 28-70mm f/2.8D.
7 With maximum effective aperture of f/5.6 or faster
8 If AF 80-200mm f/2.8, AF 35-70mm f/2.8, new-model AF 28-85mm f/3.5-4.5, or AF 28-85mm f/3.5-4.5, is zoomed in while focusing at minimum range, image on matte screen in viewfinder may not in focus when in-focus indicator is displayed. Focus manually using image in viewfinder as guide.
9 With maximum aperture of f/5.6 or faster.
10 Some lenses can not be used.
11 Can be used in mode M, but camera exposure meter can not be used.
12 Can be used in mode M at shutter speeds slower than 1/125s, but camera exposure meter can not be used.
13 Attach in vertical orientation (can be used in horizontal orientation once attached).
• Medical Nikkor 200mm f/5.6 requires AS-15 for flash control.

Incompatible Accessories and Non-CPU Lenses

The following accessories and non-CPU lenses can NOT be used with the D70:

- TC-16A AF Teleconverter
- Non-Al lenses
- Lenses that require the AU-1 focusing unit (400mm f/4.5, 600mm f/5.6, 800mm f/8, 1200mm f/11)
- Fisheye (6mm f/5.6, 8mm f/8, OP 10mm f/5.6)
- 21mm f/4 (old type)
- K2 rings
- ED 180-600mm f/8 (serial numbers 174041-174180)
- ED 360-1200mm f/il (serial numbers 174031-174127)
- 200-600mm f/9.5 (serial numbers 280001-300490)
- Lenses for the F3AF (80mm f/2.8, 200mm f/3.5, TC-16 Teleconverter)
- PC 28mm f/4 (serial number 180900 or earlier)
- PC 35mm f/2.8 (serial numbers 851001- 906200)
- PC 35mm f/3.5 (old type)
- 1000mm f/6.3 Reflex (old type)
- 1000mm f/11 Reflex (serial numbers 142361-143000)
- 2000mm f/11 Reflex (serial numbers 200111-200310)

Compatible Non-CPU Lenses

Non-CPU lenses not in the list above can only be used in M (Manual) Mode. Aperture must be adjusted manually using the lens aperture ring. The camera exposure meter, depth-of-field-preview, and i-TTL flash control cannot be used.

Note: The Shutter Release Button is disabled if a mode other than M is selected when using a non-CPU lens.

Features of Nikkor Lenses

The designation of Nikkor lenses, particularly modern auto-focus types, is peppered with initials. Here is an explanation as to what some of these stand for:

- **D-type**—these lenses have a conventional aperture ring and an electronic chip that communicates information

about lens aperture and focus distance between the lens and the camera body.

- **G-type**—these lenses have no aperture ring and are only compatible with Nikon cameras that allow the aperture value to be set from the camera body. They do contain an electronic chip that communicates information about lens aperture and focus distance between the lens and the camera body, similar to the D-type lenses.

- **DX**—lenses in the DX-Nikkor range have been especially designed for use on Nikon D-SLR cameras. They project a smaller image circle compared with a 35mm format lens, but the light exiting their rear element is more collimated to improve the efficiency of the photo sites on the camera's sensor.

- **AF-S**—not to be confused with Single-servo autofocus, AF S denotes the lens has a silent-wave focusing motor that uses alternating magnetic fields to move the lens elements to adjust focus. This system offers the fastest autofocusing of all AF Nikkor lenses. Most AF-S lenses have an additional feature that allows the photographer to switch between autofocus and manual focus, without adjusting any camera controls, by just taking hold of the focus ring.

- **ED**—to reduce the effect of chromatic aberration, Nikon developed a special type of glass to bring various wavelengths of light to a common point of focus.

- **IF**—to speed up focusing, particularly with long focal length lenses, Nikon developed their internal focusing (IF) system. This moves a group of elements within the lens so that it does not change in length during focusing, and prevents the front filter mount from rotating, which facilitates use of filters such as a polarizer.

Photographing wildlife subjects in the context of their environment usually conveys more to the viewer than a tightly cropped portrait. In this case, the lens was zoomed out to a shorter focal length, which captured a wider field of view.

Filters

The D70's white balance control obviates the need to carry a range of color correction and color compensating filters that you would normally need when shooting on film. However, filters are an integral part of any digital photographer's equipment, because there are a few filter effects that you simply cannot replicate using a computer; the good news is you do not need a great many! I would recommend that you consider the following three types.

Polarizing Filter

Probably the most useful and well-known filter is a polarizer. Often associated with its ability to deepen the color of a blue sky, a polarizer has many other uses. The polarizer's unique effect is one that makes it an essential filter for film or digital.

192

Since it can remove reflections from non-metallic surfaces, including water, it is a favorite with landscape photographers. Even on a dull overcast day, a polarizer can help reduce the glare from foliage, thereby intensifying color.

Hint: The D70's AF and metering will not function properly with a linear-type polarizing filter; you must use a circular-type polarizer.

Neutral Density Filters

The D70's relatively high base sensitivity of ISO 200 often means that in bright light you cannot set a lens aperture or shutter speed to achieve the required results. Continuous tone neutral density filters help to reduce the overall exposure so you can use longer shutter speeds and/or wider apertures under these conditions.

Graduated Neutral Density Filters

Coping with excessive contrast is one of the most difficult aspects of digital photography. For example, the sky is often much brighter than the land, even at each end of the day, which can make shooting landscapes tricky. Graduated neutral density filters, clear on one side and becoming progressively denser toward the other, are the ideal solution. They come in a variety of strengths and gradients. If you use a slot-in type of filter system, it is easy to align these graduated filters so their dense area darkens the sky, leaving the clear portion over the foreground area.

Note: Nikon does not produce graduated neutral density filters.

Hint: Nikon states that the 3D Color Matrix and Matrix metering of the D70 is not recommended when using any filter with a filter factor over 1x. The filter factor is the amount of exposure compensation required to adjust for the reduction in light transmission caused by the filter. For example, a filter factor of 2x is equivalent to one-stop; a factor of 8x is equivalent to three-stops. So this will apply to polarizing and neutral density filters. In such situations switch to Center-weighted or Spot Metering.

General Accessories

- **2370 Eyepiece adapter**—allows viewfinder accessories with a round attachment thread to be mounted on the D70's square viewfinder eyepiece.
- **AS-15**—adapter that mounts into the camera's hot shoe, providing a connection to standard PC sync lead.
- **BF-1A**—body cap that will help prevent dust from entering the camera.

Note: The earlier BF-1 type cap should not be used—it may damage the lens mount.

- **BM-4**—LCD Monitor screen cover for the D70.
- **BM-5**—LCD Monitor screen cover for the D70s.
- **DG-2**—viewfinder eyepiece magnifier that provides an approximate 2x magnification of the central area of the viewfinder field.

Note: Requires the Eyepiece adapter to be fitted.

- **DK-5**—viewfinder eyepiece cover used to prevent light entering the viewfinder and affecting exposure measurement.
- **DK-3**—circular rubber eyecup for the Nikon FM3A that can be attached via the square-to-circular viewfinder accessory Eyepiece adapter. It requires a viewfinder eyepiece filter for the FM3A camera to hold it in place. The circular eyecup provides a better light seal when held to the photographer's eye orbit than the D70's standard square eyecup.
- **DR-6**—right angle viewer that can attach directly to the square frame of the D70's viewfinder eyepiece. It is useful when the camera is at a low shooting position.
- **EC-AD1**—adapter that accepts Type I CompactFlash memory cards for connection to PCMCIA card slot.
- **EH-5**—multi-voltage AC adapter for powering the D70.
- **EN-EL3**—7.4V 1400mAh lithium-ion rechargeable battery for the D70 and the D70s.
- **EN-EL3a**—7.4V 1500mAh lithium-ion rechargeable battery for the D70 and the D70s.

- **MC-DC1**—3'3" (1 m) long Remote Release cord for D70s camera. (Currently, Nikon has no plans to introduce an extension cable for the MC-DC1.)
- **MH-18**—multi-voltage AC charger for a single EN-EL3 or EN-EL3a battery.
- **MH-18a**—compact version of the MH-18 multi-voltage AC charger for a single EN-EL3 or EN-EL3a battery.
- **MH-19**—multiple battery charger that can charge two EN-EL3/3a batteries and supports either a multi-voltage AC supply or 12V DC motor vehicle supply.
- **ML-L1 Remote**—an infra red remote release that can be substituted for the ML-L3.
- **ML-L3 Remote**—an infrared remote release for the D70. It requires a CR2025 battery.
- **MS-D70**—a battery holder for three CR2 lithium batteries that can be used as an alternative power supply.
- **Nikon Capture 4**—full support for Nikon NEF files. The D70 requires version 4.1 or higher, and the D70s requires version 4.2 or higher. The Nikon Editor application can be used to transfer images to a computer, view, edit, and print them. The Nikon Camera Control application permits remote control of a camera via a USB cable connection.
- **Teleconverters TC-14E II, TC-17E II, and TC-20E II**—small optical devices that fit between the lens and camera body to magnify the image. They are available in three different strengths (1.4x, 1.7x, and 2.0x). They reduce the maximum effective aperture of the lens, but retain the minimum focus distance.

Working with Pictures

Image Information

You may be surprised to learn that, in addition to image data, the picture files generated by the D70 contain a wealth of other information that includes the shooting parameters and instructions about printing pictures.

Exchangeable Image Format (EXIF)
The D70 uses the EXIF standard for embedding information within the image file (sometimes this information is referred to as metadata, which is a more generic term). The firmware of the D70 supports current versions of EXIF (since firmware and software can be updated at any time, check with Nikon to insure you have the latest versions available). EXIF attaches the following information to each image file:

- Nikon (the name of the camera manufacturer).

- D70 (the model number).

- Camera firmware version number.

- Exposure information, including shutter speed, aperture, exposure mode, ISO, exposure value, date/time, exposure compensation, flash mode, and focal length.

- Thumbnail of the main image.

Many people like the soft, ethereal look of infrared (IR) black-and-white photos. Conventional IR photos were shot with special infrared sensitive film, but with the D70 and an IR accessory filter, you can be capture IR images anytime you find an appropriate subject.

Examining EXIF data, by either viewing the image information pages on the LCD Monitor or using the Shooting Data Tab in Nikon View software (see page 207), is a great teaching aid because you can see exactly what the camera settings were for each shot. By comparing pictures and the shooting data, you can quickly learn about the technical aspects of exposure, focusing, metering and flash exposure control.

International Press Telecommunications Council (IPTC)

Many image processing applications, including Nikon View and Nikon Capture (see page 209), allow further information to be tagged to the image file. The International Press Telecommunications Council (IPTC) has developed a standard known as Digital Newsphoto Parameter Record (DNPR), which can carry additional image information including origin, authorship, copyright, captions, and key words for searching purposes. The camera itself does not write any DNPR metadata to its image files; that is done by other applications.

Note: Many people and applications refer erroneously to DNPR as the "IPTC data".

Any application that is DNPR compliant will show this information and allow you to edit it. However, if you are considering submitting pictures for publication, you should make use of DNPR metadata, as most publishing organizations require it to be present before accepting a submission.

Nikon's image processing software is DNPR compliant, allowing you to create and store written details about each photo, such as time, place, title, and/or captions. You can access this 'metadata' at any time.

Camera Connections

Connecting to a TV or Video Monitor

The D70 can be connected to a television set or VCR for playback or recording of images by using the EG-D100 video cable. First, you need to select the appropriate video standard. NTSC is the video standard used in the USA, Canada, and Japan. PAL is used in most European countries.

Press the **MENU** button and navigate to the Set-up Menu and highlight Video Mode. Press ⊚ and select either NTSC or PAL. Now switch the camera off.

Beneath the rubber covers on the left side of the camera body are several cord sockets. The DC-in and Video out sockets are located together under one cover, and the USB connector is under a separate cover, towards the bottom of the camera. (Note that this picture shows the D70 camera).

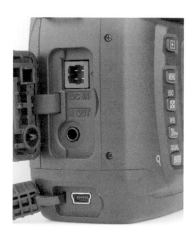

To connect the camera, make sure its power is switched OFF. Open the large rubber cover on the left end of the camera body to reveal the ports for DC-in (top) and Video out (bottom), then connect the narrow jack-pin of the EG-D100 to the camera and the other end to the TV/VCR. Tune the TV to the video channel, and turn on the camera. The image that would normally be displayed on the LCD Monitor will be shown on the television screen or recorded to videotape.

Note: The LCD Monitor will remain blank but all other camera operations will function normally. So, you can take pictures with

the camera connected to a TV set or video monitor and carry out review/playback functions as you would with the LCD Monitor.

Connecting to a Computer

The D70/D70s can be connected directly to a computer via the supplied UC-E4 USB cable. They both support a standard Full Speed USB (1.1) interface with a maximum transfer rate of 12 Mbps. You can download images from the camera using the supplied Nikon View software, or alternatively by setting camera controls and operating the camera from a computer using the optional Nikon Capture software.

Hint: If you use the D70/D70s connected to a computer for any function, be sure that the EN-EL3/3a battery is fully charged. Preferably, use the EH-5 AC adapter to prevent interruptions to data transfer by loss of power.

Before connecting the D70 to a computer, either the supplied Nikon View or Picture Project software, or an appropriate third party application suitable for data transfer must be installed, and the camera should be configured for one of the following two USB connection options.

Open the Setup Menu and navigate to the USB option. Press ⊙ to display options for M (Mass storage) and P (PTP). Select the appropriate option (see descriptions below) and press ⊙ to set it.

Mass storage: In this configuration the D70 acts like a card reader and the computer sees the memory card in the camera as an external disk drive. This is the default setting and it only allows the computer to read the data on the memory card. Use this option if your computer is running Windows (98, Me, or 2000), or Macintosh OS (9.x).

Point to Point (PTP): In this configuration the D70 acts like another device on a computer network and the computer can communicate and control camera operations. Use this option if you want to use the camera control features in Nikon Capture using Windows XP or Macintosh OS X.

Digital "instant" photography is just a push of the button away with this fun, take-along direct printer from Epson. Take one to your next party or family gathering and enjoy one of the most fun parts of owning a digital camera—sharing pictures. ©Epson America, Inc.

To connect the camera to the computer using the UC-E4 lead, first make sure it is switched OFF. Open the lower rubber cover on the left end of the camera and plug in the appropriate end of the UC-E4 (the plugs on each end are unique so you can only connect the lead one-way). Turn the camera ON and the computer should recognize the camera and launch Nikon View.

The D70 will continue to operate normally when tethered to a computer so you can shoot and download images directly, as well as control the camera using Nikon Capture software.

To disconnect, turn the camera OFF before removing the lead.

Card Readers
Card readers are an inexpensive and simple way to download images from memory card. They are readily available

at stores that sell digital cameras. Most photographers prefer this method of downloading for the following reasons:

- If you use the linked camera method, you will drain battery power with a risk that data could be lost or corrupted if the power fails.

- The D70's standard USB 1.1 (12Mbps) connection is far slower than a card reader that supports either the High Speed USB 2.0 (480Mbps), or a Firewire (400Mbps) interface.

- Using a card reader allows you to run software to recover lost or corrupted image files as well as diagnose problems with the memory card.

- You can leave a card reader permanently attached to your computer, which further reduces the risk of losing or corrupting files as a result of a poor connection due to the wear and tear caused by constantly connecting the camera.

Direct Printing

The D70 allows you to select a set of images (JPEG files only) that can be printed directly by either connecting the camera to a compatible printer or inserting the memory card directly into a compatible printer.

Note: There are subtle differences in the functionality of these two methods. For example, connecting the D70 to a compatible printer allows you to perform cropping before printing, whereas only full frame is available when printing from the memory card (unless the printer software allows cropping).

It is important to note that direct printing from the D70 will only work with JPEG files. Nikon recommends they be recorded in the sRGB color mode (Ia & IIIa). So, either choose *Direct print* from the Optimize Image Menu or select *Custom* and set the color mode accordingly.

Linking the D70 with a Printer

You connect the D70 to a PictBridge compatible printer in order to print pictures directly from the camera. It is essential that you make sure the camera battery is fully charged before starting direct printing from the camera. To be safe, use the camera with the accessory AC adapter.

- Set the USB option in the Setup Menu to PTP.

- Turn the printer on and the camera off.

- Connect the printer to the camera using the UC-E4 USB cord.

- Turn the camera on and the PictBridge menu will be shown on the LCD Monitor.

Three options are presented:
- Print—you can print selected pictures at one per page (cropping the images if the printer supports this function), or print all the selected pictures on a single page to produce a contact sheet.

- Print (DPOF)—you can print pictures tagged with DPOF metadata in their designated print order. Alternatively, you can change the print order if required.

- Setup—you can choose to imprint the date you recorded your images, plus select whether or not they are printed with a border.

Note: On the D70s there is an additional selection in printing Setup option in which you can select a specific paper size for the print.

Note: Printing cannot be performed with the default Mass storage USB connection. Nikon does not recommend connecting via a USB hub.

This photo was printed directly by connecting the D70 to a printer using the UC-34 USB connecting cord. Photo © Eric Dougherty

Note: The PictBridge standard does not add data to the image file like DPOF (see page 206). Instead, it uses DPOF metadata stored in the image file to instruct a compatible printer how to print the pictures.

Selecting Pictures for Printing

Highlight *Print* and press ⊙ to open the next page, which provides an additional three options. Highlight *Choose folder* and press ⊙ to display the folder list. Select a folder by pressing ⊙ and then press ⊙ to return to the Print Menu.

Highlight *Print select* and press ⊙ to display the pictures in the selected folders. The display in the LCD Monitor will show three small and one large thumbnail picture. The selected picture will have a yellow border around its small thumbnail and also be displayed as the large thumbnail. You can scroll through all the pictures by pressing ⊙ , and select the pictures to be printed by pressing ⊙ . A small icon 🖼 will appear in the image area. The figure "1" indicates that one copy will be printed. If you press ⊙ again, the figure will increase incrementally by one each time to show the number of copies that will be printed up to a maximum of 99. To begin printing, press the ⌨ button; you can cancel printing at any stage by pressing the ⌨ button again.

Digital Print Order Format (DPOF)
If you are away from home, say on vacation, you can still produce prints from your digital files even if you do not have your own printer with you. The D70 supports Digital Print Order Format (DPOF) that, unlike PictBridge, embeds data in the image file that allows you to insert the memory card into any DPOF compatible home printer or commercial mini-lab printer, and get a set of prints of those images you want.

To select images for printing, open the Playback Menu and navigate to Print Set, then press ⊙ to select it. Highlight *Select/set* and press ⊙ to open the option. A series of up to nine thumbnail images will displayed on the LCD Monitor from the folder or folders selected in the Playback fldr menu; scroll through them by pressing ⊙ , which moves a yellow frame to highlight the selected image. If you press ⊙ a small icon 🖼 will appear in the image area. The figure 1 indicates that one copy will be printed. If you press ⊙ again the figure will increase incrementally by one each time to show the number of copies that will be printed. Pressing ⊙ decreases the number of copies that will be printed.

Printing Image Data
From the PictBridge menu, highlight *Setup* and press ⊙ this will show the option *Imprint date*. Pressing ⊙ again

will place a check mark in the box next to Imprint data. The date of recording the image will appear on all pictures printed via the direct connection.

Note: There is no Data imprint [shutter speed and aperture] option from the PictBridge menu.

Alternatively, once you have finished making your selection via the Print Set menu press the ⏎ENTER button.

This opens a further page that allows you to have information printed on the image: select *Data imprint* to print shutter speed and aperture values, and select *Imprint date* to print the date the image was recorded, by pressing ⊙ for each option. Pressing ⊙ again will deselect the appropriate option.

Nikon Software

It is beyond the scope of this book to describe in detail the features and functions of Nikon's dedicated software, so I have provided merely an overview. Initial supplies of the D70 came with a copy of Nikon View, but towards the end of 2004 this was replaced by their new browser application, Picture Project. While Nikon View has been updated to ensure compatibility with the many of the recent upgrades to Nikon Capture, it still does not support some of the new Nikon Capture tools. It seems unlikely that Nikon will continue the development of Nikon View. The point of divergence on the evolutionary tree has been passed; Nikon Capture and Picture Project will continue to mature while Nikon View slowly withers, which in my opinion is a great pity, as I am not a fan Picture Project!

Nikon View and Picture Project

As explained, one or the other of these two applications come supplied with the camera, and updates are available free for download from Nikon's various support websites (see page 221). Both applications control the transfer of images, either directly from the camera or from a card

reader, and allow a number of preferences to be set, including file naming and numbering. These softwares also provide an image browsing capability to display images so you can review, sort, and edit them once they have been transferred to a computer.

As soon as the transfer is complete and images have been placed in the appropriate folder, the browser window will auto-launch and the last set of images to be imported will be displayed as a series of thumbnail pictures.

Shooting data can be viewed by clicking on the arrowhead at the left end of the bar labeled *Shooting Data*. The information for the highlighted image (it will be highlighted by a selection frame) is then shown in a box that opens beneath the menu bar. You can search for other images in the directory tree shown to the left side of the main browser window. You can also view images with a restricted version of Nikon Editor, which allows you to use a limited number of tools and controls, including brightness, contrast, image size, sharpening (although no parameters are shown—just Off, Low, Medium, and High), and red-eye reduction (only available for JPEG files). For NEF files there are further controls that permit exposure compensation of +/- 2EV, and white balance (within the available preset values) can be subsequently adjusted at any time.

Note: It is not possible to rescue grossly overexposed images using exposure compensation, as areas with burnt out highlights will have no data for the application to work with.

Note: In practical terms, the range of exposure compensation for NEF files using Nikon's software is closer to −1.5EV to +1EV, as changes beyond these limits can introduce unwanted artifacts.

Nikon Capture
Nikon Capture is a more sophisticated application than Nikon View and Picture Project, permitting a far greater level of image control and the ability to operate compatible

cameras remotely. It is available as an optional extra, and has two distinct components: Nikon Editor and Nikon Camera Control. Nikon Editor is used to assist processing and enhancing of NEF and JPEG files, with the option of converting them to other formats or opening them directly into another image-processing application, such as Adobe Photoshop. Nikon Camera Control allows full remote control of a D70 or D70s while the camera is connected to a computer via a UC-E4 USB cable. It also allows the direct transfer of images from the camera to a computer, effectively turning the computer hard drive in to a large volume memory card.

Nikon Capture 4 Editor offers many features, including:

- Advanced white balance control with the ability to specify a color temperature and sample from a gray point.
- Advanced NEF file control that permits attributes such as exposure compensation, sharpening, contrast, color mode, saturation, and hue to be modified after the exposure has been made.
- The Image Dust Off feature, which compares an NEF file with a reference image taken with the same camera to help reduce the effects of any dust particles on the low-pass filter.
- The Dynamic Exposure Extender, which emulates the "dodge & burn" techniques of traditional photographic printing to control highlight and shadow areas to produce a more balanced exposure.
- Color Noise Reduction, which minimizes the effect of random electronic noise that can occur, especially at high sensitivity settings.
- Edge Noise Reduction accentuates the boundary between areas of the image to make them more distinct.
- Colour Moiré Reduction helps to remove the effects of moiré, which can occur when an image contains areas with a very fine repeating pattern.
- Fisheye Image Transformer converts images taken with the AF DX Fisheye 10.5mm f/2.8G lens so they appear as though a conventional rectilinear lens has taken them.

Making the Most of Your D70s/D70

Workflow

Using film for photography is familiar to most people; load the camera, take the pictures, and then have someone else do the processing and printing for you. Shooting digitally brings a number of new aspects to your photographic procedure or process, and provides a far greater level of control. Therefore, it is essential to develop a routine to make sure you work in an efficient and effective way. You may wish to consider the following seven-point workflow as a general guide to establishing your own routine.

Preparation:
- Familiarize yourself with the camera.

- Make sure the camera battery is charged and carry a spare.

- Use two or three memory cards to reduce the risk of a catastrophic loss of all your pictures (if they were saved to a single large capacity card that was lost or became corrupted).

- Format all memory cards in the camera in which they will be used (not in another camera or the computer).

☜ *With digital cameras it is a good idea to develop a routine or workflow that you can use to prepare for a day-shoot on location. If you make your digital workflow a habit, you won't discover that you forgot an essential step when you arrive at your destination.*

Shooting:
- Adjust camera settings to match the requirements of your shoot; choose an appropriate image quality, size, and color space.

- Set other camera controls such as metering, ISO, white balance, and autofocus according to the particular shooting conditions.

- Review images on the spot and make any adjustments you deem necessary. The histogram display is extremely useful for checking exposure values.

- Do not be in too much of a hurry to delete pictures unless they are obvious failures. It is often better to edit after the shoot rather than "on the fly."

Transfer:
- Before transferring images to your computer, designate a specific folder or folders in which the images will be stored so you know where to find them.

- Use a card reader rather than connecting the camera directly to the computer. It is much faster and more reliable.

- If your browser application permits you to assign general information to the image files during transfer (e.g. DNPR metadata) make sure you complete appropriate fields for image authorship and copyright.

Edit and File:
- Use a browser application to sort through your pictures.

- Print a contact sheet of small thumbnail images to help you decide which images to retain.

- Consider renaming files and assigning further information and key words to facilitate locating images at a later date.

This picture was shot using a high-quality, low compression JPEG format file. Once it was downloaded into the computer it was converted to a TIFF for processing.

Processing:

- Make copies of RAW files and save them to a working file format such as TIFF or Adobe Photoshop PSD.

- Do not use the JPEG format for processing.

- Make adjustments in an orderly and logical sequence starting with overall brightness, contrast, and color. Then make more local adjustments to correct problems or enhance the image.

- Save your adjusted file as a master copy to which you can then apply a crop, resizing, sharpening, and any other finishing touches appropriate to your output requirements.

Make sure you back up your photos on CDs, DVDs, or an external hard drive.

Archive:

- Data can become lost or corrupted at any time for a variety of reasons, so always make multiple back-up copies of your original files and the edited master copies.

- CDs have a limited capacity, so consider DVDs, or an external hard drive.

Display:

- We all shoot pictures for others to see and enjoy. Digital technology has expanded the possibilities of image display considerably; we can email pictures to family and friends, prepare digital slideshows, or post images to a website.

- Home printing in full color is now reliable, cost effective, and, achievable. Spend time to set up your system properly; calibrate your monitor and printer regularly, use an appropriate resolution for the print size you require, then choose paper type and finish accordingly.

Camera Settings

The following table lists the settings on the D70 that can be adjusted in each shooting mode. It is important to note that the Digital Vari-Program Modes deny access to many significant camera controls, including metering, white balance, exposure compensation, and exposure bracketing.

Camera Settings	AUTO	🏃	🏞	🌷	🤸	🌆	👤	P	S	A	M
Image size	✔	✔	✔	✔	✔	✔	✔	✔	✔	✔	✔
Image quality	✔	✔	✔	✔	✔	✔	✔	✔	✔	✔	✔
Sensitivity (ISO equivalency)	✔	✔	✔	✔	✔	✔	✔	✔	✔	✔	✔
White balance[1]								✔	✔	✔	✔
Optimize image[1]								✔	✔	✔	✔
Shooting mode[2]	✔	✔	✔	✔	✔	✔	✔	✔	✔	✔	✔
Focus lock	✔	✔	✔	✔	✔	✔	✔	✔	✔	✔	✔
Metering[1]								✔	✔	✔	✔
Depth-of-field preview	✔	✔	✔	✔	✔	✔	✔	✔	✔	✔	✔[3]
Flexible program[4]								✔			
Auto-exposure lock	✔	✔	✔	✔	✔	✔	✔	✔	✔	✔	✔
Exposure compensation[1]								✔	✔	✔	✔
Bracketing[1]								✔	✔	✔	✔
Flash sync mode [1,5]	✔	✔		✔			✔	✔	✔	✔	✔
Manual pop-up for built-in Speedlight								✔	✔	✔	✔
Auto pop-up for built-in Speedlight	✔	✔		✔			✔				
Flash exposure compensation (FV)[1]								✔	✔	✔	✔
Custom Setting 2: **Autofocus** [1,5]	✔	✔	✔	✔	✔	✔	✔	✔	✔	✔	✔
Custom Setting 3: **AF-area mode** [1,5]	✔	✔	✔	✔	✔	✔	✔	✔	✔	✔	✔
Custom Setting 4: **AF assist**	✔	✔		✔			✔	✔	✔	✔	✔
Custom Setting 5: **ISO auto**	✔	✔	✔	✔	✔	✔	✔	✔	✔	✔	✔
Custom Setting 19: **Flash mode**								✔	✔	✔	✔

1 Setting last in effect is restored next time P , S , A , or M mode is selected.
2 If self-timer, delayed remote, or quick-response remote mode is selected when camera is turned off, single-frame or continuous mode (whichever was last used) will be selected when camera is turned on.
3 CPU lens required.
4 Selecting another mode cancels flexible program.
5 Selecting 🏠 , 🏃 , 🏞 , 🌷 , 🤸 , 🌆 , or 👤 restores default for selected mode.

Troubleshooting

The D70 is a sophisticated electronic device capable of reporting a range of malfunctions and problems by way of indicators and error messages that appear in the viewfinder, control panel, and LCD Monitor. The following table will assist you in finding a solution should one of these indicators or messages be displayed.

Indicator		Problem	Solution
Control panel	View-finder		
◀▬▬		Low battery.	Ready a fully-charged spare battery.
◀▬▬ (blinks)	(blinks)	Battery exhausted.	Replace battery.
FE E (blinks)		Lens aperture ring is not set to minimum aperture.	Set ring to minimum aperture (largest f/-number).
F- - (blinks)		No lens attached, or non-CPU lens attached.	Attach CPU lens (IX Nikkor excluded), or rotate mode dial to **M** and use lens aperture ring to set aperture.
	● (blinks)	Camera unable to focus using autofocus.	Focus manually
H ¡		Subject too bright; photo will be overexposed.	• If sensitivity (ISO equivalency) is over 200, lower sensitivity • Use ND filter • In mode: **S** Increase shutter speed **A** Choose a smaller aperture (larger f/-number)
L o		Subject too dark; photo will be underexposed.	• If sensitivity (ISO equivalency) is under 1600, raise sensitivity • Use built-in Speedlight. • In mode: **S** Lower shutter speed **A** Choose a larger aperture (smaller f/-number)
buL b (blinks)		buL b selected in mode **S**.	Change shutter speed or select mode **M**.

216

Indicator		Problem	Solution
Control panel	**View-finder**		
- - (blinks)		- - selected in remote control mode and mode dial rotated to **S**.	Change shutter speed or select mode **M**.
	⚡ (blinks)	• Flash required for correct exposure (**P**, **S**, **A**, **M** modes). • Flash has fired at full power (⚡ blinks for three seconds after flash fires).	• Raise built-in Speedlight. • Check photo in monitor; if underexposed, adjust settings and try again.
☐⚡ (blinks)	⚡	Speedlight that does not support i-TTL flash control attached and set to TTL.	Change flash mode setting on optional Speedlight.
FuLL 0 (blinks)	FuL 0 (blinks)	Memory insufficient to record further photos at current settings, or camera has run out of file or folder numbers.	• Reduce quality or size. • Delete photographs. • Insert new memory card.
Err (blinks)		Camera malfunction.	Release shutter. If error persists or appears frequently, consult with Nikon-authorized service representative.

Reset Button

Operation of the D70 is totally dependent on electrical power. Occasionally, the camera may stop functioning properly, or display unusual characters or unexpected messages in the viewfinder and LCD displays. Such behavior is generally due to the effects of electrostatic charge. If this occurs, try switching

The Reset button is a tiny hole on the far left side of the camera's base plate. Also found on the camera's under side are the serial number, battery chamber cover, and tripod socket.

Indicator		Problem	Solution
Monitor	**Control panel**		
NO CARD PRESENT	-E-	Camera cannot detect memory card.	Turn camera off and confirm that card is correctly inserted.
CARD IS NOT FORMATTED	For	Memory card has not been formatted for use in D70.	Format memory card.
THIS CARD CANNOT BE USED	[CHA] (blinks)	• Error accessing memory card. • Unable to create new folder • Card has not been formatted for use in D70.	• Use Nikon-approved card. • Check that contacts are clean. If card is damaged, contact retailer or Nikon representative. • Delete files or insert new memory card. • Format memory card.
FOLDER CONTAINS NO IMAGES		• Memory card contains no images. • Current folder is empty.	• Insert another card. • Set **Playback dr** to **All**.
ALL IMAGES HIDDEN		All photos in current folder are hidden.	Set **Playback dr** to **All** or use **Hide image** to reveal hidden photos.
FILE DOES NOT CONTAIN IMAGE DATA		File has been created or modified using a computer or different make of camera, or file is corrupt.	Delete file or reformat memory card.

the camera off, disconnecting it from its power supply (remove the EN-EL3/3a battery, or unplug the EH-5 AC adapter), then reconnect the power, and switch the camera on again. As an alternative, try depressing the Depth-of-field Preview Button rapidly five or six times while the camera is switched to ON.

If this fails to rectify the situation, press the Reset Button located on the base of the camera toward the left-hand end. It is recessed in the base-plate of the camera, so you will need the tip of a ballpoint pen or a paperclip to access it. This will also reset the internal clock, so you will have to re-enter the correct date and time.

Approved Memory Cards

There are a plethora of memory cards on the market but Nikon has only tested and approved those listed in the table below for use with the D70. However, CompactFlash and Microdrive technologies are well established, so although Nikon will not guarantee operation with other makes of card, you should not experience significant problems.

SanDisk	SDCFB	16 MB, 48 MB, 80 MB, 96 MB, 128 MB, 160 MB, 256 MB, 512 MB, 1 GB
	SDCFB (Type II)	192 MB, 300 MB
	SDCF2B (Type II)	256 MB
	SDCFH (Ultra)	128 MB, 192 MB, 256 MB, 384 MB, 512 MB, 1 GB
	SDCFH (Ultra II)	256 MB
	SDCFX	512 MB, 1 GB
Lexar Media	4x USB	16 MB, 32 MB, 64 MB
	8x USB	16 MB, 32 MB, 48 MB, 64 MB, 80 MB
	10x USB	160 MB
	12x USB	64 MB, 128 MB, 192 MB, 256 MB, 512 MB
	16x USB	192 MB, 256 MB, 320 MB, 512 MB, 640 MB, 1 GB
	24x USB	256 MB, 512 MB
	24x W A USB	
	32x W A USB	1 GB
	40x W A USB	256 MB, 512 MB, 1 GB, 2 GB, 4 GB
Renesas Technology (Hitachi)	Compact FLASH HB28 C8x	16 MB, 32 MB
Microdrive	DSCM	512 MB, 1 GB
	3K4	2 GB, 4 GB

Operation is not guaranteed with other makes of card. For more details on the above cards, please contact the manufacturer.

Memory Card Capacity

The table below provides information on the approximate number of images that can be stored on a 256Mb memory card at the various image quality and size settings available on the D70.

Image quality	Image size	File size*	No of images*	Buffer capacity†
NEF (Raw)	—	5.0 MB	44‡	4
JPEG Fine	L	2.9 MB	73	9
	M	1.6 MB	130	7
	S	0.8 MB	279	19
JPEG Normal	L	1.5 MB	144	12
	M	0.8 MB	253	7
	S	0.4 MB	528	27
JPEG Basic	L	0.8 MB	279	19
	M	0.4 MB	481	7
	S	0.2 MB	950	49
NEF+JPEG Basic	L**	5.8 MB††	39††	4

* All figures are approximate. File size varies with scene recorded.
† Maximum number of frames that can be stored in memory buffer.
‡ Exposure count display shows 23 exposures remaining.
** Size of JPEG image fixed at L. When opened in PictureProject or Nikon Capture 4 version 4.1 or later, NEF image is 3,008x2,000 pixels.
†† Total file size of NEF (RAW) and JPEG images.
‡‡ Exposure count display shows 21 exposures remaining.

When enough memory remains on the memory card to record a thousand or more pictures at current settings, the number of exposures remaining will be shown in thousands, rounded down to the nearest hundred (e.g. if there is room for approximately 1,260 exposures, the exposure count display will show 1.2K).

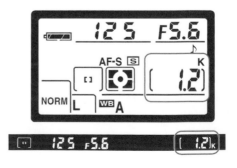

For best results use quality memory cards, reformat cards in the camera before a shoot, and set the camera for the highest quality JPEG settings or use NEF.

Web Support

Nikon maintains product support, and provides further information on-line at the following sites:

http://www.nikonusa.com—for continental North America

http://www.europe-nikon.com/support—for most European countries

http://www.nikon-asia.com—for Asia, Oceania, Middle East, and Africa

Glossary

A
See Aperture-Priority mode.

AA
Auto aperture. Refers to a Nikon flash mode in which the flash level is automatically adjusted for aperture.

aberration
An optical flaw in a lens that causes the image to be distorted or unclear.

Adobe Photoshop
Professional-level image-processing software with extremely powerful filter and color-correction tools. It offers features for photography, graphic design, web design, and video.

Adobe Photoshop Elements
A limited version of the Photoshop program, designed for the avid photographer. The Elements program lacks some of the more sophisticated controls available in Photoshop, but it does have a comprehensive range of image-manipulation options, such as cropping, exposure and contrast controls, color correction, layers, adjustment layers, panoramic stitching, and more.

AE
See automatic exposure.

AF
See automatic focus.

AF-D
AF Nikkor lenses that communicate the distance of the focused subject to a compatible camera body in order to improve the accuracy of exposure calculations for both ambient light and flash. (AF-G, AF-I, and AF-S lenses also perform this function.) AF-D lenses are focused by a motor mounted in the camera body.

AF-G
AF Nikkor lenses that lack a conventional aperture ring. They are only compatible with those cameras that permit the aperture to be set from the camera body.

AF-I
The first series of AF Nikkor lenses to have an internal focusing motor.

AF-S
AF Nikkor lenses that use a silent wave focusing motor mounted within the lens. The technology used in AF-S lenses permits faster and more responsive automatic focusing as compared to the AF-I and AF-D lenses.

AI
Automatic Indexing.

AI-S
Nikon F-mount lens bayonet for manual focus Nikkor lenses. They have a small notch milled out of the bayonet ring.

ambient light
See available light.

angle of view
The area seen by a lens, usually measured in degrees across the diagonal of the film frame.

anti-aliasing
A technique that reduces or eliminates the jagged appearance of lines or edges in an image.

aperture
The opening in the lens that allows light to enter the camera. Aperture is usually described as an f/number. The higher the f/number, the smaller the aperture; the lower the f/number, the larger the aperture.

Aperture-Priority mode
A type of automatic exposure in which you manually select the aperture and the camera automatically selects the shutter speed.

artifact
Information that is not part of the scene but appears in the image due to technology. Artifacts can occur in film or digital images and include increased grain, flare, static marks, color flaws, noise, etc.

artificial light
Usually refers to any light source that doesn't exist in nature, such as incandescent, fluorescent, and other manufactured lighting.

astigmatism
An optical defect that occurs when an off-axis point is brought to focus as sagittal and tangential lines rather than a point.

automatic exposure
When the camera measures light and makes the adjustments necessary to create proper image density on sensitized media.

automatic flash
An electronic flash unit that reads light reflected off a subject (from either a preflash or the actual flash exposure), then shuts itself off as soon as ample light has reached the sensitized medium.

automatic focus
When the camera automatically adjusts the lens elements to sharply render the subject.

available light
The amount of illumination at a given location that applies to natural and artificial light sources but not those supplied specifically for photography. It is also called existing light or ambient light.

backlight
Light that projects toward the camera from behind the subject.

backup
A copy of a file or program made to ensure that, if the original is lost or damaged, the necessary information is still intact.

barrel distortion
A defect in the lens that makes straight lines curve outward away from the middle of the image.

bit
Binary digit. This is the basic unit of binary computation. See also, byte.

bit depth
The number of bits per pixel that determines the number of colors the image can display. Eight bits per pixel is the minimum requirement for a photo-quality color image.

bounce light
Light that reflects off of another surface before illuminating the subject.

bracketing
A sequence of pictures taken of the same subject but varying one or more exposure settings, manually or automatically, between each exposure.

brightness
A subjective measure of illumination. See also, luminance.

buffer
Temporarily stores data so that other programs, on the camera or the computer, can continue to run while data is in transition.

built-in flash
A flash that is permanently attached to the camera body. The built-in flash will pop up and fire in low-light situations when using the camera's automated exposure settings.

built-in meter
A light measuring device that is incorporated into the camera body.

bulb
A camera setting that allows the shutter to stay open as long as the shutter release is depressed.

byte
A single group of eight bits that is processed as one unit. See also, bit.

card reader
Device that connects to your computer and enables quick and easy download of images from memory card to computer.

CCD
Charge Coupled Device. This is a common digital camera sensor type that is sensitized by applying an electrical charge to the sensor prior to its exposure to light. It converts light energy into an electrical impulse.

chromatic aberration
Occurs when light rays of different colors are focused on different planes, causing colored halos around objects in the image.

chrominance
Hue and saturation information.

chrominance noise
A form of artifact that appears as a random scattering of densely packed colored "grain." See also, luminance and noise.

close-up
A general term used to describe an image created by closely focusing on a subject. Often involves the use of special lenses or extension tubes. Also, an automated exposure setting that automatically selects a large aperture (not available with all cameras).

CLS
Creative Lighting System. This is a flash control system that Nikon introduced with its SB-800 and SB-600 Speedlights. See also, Speedlight.

CMOS

Complementary Metal Oxide Semiconductor. Like CCD sensors, this sensor type converts light into an electrical impulse. CMOS sensors are similar to CCDs, but allow individual processing of pixels, are less expensive to produce, and use less power. See also, CCD.

CMYK mode

Cyan, magenta, yellow, and black. This mode is typically used in image-editing applications when preparing an image for printing.

color balance

The average overall color in a reproduced image. How a digital camera interprets the color of light in a scene so that white or neutral gray appear neutral.

color cast

A colored hue over the image often caused by improper lighting or incorrect white balance settings. Can be produced intentionally for creative effect.

color space

A mapped relationship between colors and computer data about the colors.

CompactFlash (CF) card

One of the most widely used removable memory cards.

complementary colors

In theory: any two colors of light that, when combined, emit all known light wavelengths, resulting in white light. Also, it can be any pair of dye colors that absorb all known light wavelengths, resulting in black.

compression

Method of reducing file size through removal of redundant data, as with the JPEG file format.

contrast

The difference between two or more tones in terms of luminance, density, or darkness.

contrast filter

A colored filter that lightens or darkens the monotone representation of a colored area or object in a black-and-white photograph.

CPU

Central Processing Unit. This is the "brains" of a computer or a lens that perform principle computational functions.

critical focus

The most sharply focused plane within an image.

cropping

The process of extracting a portion of the image area. If this portion of the image is enlarged, resolution is subsequently lowered.

dedicated flash

An electronic flash unit that talks with the camera, communicating things such as flash illumination, lens focal length, subject distance, and sometimes flash status.

default

Refers to various factory-set attributes or features, in this case of a camera, that can be changed by the user but can, as desired, be reset to the original factory settings.

depth of field

The image space in front of and behind the plane of focus that appears acceptably sharp in the photograph.

diaphragm

A mechanism that determines the size of the lens opening that allows light to pass into the camera when taking a photo.

digital zoom

The cropping of the image at the sensor to create the effect of a telephoto zoom lens. The camera interpolates the image to the original resolution. However, the result is not as sharp as an image created with an optical zoom lens because the cropping of the image reduced the available sensor resolution.

diopter

A measurement of the refractive power of a lens. Also, it may be a supplementary lens that is defined by its focal length and power of magnification.

download

The transfer of data from one device to another, such as from camera to computer or computer to printer.

dpi

Dots per inch. Used to define the resolution of a printer, this term refers to the number of dots of ink that a printer can lay down in an inch.

DPOF

Digital Print Order Format. A feature that enables the camera to supply data about the printing order of image files and the supplementary data

contained within them. This feature can only be used in conjunction with a DPOF compatible printer.

D-TTL

A flash control system that relies on a series of pre-flashes to determine the output required from a Nikon Speed-light. The system does not monitor the flash output during actual exposure. See also, Speedlight.

D-type Nikkor

A series of lenses that have a built-in CPU that is used to communicate the focus distance informa-tion to the camera body, improving the accuracy of exposure measurement.

DX

Nikkor lenses designed specifically for the Nikon DX format sensor.

dye sublimation printer

Creates color on the printed page by vaporizing inks that then solidify on the page.

ED glass

Extra-low Dispersion glass. Developed by Nikon, this glass was incorporated into many of their camera lenses to reduce the effects of chro-matic aberration. See also, chromatic aberration.

electronic flash

A device with a glass or plas-tic tube filled with gas that, when electrified, creates an intense flash of light. Also called a strobe. Unlike a flash bulb, it is reusable.

electronic rangefinder

A system that utilizes the AF technology built into a cam-era to provide a visual con-firmation that focus has been achieved. It can oper-ate in either manual or AF focus modes.

EV

Exposure Value. A number that quantifies the amount of light within an scene, allow-ing you to determine the rela-tive combinations of aperture and shutter speed to accu-rately reproduce the light lev-els of that exposure.

EXIF

Exchangeable Image File Format. This format is used for storing an image file's interchange information.

exposure

When light enters the cam-era and reacts with the sensi-tized medium. The term can also refer to the amount of light that strikes the light sensitive medium.

exposure meter

See light meter.

extension tube

A hollow metal ring that can be fitted between the camera and lens. It increases the dis-tance between the optical center of the lens and the sensor and decreases the minimum focus distance of the lens.

f/

See f/stop.

FAT

File Allocation Table. This is a method used by computer operating systems to keep

track of files stored on the hard drive.

file format

The form in which digital images are stored and recorded, e.g., JPEG, RAW, TIFF, etc.

filter

Usually a piece of plastic or glass used to control how cer-tain wavelengths of light are recorded. A filter absorbs selected wavelengths, prevent-ing them from reaching the light sensitive medium. Also, software available in image-processing computer pro-grams can produce special filter effects.

FireWire

A high speed data transfer standard that allows outlying accessories to be plugged and unplugged from the computer while it is turned on. Some digital cameras and card read-ers use FireWire to connect to the computer. FireWire trans-fers data faster than USB. See also, Mbps.

firmware

Software that is permanently incorporated into a hardware chip. All computer-based equipment, including digital cameras, use firmware of some kind.

flare

Unwanted light streaks or rings that appear in the viewfinder, on the recorded image, or both. It is caused by extraneous light entering the camera during shooting. Dif-fuse flare is uniformly reflected light that can lower the contrast of the image. Zoom lenses are susceptible

to flare because they are comprised of many elements. Filters can also increase flare. Use of a lens hood can often reduce this undesirable effect.

f/number
See f/stop.

focal length
When the lens is focused on infinity, it is the distance from the optical center of the lens to the focal plane.

focal plane
The plane on which a lens forms a sharp image. Also, it may be the film plane or sensor plane.

focus
An optimum sharpness or image clarity that occurs when a lens creates a sharp image by converging light rays to specific points at the focal plane. The word also refers to the act of adjusting the lens to achieve optimal image sharpness.

FP high-speed sync
Focal Plane high-speed sync. Some digital cameras emulate high shutter speeds by switching the camera sensor on and off rather than moving the shutter blades or curtains that cover it. This allows flash units to be synchronized at shutter speeds higher than the standard sync speed. In this flash mode, the level of flash output is reduced and, consequently, the shooting range is reduced.

f/stop
The size of the aperture or diaphragm opening of a lens, also referred to as f/number or stop. The term stands for the ratio of the focal length (f) of the lens to the width of its aperture opening. (f/1.4 = wide opening and f/22 = narrow opening.) Each stop up (lower f/number) doubles the amount of light reaching the sensitized medium. Each stop down (higher f/number) halves the amount of light reaching the sensitized medium.

full-frame
The maximum area covered by the sensitized medium.

full-sized sensor
A sensor in a digital camera that has the same dimensions as a 35mm film frame (24 x 36 mm).

GB
See gigabyte.

gigabyte
Just over one billion bytes.

GN
See guide number.

gray card
A card used to take accurate exposure readings. It typically has a white side that reflects 90% of the light and a gray side that reflects 18%.

gray scale
A successive series of tones ranging between black and white, which have no color.

guide number
A number used to quantify the output of a flash unit. It is derived by using this formula: GN = aperture x distance. Guide numbers are expressed for a given ISO film speed in either feet or meters.

hard drive
A contained storage unit made up of magnetically sensitive disks.

histogram
A graphic representation of image tones.

hot shoe
An electronically connected flash mount on the camera body. It enables direct connection between the camera and an external flash, and synchronizes the shutter release with the firing of the flash.

icon
A symbol used to represent a file, function, or program.

IF
Internal Focusing. This Nikkor lens system shifts a group of elements within the lens to acquire focus more quickly without changing the overall length of the lens (as occurs with conventional, helical focusing mechanisms).

image-processing program
Software that allows for image alteration and enhancement.

infinity
In photographic terms, the theoretical most distant point of focus.

interpolation
Process used to increase image resolution by creating new pixels based on existing pixels. The software intelligently looks at existing pixels and creates new pixels to fill the gaps and achieve a higher resolution.

IS

Image Stabilization. This is a technology that reduces camera shake and vibration. It is used in lenses, binoculars, camcorders, etc.

ISO

From ISOS (Greek for equal), a term for industry standards from the International Organization for Standardization. When an ISO number is applied to film, it indicates the relative light sensitivity of the recording medium. Digital sensors use film ISO equivalents, which are based on enhancing the data stream or boosting the signal.

i-TTL

A Nikon TTL flash control system that has a refined monitor pre-flash sequence and offers improved flash exposure control. See also, TTL.

JFET

Junction Field Effect Transistor, which are used in digital cameras to reduce the total number of transistors and minimize noise.

JPEG

Joint Photographic Experts Group. This is a lossy compression file format that works with any computer and photo software. JPEG examines an image for redundant information and then removes it. It is a variable compression format because the amount of leftover data depends on the detail in the photo and the amount of compression. At low compression/high quality, the loss of data has a negligible effect on the photo. However, JPEG should not be used as a working format—the file should be reopened and saved in a format such as TIFF, which does not compress the image.

KB

See kilobyte.

kilobyte

Just over one thousand bytes.

latitude

The acceptable range of exposure (from under to over) determined by observed loss of image quality.

LBCAST

Lateral Buried Charge Accumulator and Sensing Transistor array. This is an array that converts received light into a digital signal, attaching an amplification circuit to each pixel of the imaging sensor.

LCD

Liquid Crystal Display, which is a flat screen with two clear polarizing sheets on either side of a liquid crystal solution. When activated by an electric current, the LCD causes the crystals to either pass through or block light in order to create a colored image display.

LED

Light Emitting Diode. It is a signal often employed as an indicator on cameras as well as on other electronic equipment.

lens

A piece of optical glass on the front of a camera that has been precisely calibrated to allow focus.

lens hood

Also called a lens shade. This is a short tube that can be attached to the front of a lens to reduce flare. It keeps undesirable light from reaching the front of the lens and also protects the front of the lens.

lens shade

See lens hood.

light meter

Also called an exposure meter, it is a device that measures light levels and calculates the correct aperture and shutter speed.

lithium-ion

A popular battery technology (sometimes abbreviated to Li-ion) that is not prone to the charge memory effects of nickel-cadmium (Ni-Cd) batteries, or the low temperature performance problems of alkaline batteries.

long lens

See telephoto lens.

lossless

Image compression in which no data is lost.

lossy

Image compression in which data is lost and, thereby, image quality is lessened. This means that the greater the compression, the lesser the image quality.

low-pass filter

A filter designed to remove elements of an image that correspond to high-frequency data, such as sharp edges and fine detail, to reduce the effect of moiré. See also, moiré.

luminance
A term used to describe directional brightness. It can also be used as luminance noise, which is a form of noise that appears as a sprinkling of black "grain." See also, brightness, chrominance, and noise.

M
See Manual exposure mode.

Mac
Macintosh. This is the brand name for computers produced by Apple Computer, Inc.

macro lens
A lens designed to be at top sharpness over a flat field when focused at close distances and reproduction ratios up to 1:1.

main light
The primary or dominant light source. It influences texture, volume, and shadows.

Manual exposure mode
A camera operating mode that requires the user to determine and set both the aperture and shutter speed. This is the opposite of automatic exposure.

MB
See megabyte.

Mbps
Megabits per second. This unit is used to describe the rate of data transfer. See also, megabit.

megabit
One million bits of data. See also, bit.

megabyte
Just over one million bytes.

megapixel
A million pixels.

memory
The storage capacity of a hard drive or other recording media.

memory card
A solid state removable storage medium used in digital devices. They can store still images, moving images, or sound, as well as related file data. There are several different types, including Compact-Flash, SmartMedia, and xD, or Sony's proprietary Memory Stick, to name a few. Individual card capacity is limited by available storage as well as by the size of the recorded data (determined by factors such as image resolution and file format). See also, CompactFlash (CF) card, file format.

menu
A listing of features, functions, or options displayed on a screen that can be selected and activated by the user.

microdrive
A removable storage medium with moving parts. They are miniature hard drives based on the dimensions of a CompactFlash Type II card. Microdrives are more susceptible to the effects of impact, high altitude, and low temperature than solid-state cards are. See also, memory card.

middle gray
Halfway between black and white, it is an average gray tone with 18% reflectance. See also, gray card.

midtone
The tone that appears as medium brightness, or medium gray tone, in a photographic print.

mode
Specified operating conditions of the camera or software program.

moiré
Occurs when the subject has more detail than the resolution of the digital camera can capture. Moiré appears as a wavy pattern over the image.

MOSFET
Metal Oxide Semiconductor Field Effect Transistor, which is used as an amplifier in digital cameras.

NEF
Nikon Electronic File. This is Nikon's proprietary RAW file format, used by Nikon digital cameras. In order to process and view NEF files in your computer, you will need Nikon View (version 6.1 or newer) and Nikon Capture (version 4.1 or newer).

Nikkor
The brand name for lenses manufactured by Nikon Corporation.

noise
The digital equivalent of grain. It is often caused by a number of different factors, such as a high ISO setting, heat, sensor design, etc. Though usually undesirable, it may be added for creative effect using an image-processing program. See also, chrominance noise and luminance.

normal lens
See standard lens.

operating system (OS)
The system software that provides the environment within which all other software operates.

overexposed
When too much light is recorded with the image, causing the photo to be too light in tone.

P
See Program mode.

pan
Moving the camera to follow a moving subject. When a slow shutter speed is used, this creates an image in which the subject appears sharp and the background is blurred.

PC
Personal Computer. Strictly speaking, a computer made by IBM Corporation. However, the term is commonly used to refer to any IBM compatible computer.

perspective
The effect of the distance between the camera and image elements upon the perceived size of objects in an image. It is also an expression of this three-dimensional relationship in two dimensions.

pincushion distortion
A flaw in a lens that causes straight lines to bend inward toward the middle of an image.

pixel
Derived from picture element. A pixel is the base component of a digital image. Every individual pixel can have a distinct color and tone.

plug-in
Third-party software created to augment an existing software program.

polarization
An effect achieved by using a polarizing filter. It minimizes reflections from non-metallic surfaces like water and glass and saturates colors by removing glare. Polarization often makes skies appear bluer at 90 degrees to the sun. The term also applies to the above effects simulated by a polarizing software filter.

pre-flashes
A series of short duration, low intensity flash pulses emitted by a flash unit immediately prior to the shutter opening. These flashes help the TTL light meter assess the reflectivity of the subject. See also, TTL.

Program mode
In Program exposure mode, the camera selects a combination of shutter speed and aperture automatically.

RAM
Stands for Random Access Memory, which is a computer's memory capacity, directly accessible from the central processing unit.

RAW
An image file format that has little or no internal processing applied by the camera. It contains 12-bit color information, a wider range of data than 8-bit formats such as JPEG.

RAW+JPEG
An image file format that records two files per capture; one RAW file and one JPEG file.

rear curtain sync
A feature that causes the flash unit to fire just prior to the shutter closing. It is used for creative effect when mixing flash and ambient light.

red-eye reduction
A feature that causes the flash to emit a brief pulse of light just before the main flash fires. This helps to reduce the effect of retinal reflection.

resolution
The amount of data available for an image as applied to image size. It is expressed in pixels or megapixels, or sometimes as lines per inch on a monitor or dots per inch on a printed image.

RGB mode
Red, Green, and Blue. This is the color model most commonly used to display color images on video systems, film recorders, and computer monitors. It displays all visible colors as combinations of red, green, and blue. RGB mode is the most common color mode for viewing and working with digital files onscreen.

S
See Shutter-priority mode.

saturation
The intensity or richness of a hue or color.

sharp
A term used to describe the quality of an image as clear, crisp, and perfectly focused,

as opposed to fuzzy, obscure, or unfocused.

short lens
A lens with a short focal length—a wide-angle lens. It produces a greater angle of view than you would see with your eyes.

shutter
The apparatus that controls the amount of time during which light is allowed to reach the sensitized medium.

Shutter-priority mode
An automatic exposure mode in which you manually select the shutter speed and the camera automatically selects the aperture.

slow sync
A flash mode in which a slow shutter speed is used with the flash in order to allow low-level ambient light to be recorded by the sensitized medium.

SLR
Single-lens reflex. A camera with a mirror that reflects the image entering the lens through a pentaprism or pentamirror onto the viewfinder screen. When you take the picture, the mirror reflexes out of the way, the focal plane shutter opens, and the image is recorded.

small-format sensor
In a digital camera, this sensor is physically smaller than a 35mm frame of film. The result is that standard 35mm focal lengths act like longer lenses because the sensor sees an angle of view smaller than that of the lens.

Speedlight
The brand name of flash units produced by Nikon Corporation.

standard lens
Also known as a normal lens, this is a fixed-focal-length lens usually in the range of 45 to 55mm for 35mm format (or the equivalent range for small-format sensors). In contrast to wide-angle or telephoto lenses, a standard lens views a realistically proportionate perspective of a scene.

stop
See f/stop.

stop down
To reduce the size of the diaphragm opening by using a higher f/number.

stop up
To increase the size of the diaphragm opening by using a lower f/number.

strobe
Abbreviation for stroboscopic. An electronic light source that produces a series of evenly spaced bursts of light.

synchronize
Causing a flash unit to fire simultaneously with the complete opening of the camera's shutter.

telephoto effect
When objects in an image appear closer than they really are through the use of a telephoto lens.

telephoto lens
A lens with a long focal length that enlarges the subject and produces a narrower angle of view than you would see with your eyes.

thumbnail
A miniaturized representation of an image file.

TIFF
Tagged Image File Format. This popular digital format uses lossless compression.

tripod
A three-legged stand that stabilizes the camera and eliminates camera shake caused by body movement or vibration. Tripods are usually adjustable for height and angle.

TTL
Through-the-Lens, i.e. TTL metering.

USB
Universal Serial Bus. This interface standard allows outlying accessories to be plugged and unplugged from the computer while it is turned on. USB 2.0 enables high-speed data transfer.

vignetting
A reduction in light at the edge of an image due to use of a filter or an inappropriate lens hood for the particular lens.

viewfinder screen
The ground glass surface on which you view your image.

VR
Vibration Reduction. This technology is used in such photographic accessories as a VR lens.

wide-angle lens
A lens that produces a greater angle of view than you would see with your eyes, often causing the image to appear stretched. See also, short lens.

Wi-Fi
Wireless Fidelity, a technology that allows for wireless networking between one Wi-Fi compatible product and another.

zoom lens
A lens that can be adjusted to cover a wide range of focal lengths.

Index

Also by Simon Stafford:

The New Nikon Compendium:
Cameras, Lenses, & Accessories Since 1917

This is a Nikon enthusiast's dream: the most complete Nikon reference book ever. At almost double the size of the original, it describes virtually every Nikon camera ever produced, right up to the digital models. It aids identification, offers user-friendly tips, explains what system fits with which camera, and discusses how to match equipment from one generation to items from another.
416 pages (all in b/w with 28 color plates)
7 1/2 x 10. *ISBN 1-57990-592-7*

Also from Lark Books:

PCPhoto Digital SLR Handbook
by Rob Sheppard

This is a comprehensive guide to the fastest-selling type of camera on the market. It's a photographer's dream manual, with the newest and hottest cameras, high-quality images, and in-depth information provided by an expert author and editor of *PCPhoto*, the number one digital photography magazine.
176 pages (all in color).
6x9. *ISBN 1-57990-602-8*

The Joy of Digital Photography
by Jeff Wignall

This all-in-color digital manual will encourage and inspire photographers of all skill levels. Everything is covered, from creative photography to common problems and solutions, from exposure and flash to dealing with the weather and your subject's mood! In addition, author Jeff Wignall offers a Photoshop primer, a handy workflow checklist, and plenty of post-production tips.

288 pages (all in color)
8 1/2 x 11. *ISBN 1-57990-578-1*

Complete Guide to Filters for Digital Photography
by Joseph Meehan

This book is a wide-ranging overview of digital-camera and computer-based filtration. It provides photographers with helpful information about how digital cameras respond to traditional photographic filters and which filters are most useful. In addition, it details how to use Photoshop filters, third-party plug-ins, improve color rendition, and simulate traditional effects.

168 pages (all in color)
8 1/2 x 11. *ISBN 1-57990-447-5*

Epson Complete Guide to Digital Printing: Updated Edition
by Rob Sheppard

Epson is at the cutting edge of digital photo-quality printing. Their STYLUS Photo Ink jet models enable anyone to make great prints right at home. Rob Sheppard walks photographers through the world of digital printing with helpful information as well a write-ups and pictures from acclaimed photographers explaining how Epson printers and digital photography have enhanced their art.

160 pages (all in color)
8 1/2 x 11. *ISBN 1-57990-586-2*

The Complete Guide to Color Correction
by Michael Walker & Neil Barstow

This comprehensive guide to color correction brings a fresh perspective to common problems, with a full discussion of monitor calibration and resolution, consistency across varying platforms, operating systems, and image-processing software. A hands-on workshop provides lessons in adjusting skin tones, retouching and restoring archived photos, and more.

192 pages (all in color)
8 1/4 x 9 1/2. *ISBN 1-57990-543-9*